Alex Gartenfeld Gean Moreno Stephanie Seidel

The Everywhere Studio

The Institute of
Contemporary Art, Miami

DelMonico Books•Prestel
Munich London New York

CONTENTS

FOREWORD . 8

ACKNOWLEDGMENTS . 11

INTRODUCTION . 13
Alex Gartenfeld

Pablo Picasso . 22
Philip Guston . 26
Yves Klein . 30
Andy Warhol . 35
Roy Lichtenstein . 38
John Baldessari . 41
Faith Ringgold . 45

STUDIO/STREETS
Faith Ringgold's Sense of Practice 49
Sampada Aranke

Bruce Nauman . 62
Edward and Nancy Kienholz . 64
Giulio Paolini . 67
Paul McCarthy . 68

HOUSE, YARD, STUDIO, SET
Paul McCarthy's Working Spaces 71
John C. Welchman

Tetsumi Kudo . 82

WHOSE PORTRAIT IS IT?
Tetsumi Kudo's Turn from Object
to Subject in the 1970s . 85
Tomohiro Masuda

Joseph Beuys . 95
Dieter Roth . 96
Daniel Spoerri . 101
Christo . 103
Lucas Samaras . 104

CONTENTS

ANTINOMIES OF THE STUDIO
Artistic Production in the Social Factory . 109
Gean Moreno

Carolee Schneemann . 118
Jay DeFeo . 121
Heidi Bucher . 125
Miriam Schapiro . 127

POSE AND EXPOSURE
Feminist Studio Practices of the 1960s and 1970s 129
Stephanie Seidel

Marc Camille Chaimowicz . 141
Stuart Brisley . 142

ZL656395C . 145
Stuart Brisley

Gilbert & George . 148
Art & Language . 150

HOW TO MAKE AN ARTWORK
Some Imaginary Relations to Relations of Production 153
John Miller

Alan Charlton . 165
Hanne Darboven . 166
Martin Kippenberger . 169
Jörg Immendorff . 170
Anna Oppermann . 172

REHEARSING PAINTING . 175
Sabeth Buchmann

Andrea Zittel . 184
Matthew Barney . 186
Cheryl Donegan . 188
David Hammons . 191

WORK/OUT . 193
Dieter Roelstraete

of MOS Architects, New York, for working with our curatorial team to realize an exhibition design that matches the flexibility and innovation of the exhibition's premise.

Loans from the Museum of Modern Art, New York; the Laurenz Foundation, Schaulager, Basel; The Broad, Los Angeles; Städtische Galerie im Lenbachhaus, Munich; the Musée d'Art Moderne de la Ville de Paris; Klassik Stiftung Weimar und Neues Museum, Weimar; and Museum moderner Kunst Stiftung Ludwig Wien (mumok), Vienna, allowed ICA Miami to present some of the exhibiting artists' most important works—brilliant pieces that form a central passage between the exhibition and the curators' line of argumentation. We acknowledge Ulrike Bestgen, Fabrice Hergott, Joanne Heyler, Eva Huttenlauch, Katherine Hinds, and Susanne Neuburger for facilitating these loans.

Funding from the Knight Contemporary Art Fund at the Miami Foundation has made "The Everywhere Studio" and this catalogue possible. Major support was provided by Art Mentor Foundation Lucerne, Deutsche Bank, Yves Saint Laurent, and the Dr. Kira and Mr. Neil Flanzraich Fund for Curatorial Research at ICA Miami. Additional support was provided by the Jacques and Natasha Gelman Foundation. With the enthusiastic and unwavering leadership of our board of trustees, ICA Miami is able to continuously present rigorous and provocative programming.

Ellen Salpeter
Director, Institute of Contemporary Art, Miami

ACKNOWLEDGMENTS

Maya Balcioglu, Daniele Balice, Douglas Baxter, Dorian Bergen, Anders Bergstrom, Irma and Norman Braman, Peter Bentley Brandt, Mayo and Indigo Bucher, Michael Cary, Courtney Casci, Andrea Cashman, Paul and Trudy Cejas, Graham Dalik, Carla Donauer, Esther Dörring, Adriana Elgarresta, Barbara Escobar, Julie Fliegenspan, Lisa Franzen, Florentine Gallwas, Christoph Gerozissis, Peter Gould, Cornelia Greengrassi, Aramis Gutierrez, Nora Heidorn, Marvin Hernandez, Joanne Heyler, Lena Ipsen, Lisa Jann, Finola Jones, Josie Keefe, Emily-Jane Kirwan, Birte Kleemann, Kerri Kneer, Matthias Koddenberg, Joey Kraft, Nicole Krapat, Petra and Stephen Levin, Leah Levy, Martin Z. Margulies, Karl McCool, Liz Mulholland, Tim Neuger, Wendy Olsoff, Sarah Palay, Barry Rosen, Lili Rusing, Karin Seinsoth, Samantha Sheiness, Jessica Silverman, Silvia Sokalski, Juliet Sorce, Thaddaeus Ropac, Joanna Thornberry, Barbara Thumm, Stefano Tonchi, Jacqueline Tran, Sam Tsao, Ute Vorkoeper, Sarah Watson, Stephanie Weber, Nici Wegener, Begum Yasar.

We thank all the artists who contributed to the exhibition and MOS Architects for their innovative exhibition design.

We commend the authors of this volume for their insightful essays on the topic of the artist's studio, and Chad Kloepfer for his compelling design.

Alex Gartenfeld

INTRODUCTION

The art of yesterday and today is not only marked by the studio as an essential, often unique, place of production; it proceeds from it.
—Daniel Buren[1]

In his seminal 1971 text "The Function of the Studio," Daniel Buren defines the studio as follows:

1. It is the place where the work originates.
2. It is generally a private place, an ivory tower perhaps.
3. It is a stationary place where portable objects are produced.[2]

This abbreviated description leads to a compelling explanation of Buren's "distrust of the studio and its simultaneously idealizing and ossifying function,"[3] which hinges on the fate of the artwork when it is "expelled" from the site of its production and hence gives primacy to the decisive relationship of the studio to the world at large. In Buren's conception of the studio, its crucial characteristic is that it is not part of the commons but a space apart: an isolated site that produces the specific type of subjectivity that comes out of an "ivory tower." And while both the "private" studio and the "portable" art object strive for autonomy, they inevitably mark each other with the real. Once released from the studio and put on display, Buren writes, the artwork "may become what even its creator had not anticipated, serving instead, as is usually the case, the greater profit of financial interests and the dominant ideology."[4] While the studio is a site of production like the factory floor, only the former produces an illusion of autonomy.

Buren's understanding of this "gap between studio and gallery" is in some ways an extension of the position staked out by Robert Smithson in his critical move toward a "post-studio" mode that relied on making work at a "site" outside both studio and gallery, with a "non-site" corollary—usually a kind of documentation—in the conventional exhibition space. What allowed

Daniel Buren, *Photo-souvenir: Affichage sauvage*,
May 1969 (detail). Courtesy the artist

Smithson to be, as he said, "unbounded," and what likewise facilitated Buren's production of large site-specific works, was for both artists their rejection of the idealized autonomy of the previous model of the studio as well as an immersion into vastly different systems whose complexities they each in their own way set out to explore. But many other artists since the 1960s—from the pioneers of Minimalism and "happenings" to figures affiliated with relational aesthetics and net art—have sought to overcome the disconnect between art and life by rejecting the idea of the traditional studio as the only tenable site of artistic production. In grappling with the problems that Buren outlined, they have critiqued not only the privileged disengagement of studio-based aesthetic production, but also the inevitable and deepening relationship of art to media, and the kinds of value and subjectivity this has produced in turn.

Indeed, between Buren's writing of his text in 1971 and its publication in 1979, one might say that the world—or at least large parts of its increasingly globalized economic system, and especially, of course, its privileged and exclusionary cosmopolitan centers—was itself well on the way to being remodeled according to post-studio tenets. In the West, Fordist manufacturing was giving way to post-Fordist, service-based economies and/or being replaced by cognitive labor; at the same time, many notionally socially democratic states were beginning their transformation into financialized neoliberal regimes.[5] One consequence of these shifts was that what critically engaged artists had assumed to be a position of resistance—not least their embrace of flexible, dematerialized, and informationalized artistic practices—became the dominant paradigm for work across society.

From today's perspective, it almost need not be said that these new forms of labor have led to less rather than more autonomy. Instead, the financialization and deregulation have also dissolved the stability of the spaces of production, and with them a host of social and economic protections. The precarity that is pervasive across today's globalized world could, moreover, be said to lie at the roots of the class anxiety, xenophobia, and ressentiment

that we encounter all too often today. This raises fundamental questions about whether art is at all capable of proposing truly liberated—or, for that matter, authentically critical—working methods. At the same time, it is clear that artists inhabit an exclusive and in some ways extremely privileged social position, in that their role carries an even intensified symbolic power.

It is within this broader context of a new economy and media landscape that "The Everywhere Studio" takes up its exploration of the consequences of Buren's ideas for post-studio practices and how they anticipated the mutability of the studio as model and metaphor. In part, this offers a way to critically examine his assumptions about the nature of the artist's work and its functions within society at large, but it also offers a way to explore the forms of subjectivity that are explicitly or implicitly constructed through art's changing relationship to labor and the place(s) where (art)work is made and displayed. It brings established and well-known artists together with lesser known positions that complicate conventional ideas about the studio in literal and metaphorical terms: not only as a physical place, but also as an interface for the mediation of inside and outside, private and public, labor and identity, and the sites of production, circulation, and display.

In other words, the exhibition is in part premised upon the idea that the work of art is, among much else, evidence. As Buren understood, it bears witness to the architectural, economic, and material values of its time; it indexes the systems and structures that support it. But it also departs from Buren's investigation to reflect on historical, economic, and cultural shifts since. If countless critically minded artists continue to engage with the studio, it is no longer, as in the post-studio model, *elsewhere*. In a broader sense, the traditional subject in the studio—as the central site not only of artistic production, but also of the construction of the artist's subjectivity—has utterly dissolved, because in a very real sense the studio is *everywhere*: it has become a precondition for labor, the performance of the self, artistic production, and capitalism itself—from all of which there is, arguably, no longer any respite or retreat.

In Luc Boltanski and Ève Chiapello's 2005 book *The New Spirit of Capitalism*, they explore the easy co-optation of artistic demands for freedom, autonomy, and authenticity. In their view, the artistic critique of the post-1968 years has itself contributed to the political disengagement and "aristocratic" aspects of recent economic developments. The theorists contextualize this against the background of artists' historical unwillingness to stand in solidarity with workers: "Untempered by considerations of equality and solidarity of the social critique, [the artistic critique] can very quickly play into the hands of a particularly destructive form of liberalism."[6] This political inefficacy corresponds historically to the image of artists as themselves workers—yet workers who stand apart from the general conditions of work and thus fail to account for inherent socioeconomic complexity. It is with this sense of perversity—that the terms of work itself inform the construction of the subject—that "The Everywhere Studio" emphasizes how the erstwhile site of artistic labor has come to stand for nothing less than the dissolution of the boundaries between life and work. This fluidity has turned out to be less the utopia imagined by the historical avant-gardes and more the guiding exemplar for a new construction of subjectivity under the dictates of the so-called creative economy that makes up the foundation of today's neoliberal regimes.

Mapping this history onto the works in this exhibition, its own starting point in the 1960s marks a time characterized by a rapid metabolization of the spectacularized labor forms and mythologized subject positions represented by Abstract Expressionism. This is perhaps best encapsulated in Hans Namuth's famous photographs of Jackson Pollock in his Long Island studio in 1949, which have come to embody the cliché of what art historian Caroline A. Jones calls the "solitary, white, male, and free" artist laboring away in his hermetic atelier.[7] In the following years, this tradition of the artist's studio came to be seen as increasingly problematic. The intensifying unease with the traditional studio is apparent, for example, in the more than sixty paintings depicting the studio that Pablo Picasso made in 1963 alone. By this time, what is

considered his "late period," he had secluded himself with his wife Jacqueline Roque in his studio at Mougins, France.[8] In nearly all these images—two of which are included in the present exhibition—a painter stands before his easel with his model on the other side of it. Of course, Picasso had represented similar studio scenes many other times, but in these serial and near-identical works the rendering becomes obsessive. The studio here becomes a site for staging the breakdown and isolation of the subject as a consequence of the privacy of the studio. However famous and wealthy Picasso was at this time—and even, to a certain extent, autonomous—these works suggest that he seemed to lack anything that would suggest real agency. Value has become inherent in the person of the artist, rather than in the work itself.

No matter how problematic it came to appear, however, this classic idea of the studio is still deeply embedded in the social imaginary. The problems created by its valorization of the (usually male) individual subject and his presumed autonomy (and the concomitant rejection of feminist, interdependent models of subjectivity) is a source of response for many artists in this exhibition. In the generation that followed, critiques of this model often emerged from feminist positions, among artists ranging from Faith Ringgold and Carolee Schneemann to Anna Oppermann. In Schneemann's photographic portfolio *Eye Body: 36 Transformative Actions* (1963), for instance, the artist subtly detourns recognizable tropes of Abstract Expressionism—the horizontal format that suggests something bodily, subconscious; the scatological applications of paint; and of course the solitary artist in her studio, surrounded by her work in the form of relics. Yet Schneemann goes much further in order to desublimate these forms' meanings, repossessing the camera (and emphasizing it with a mirror) in order to underscore how the artist's body, as a performer, is in fact the subject of these works.

A few years later, Philip Guston unexpectedly became a key figure for connecting the crisis in the studio to changes in the world at large. He famously complicated his own career engagement with Abstract Expressionism by turning to figuration in a widely disparaged exhibition at the Marlborough Gallery in New York in 1970. Few people at the time understood that his newfound representational style was the result of his understanding of the waning potential of modernist-style painting, and in this regard a continuation of his hopes for painting to have a revolutionary impact. With a deliberately clumsy composition, several of Guston's works of this time critique, mock, or make abject the vaunted role of the artist and his working methodology. Paintings such as *The Studio* (1969) and *A Day's Work* (1970) cast the artist as an amorphous hooded figure, perhaps even as a member of the Ku Klux Klan. Connecting an emblematic signifier of racist violence to the artist in the isolation of his studio, Guston's images have been said to "allegorize artistic complicity" with powerful myths of freedom that in fact correspond to the mechanics of repression.[9] In hindsight, these paintings were extraordinarily prescient. As the performance of the self took on a central role in expanded commodity production, the studio became implicated in a new regime of biopolitics. Even as it became unmoored from the specificity of site, it reflected the pernicious ideologies that still dominate and construct subjectivity today.

Around the same time as Guston's volte-face, the studio was also coming to be understood as a site of social production, thanks in large part to Andy Warhol's factory. A semipublic space, it yielded screenprints and experimental films, and, just as importantly, an aura of glamor and celebrity persona. The decision to term it a *factory* is key, for it reflects the extent to which these public manifestations of the studio qualified as *work*. Rather than seeking to restage the factory itself, "The Everywhere Studio" highlights Warhol's "Dance Diagrams" from 1962 as central to his understanding of a new emergent economy and changing ideas of the artist's relation to popular culture. Mimicking mass-produced guides for dancing, and themselves rendered in a flat, commercial style, the "Dance Diagrams" highlight the new business of prescribing and regulating body movement—whether in terms of the incursions of commercialism into

leisure time, or as a biopolitical regime premised on the changing structure of working life.

Warhol is a crucial figure in another sense, too, in view of how artistic production has long been haunted by the specter of the "business artist." Performing transformations of production in a marketplace of dynamic commodities, trafficking in self-branding (with signatures and signature styles, for example), and self-mediating in their work, artists have repeatedly transgressed the boundaries of art by resembling or consciously imitating the producers of capital. In doing so, they have become forerunners of broader structural changes in society. For the theorist Maurizio Lazzarato, the defining requirement of participation in contemporary society, "is not knowledge but the injunction to become an economic subject."[10] Lazzarato argues: "To make an entrepreneur of oneself (Foucault)—that means taking responsibility for poverty, unemployment, precariousness,

welfare benefits, low wages . . . as if these were the individual's resources and investments to manage as capital, as 'his' capital."[11] Elsewhere, the theorist has compellingly critiqued Boltanski and Chiappello by analyzing the extent to which the vast majority of artists actually resemble, in economic terms, others engaged in new forms of precarious labor.[12] Addressing this drive toward entrepreneurship of the self, "The Everywhere Studio" includes many artists who have deployed the iconography of the studio to address the formation of subjectivity during a time when the persona of the artist and that of the worker mutually and dialectically reconfigured each other.

For Buren, the "privacy" of the traditional idealized studio belied how it was geared toward the manufacture of marketable goods. The post-studio artist, by contrast, offers critical and creative latitude through the externalization of the site of artistic production. But if this is a consequence of the structural demands of the mutations of capitalism, it means that dematerialized practices can no longer be understood as emancipatory, let alone necessarily so.

Another indispensable figure when considering these shifts is Martin Kippenberger. With the 1981 series "Lieber Maler, male mir" (Dear Painter, paint for me) he delegated his work to hired sign painters, picking up on John Baldessari's famed "Commissioned Paintings" from 1969, in which the artist hired sign painters to create images in a realistic style.[13] While Baldessari could be said to represent a hopeful presentation of this endeavor, mentioning the coauthors of these works (Edgar Transue, Anita Storck, etc.) in their subtitles, Kippenberger enacts the problem of outsourced or dematerialized production while emphasizing its complicated ability to amplify the myth of the artist's own genius. For his 1987 sculpture *Worktimer*, a customized green steel work cart adorned with briefcases, Kippenberger acts out the conflation of studio production with white-collar labor in order to parody the discourse of empowerment surrounding so-called creative consumption. In an untitled 1988 painting, the artist is roughly depicted, overweight and in his underwear, handling the sculpture as if

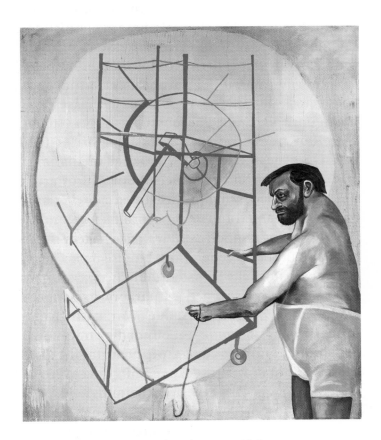

Martin Kippenberger, *Untitled*
(from the series "Self-portraits"), 1988.
Oil on canvas, 94 ½ × 78 ¹¹⁄₁₆ in.

Frances Stark, *Behold Man!*, 2013.
Inkjet prints and paint, vacuum-sealed on aluminum
and wood, 76 × 96 in.

it is an institutional orb. Throughout his career, Kippenberger made work that invoked and dramatized the economic function of the artist even as he simultaneously performed and mocked the artist's role as cultural prophet.[14]

As the combined forces of globalization, technology, and finance meant that society took on an increasingly networked character during the early 1990s, artistic production responded in manifold ways, manifesting and critiquing this new economic order, sometimes even celebrating it. David Joselit coined the term "transitive painting" to describe a tendency among artists from Kippenberger on to *"visualize"* networks of distribution and exhibition in order to critically address the economic injunctions that structure artistic production.[15] While a few practitioners sought, with premature exuberance, to celebrate this era of global networks, "The Everywhere Studio" highlights artists who connected the new sense of productivity to the frictions inherent in the new cultural and economic regime. A number of painters—among them Nicole Eisenman, Jana Euler, and Frances Stark—have in recent years turned their attention to the persona of the artist, depicting it through the tropes of the bohemian lifestyle and the autonomy of the

avant-garde, on the one hand, and on the other as an allegory of the performance of the self. Since the early 1990s, Eisenman's semicartoonish figurative paintings have mapped the surreally powerful connections between professional creative individuals and the myth of occupying a truly avant-garde pose. In *Night Studio* (2009) and *Morning Studio* (2016), Eisenman looks specifically at the role of the studio as a kind of hub in her life, considering it as a performative site of intimacy and connection.

Another artist of the same generation is Matthew Barney, whose 1988 video *Drawing Restraint 2* depicts the artist wearing a homemade harness that limits his movement as he climbs jerry-rigged supports in order to mark his studio walls with various instruments. In a sense, his body is deployed to reflect the demands posed by the new status of the studio. This work, and Barney's output more generally, has been frequently compared with Bruce Nauman's videos. (*Bouncing in the Corner, No. 1* and *No. 2: Upside Down*, both 1968, as well as *Sound for Mapping the Studio Model [The Video]*, 2001, are included in this exhibition.) Yet crucial distinctions remain: while Nauman performs essentially nonproductive gestures in the contained (and impure) isolation of the studio, Barney's performance is connected—literally by virtue of his harnesses, and metaphorically by the unseen videographer—to the *staging* of productive, even excessive gestures in an instance of aestheticized, athleticized mediation.

The extent to which the world of art is uniquely tapped into this sense of excess—in terms of symbolic capital and material production, and an accompanying symbolic ambivalence—is central to artists of Barney's generation, ranging from Jason Rhoades to Rochelle Feinstein and Cheryl Donegan. Each of their diverse practices marks out a distinctly new position, proposing a mode of art in which performativity has become unbounded by traditional constraints and the concern for "portability." In these formulations the expanded conception of art—which achieves a new, overwhelmingly mutable scale—confronts economic reality. And under these auspices, in which the artist as producer is "free" to create autonomously, at any and all moments, we witness that the system begins to break down into,

frequently, a scatological mess that invokes the new, highly physical and intimate ways our economic society creates systems of control.

As the works in "The Everywhere Studio" approach our current moment, we encounter artists for whom the flexibility offered by dematerialized practices entails both intensified economic demands and a new, constitutive, fundamental sense of precarity. In an economy driven by cognitive capital, the site of production has been distributed across time and space, making the blurring of art and life the perfect nexus from which to extract value, now in the form of a material product channeling information itself. The installation and video work of Yuri Pattison, for instance, takes as one of its central concerns the public imagination of cultural work within a communication economy.[16] For his 2016 exhibition "user, space" (whose title alone presents the necessary analogy) at Chisenhale Gallery, London, the artist constructed an installation that resulted from his extensive research on coworking spaces that promote flexible, creative entrepreneurship.[17] The artist considers these businesses representative of a new type of work, or coworking, that conflates sociability with flexibility, making older ideas of "artist, studio" redundant.[18] Pattison created a semiarchitectural workspace with Eames DSW chairs and aluminum shelving that, in the words of one critic, "brought to mind the exploitative conditions of Amazon warehouses."[19] Riffing on the post-studio mentality while comparing such practices with "precarious" freelance work, the artist sought to re-create a feeling of alienation that underscores the way subjectivity is formed in the currently dominant paradigm of coworking/start-up culture.[20] From this perspective, flexibility is above all a symptom of the end of traditional forms of art and labor.

In Matthew Angelo Harrison's installations, on the other hand, the transformation of the economy is itself pictured as a theatrical process that occurs in real time. Over the past few years, the artist has developed a 3-D printer—which stands vertically, and has other anthropomorphic qualities that merit the descriptor *elegant*—that produces objects from clay, enacting the relation between the (remote) cognitive labor of its author

and the (art) object. Presenting this printer as both producer and form, the artist highlights the notion (or ideology) that technology will replace work—a phenomenon that is both continuous with and heightened by the radical epistemic shift proposed by this mode of making.[21] Reproducing contemporary technology as a deposit of data as material, Harrison's work speaks to the ability of new labor forms to destabilize signifiers of identity in ways that promise untethered productivity. They might give us control over our work, but they might also lead to mass unemployment and/or retrench a society of repressive control.

Until recently, Harrison worked as a ceramicist in the innovation division of the Ford plant in Detroit, an experience that amplified his observations of the relationship of race and class to the organization of labor.[22] His technological facility meant the artist was awarded with specialized employment in the dedicated "innovation lab," where a team of (primarily white) people propose production solutions for executives and investors that impact vast populations of (racially diverse) employees—and where the 3-D printer is an increasingly ubiquitous tool. For a 2017 exhibition at Atlanta Contemporary, the artist programmed his printers to fabricate appropriated signifiers from African masks, which he altered to become collages that highlight frequently suppressed signifiers of black identity. Through the act of digitized reproduction, the show explored the deep racial coding of labor, its historical constitution among Black Americans, and the complex identifications that result as work takes on forms that herald the imminent obsolescence of all but the most complex forms of manual labor.

Ultimately, the studio is "everywhere" because radical transformations of society, technology, and culture have made it a condition of life today. It is not only a material site for or a conduit of artistic production, but an intrinsic part of the apparatus within which artists and nonartists alike live as subjects of an economic regime that values above all the primary artistic values of creativity and innovation. From the critical interventions of the post-studio movement to the heralds of an

incipient post-work future, this exhibition seeks to lay out not only the traces of a historical tension between the private sphere of the studio and the public space of the exhibition, but also the broader context of political and economic shifts that challenge the stable organization of society while creating an environment in which privacy itself no longer meaningfully exists.

Buren concludes "The Function of the Studio" by declaring the "extinction" of the studio model. Today this is no longer an option but an inevitability. The studio is no longer viable as a site of refuge and self-realization—except in performance, fiction, or nostalgia. It persists nonetheless, as an archetype, a still-existent site of artistic labor, a paradigm of nonartistic labor, a model for a materially driven site, and an allegory and critique of the proliferating, psychopathological forms of capitalism we live under today.

NOTES

1. Daniel Buren, "The Function of the Studio," trans. Thomas Repensek, *October* 10 (Fall 1979): 58.
2. Ibid., 51.
3. Ibid., 55.
4. Ibid., 53.
5. For a comprehensive summary of these transformations, see Manuel Castells, *The Rise of the Network Society, The Information Age: Economy, Society, and Culture*, vol. I (Oxford: Wiley-Blackwell, 2009).
6. See Luc Boltanski and Ève Chiapello, *The New Spirit of Capitalism*, trans. Gregory Elliott (London: Verso, 2005) for their thorough argumentation on the limits of the artistic critique. The argument is concisely elaborated in: Luc Boltanski and Ève Chiapello, "Vers un renouveau de la critique sociale," interview by Yann Moulier Boutang, *Multitudes*, no. 3 (2000). The English version of the quoted passage is taken from Maurizio Lazzarato, "The Misfortunes of the 'Artistic Critique' and of Cultural Employment," trans. Mary O'Neill, European Institute for Progressive Cultural Policies, http://eipcp.net/transversal/0207/lazzarato/en.
7. Caroline A. Jones, *Machine in the Studio: Constructing the Postwar American Artist* (Chicago: University of Chicago Press, 1996), 57.
8. Narratives of this artist's life abound. For a concise example, see

 John Russell, "Picasso," *New York Times Magazine*, February 26, 1984, http://www.nytimes.com/1984/02/26/magazine/picasso.html.
9. Robert Slifkin, *Out of Time: Philip Guston and the Refiguration of Postwar American Art* (Berkeley: University of California Press, 2013), 109.
10. Maurizio Lazzarato, *The Making of the Indebted Man: An Essay on the Neoliberal Condition*, trans. Joshua David Jordan (Cambridge, MA: MIT Press/Semiotext(e), 2002), 50.
11. Ibid.
12. Lazzarato, "The Misfortunes of the 'Artistic Critique.'"
13. Not coincidentally, for decades Baldessari has taught a course at the California Institute of the Arts titled "Post Studio," while continuing to operate a studio.
14. See David Joselit's analysis of Kippenberger's work, and the artist's connection of painting practices to institutional critique, in David Joselit, "Painting Beside Itself," *October* 130 (Fall 2009): 125.
15. Ibid.
16. Pattison has centered his practice on the role of the artist in society and the extent to which it approximated the production styles from other fields. Explaining the background to his 2016 installation at Frieze, he described the fraught condition of cultural production

 today: "art [is] at this tipping point of possibly becoming content or becoming a new industry." "Interview: Yuri Pattison Has His Eye on You," by José da Silva, *Art Newspaper*, October 7, 2016.
17. Press release for Pattison's exhibition at Chisenhale, London, July 7–August 28, 2016, http://www.chisenhale.org.uk/archive/exhibitions/index.php.
18. "Interview: Yuri Pattison": "It affects artists as well—rather than having a studio model, many [of these] new project spaces will have a co-working or desk-space model because [the companies] can make so much money from them."
19. Patrick Langley, "Yuri Pattison," *Frieze*, August 23, 2016, https://frieze.com/article/yuri-pattison-0.
20. Ibid.
21. Rick Smith, "3D Printing and the New Economics Of Manufacturing," *Forbes*, June 22, 2015, https://www.forbes.com/sites/ricksmith/2015/06/22/henry-ford-3d-printing-and-the-new-economics-of-manufacturing/#42252b654d26.
22. Matthew Angelo Harrison, conversation with the author, February 11, 2017.

Pablo Picasso
Le Peintre et son modèle II (The Painter and his Model II), 1963
cat. no. 84

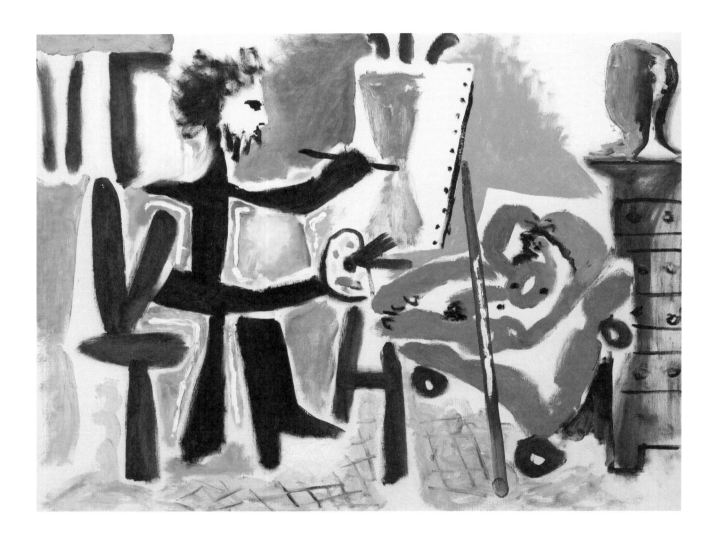

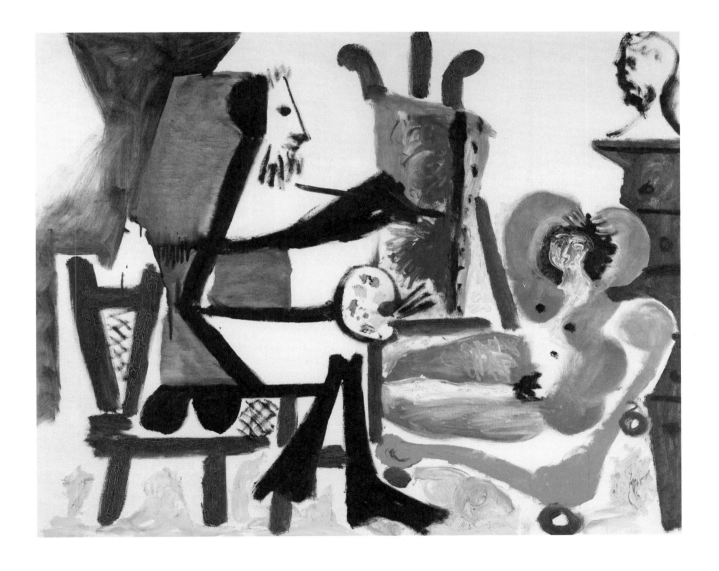

Pablo Picasso
Le Peintre et son modèle
(The Painter and his Model), 1963
cat. no. 85

Pablo Picasso
Le Peintre et son modèle
(The Painter and his Model), 1963
cat. no. 86

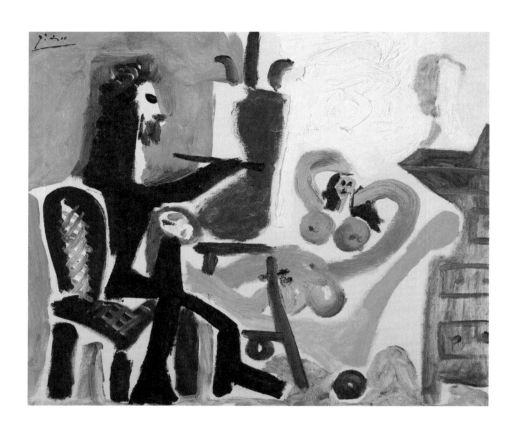

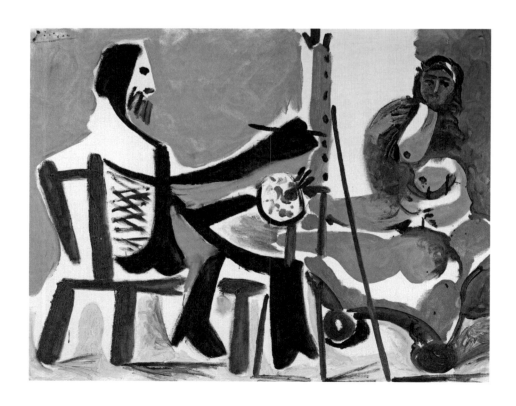

Pablo Picasso
Le Peintre (The Painter), 1963
cat. no. 87

Pablo Picasso
Le Peintre et son modèle
(The Painter and his Model), 1963
cat. no. 88

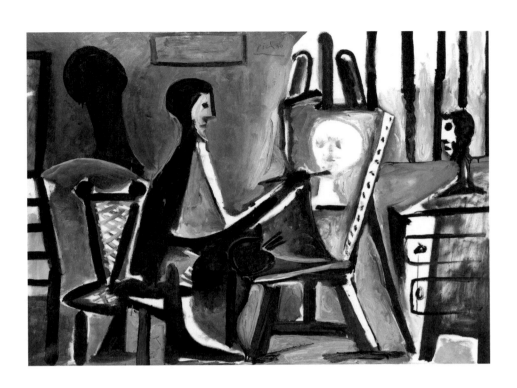

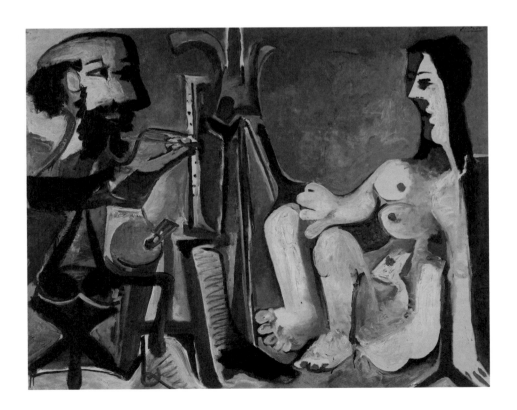

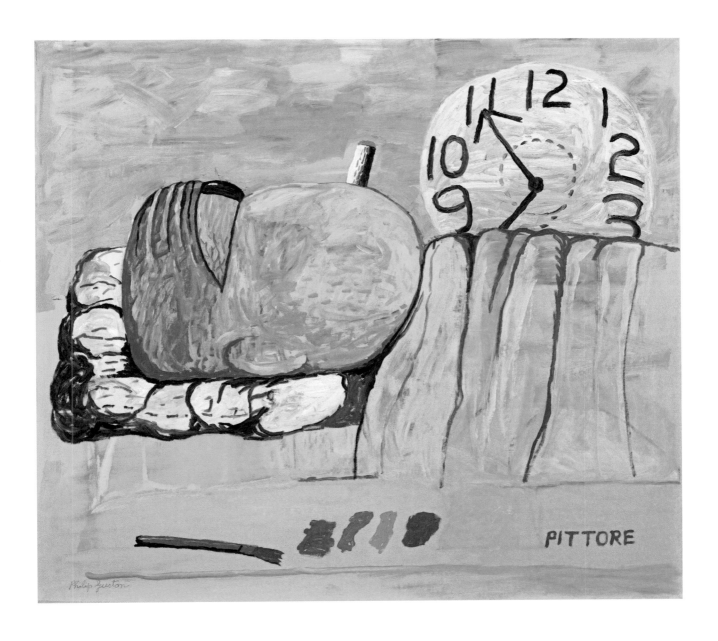

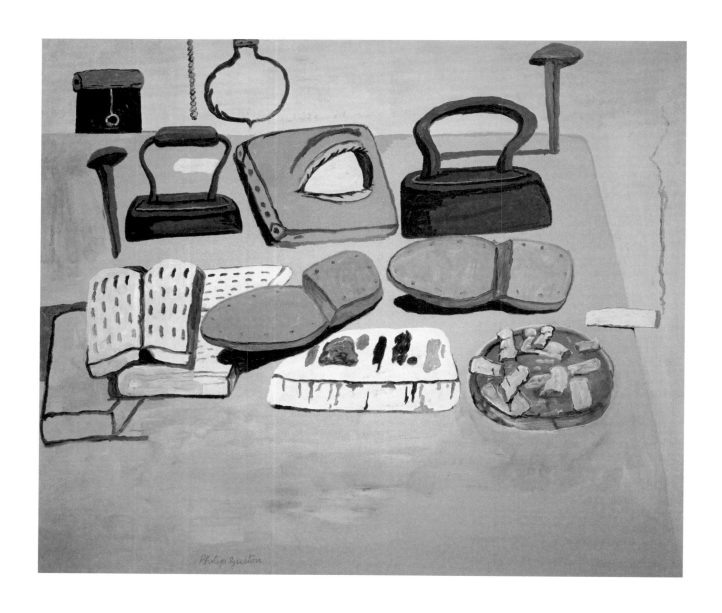

Philip Guston
Studio Bench, 1978
cat. no. 44

Philip Guston
The Studio, 1969
cat. no. 45

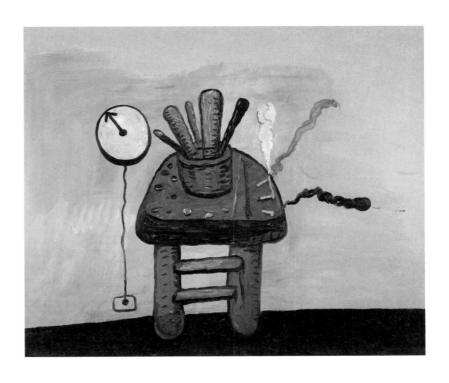

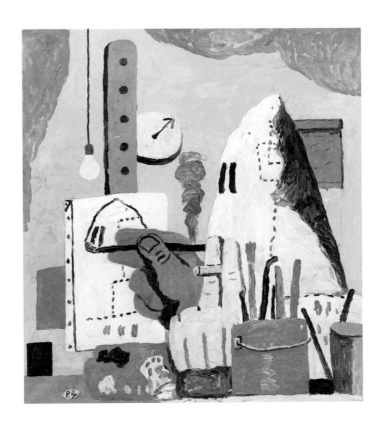

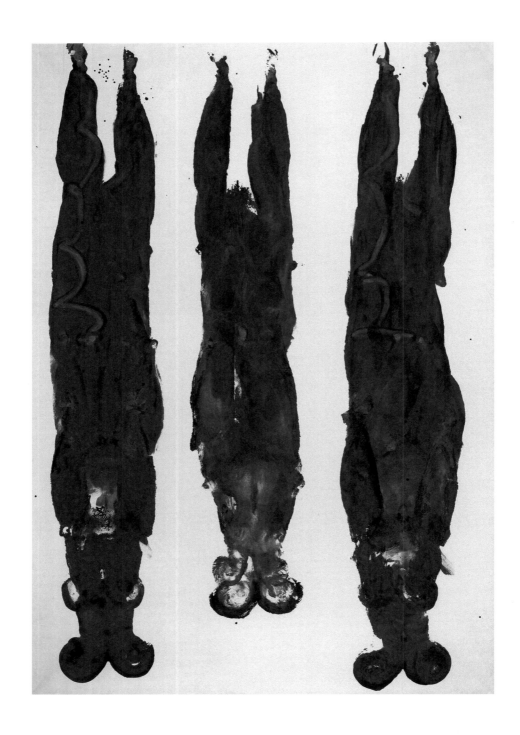

Yves Klein
Untitled Anthropometry (ANT 81), ca. 1960
cat. no. 59

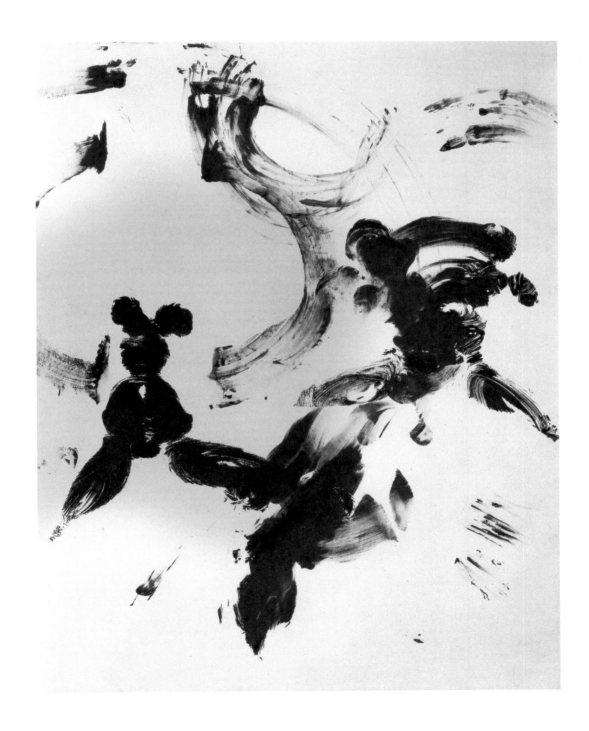

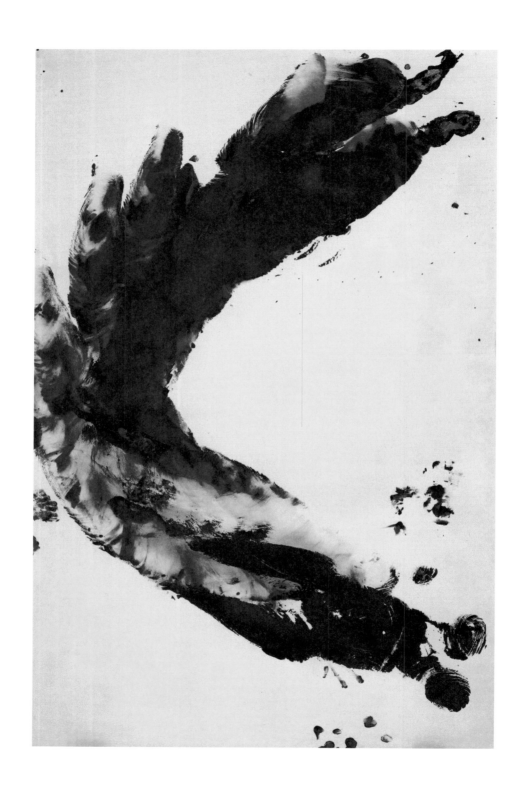

Yves Klein
Untitled Anthropometry (ANT 31), 1960
cat. no. 62

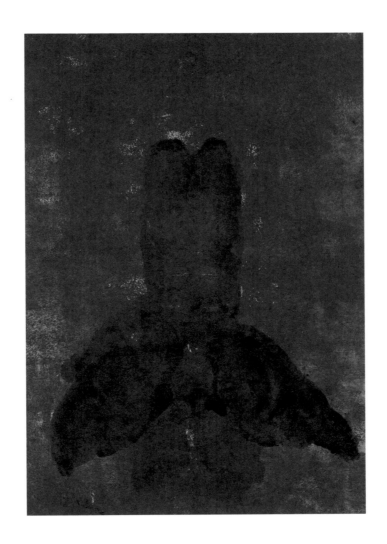

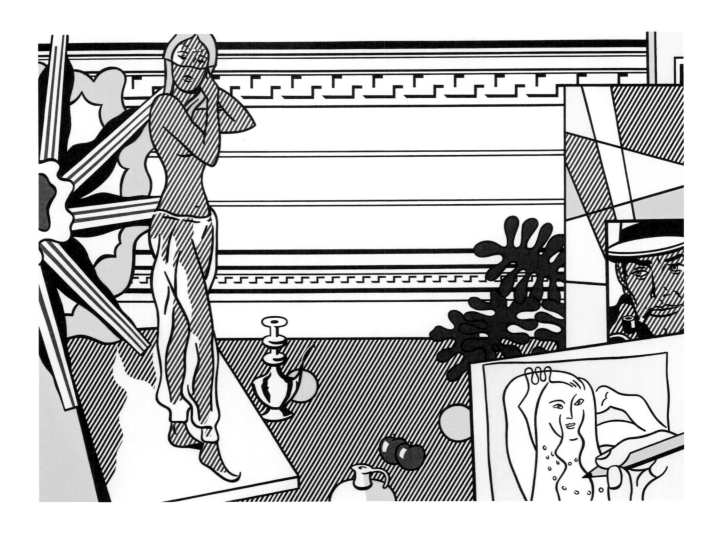

Roy Lichtenstein
Artist's Studio No.1 (Look Mickey), 1973
cat. no. 69

Roy Lichtenstein
Artist's Studio "The Dance," 1974
cat. no. 70

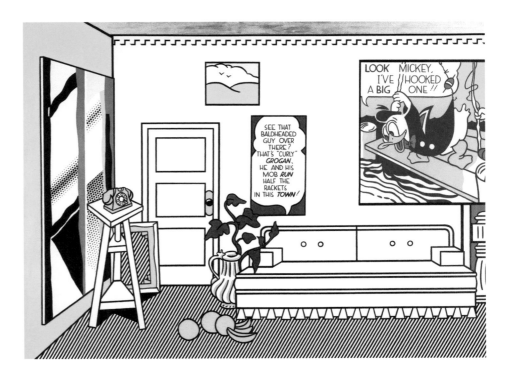

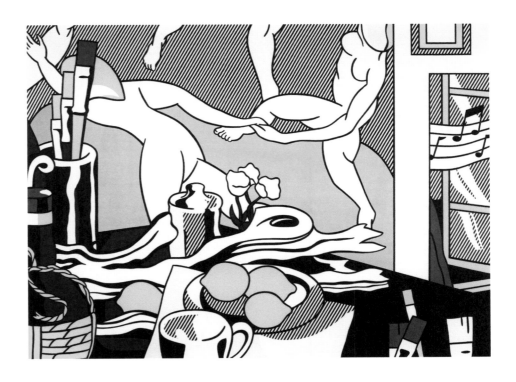

A PAINTING BY ANITA STORCK

John Baldessari
Commissioned Painting:
A Painting by Elmire Bourke, 1969
cat. no. 6

John Baldessari
Commissioned Painting:
A Painting by Pat Perdue, 1969
cat. no. 7

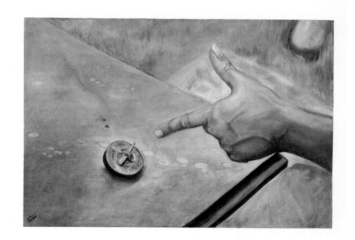

A PAINTING BY ELMIRE BOURKE

A PAINTING BY PAT PERDUE

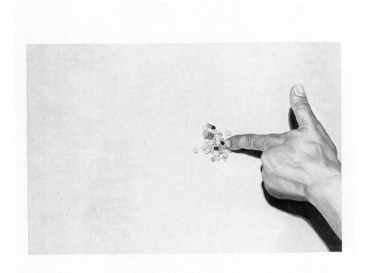

A PAINTING BY EDGAR TRANSUE

STUDIO/STREETS
Faith Ringgold's Sense of Practice

During the years from 1968 to 1970, I was caught up in a steady stream of activities protesting MoMA's exclusion of black artists. I stayed up many nights typing press releases. I spent many days at the museum distributing questionnaires to museum-goers in an attempt to expose the racist exclusion of black art from the MoMA exhibition schedule. Needless to say I did not produce much art during this time.
—Faith Ringgold [1]

The Black Studio/Streets

There is a long and varied history to the specific ways Black artists have conceptualized the studio in their practices. Central to each of these histories is the notion that the Black studio is inseparable from the streets; the Black studio/streets is made by and for those for whom space can never be taken for granted. Lingering there, at the outset of this essay, gives us a more dynamic picture of Faith Ringgold's approach to the studio, as well as her particular configuration of its relationship to the streets.

Ringgold's work emerged at a time when the notion of the studio itself was undergoing radical shifts. As curator Helen Molesworth has noted, the 1960s and '70s were marked by a consolidation in global capitalism as it shifted toward service-based labor, along with a coterminous expansion of art practices toward "dematerialized" actions and activities that rarely resulted in the

traditional art object–based commodity form.[2] Art practices that moved away from the stable, consumable art object often took the form of actions with no clear meaning, performances that prioritized ephemerality (you see it, and then it's gone), or conceptual practices with no identifiable signifier or representational cues. Around the same time, New York's early 1960s loft laws, designed to protect artists' right to live in loft spaces originally zoned for manufacturing, also consolidated the idea of the artist as a worker in a studio. The lofts could not be used solely as residences. As Molesworth points out, the "edict to work [became] . . . a mandatory component"[3] of their legal basis. If this imperative to live and work in the studio was impressed upon mostly white Conceptual artists in New York, however, what did it mean for Black American artists, for whom the question of live/work, object/activity, material/dematerial, and studio/streets was in crisis in postwar America, and for whom the 1960s and '70s brought along a very different set of spatial concerns?

Black artists at the time had inherited a particular and peculiar relationship to spatial politics and practices in general. Kellie Jones's book *South of Pico: African American Artists in Los Angeles in the 1960s and 1970s* (2017) brilliantly charts the rise of a Black Conceptual art world in Los Angeles in the 1960s, and in so doing mobilizes a nuanced attention to the spatial logics that formed and informed Black subjectivity in the United States at the time. Writing in relation to (and quoting from) Katherine McKittrick's poignant work on Black feminist geography, Jones notes:

> Because the black body historically is an object that is owned rather than a subject that possesses, it is ungeographic; black is, rather, a concept that "is cast as a momentary evidence of the violence of abstract space, an interruption in transparent space, a different (all-body) answer to otherwise undifferentiated geographies." McKittrick's project is the consideration of respatialization of black as body, as form, as geography, and as a site of contestation and complexity rather than dispossession or peripheral schema. It is located within and outside traditional space, elucidates "black social particularities and knowledges," and ultimately offers a new and expanded understanding of the normative."[4]

In this mode of Black cartographic knowledge, body, form, and geography respatialize the politics of space. In other words, Jones (via McKittrick) sees Black spatial practices as themselves implicated in the racial logics that materialize Black as a concept—an aspect that is crucial in our thinking of how the studio itself operates as a contested site in Black artistic practices of the time. If, that is to say, by the 1960s the studio had become a live/work space for predominantly white artists in New York, for Black artists working in Los Angeles (many of whom would relocate to New York by the mid-1970s), the studio was never isolated as a place of retreat, labor, or isolation. In fact, as a category, the studio was always unbound, transient, contested, and provisional. Artists such

as David Hammons, whose work often took and continues to take on the question of location with a sharpness and unparalleled quip, always made sure the studio was on shaky ground, both conceptually and materially.

Hammons's studio practice, like Ringgold's, was always already folded into the streets. As both Jones and Robert Storr have noted, for Hammons, the street often became the "workplace" and, I would add, by extension, his studio.[5] By the 1970s he was simultaneously making object-based art such as his body-print works and carrying out more quotidian performances where he would focus on unspectacular interactions with everyday people and objects.[6] For Hammons, the studio was a peripheral, provisional space that merely offered a point of reference for the constellation of events outside its walls. As he said to Jones in a 1986 interview:

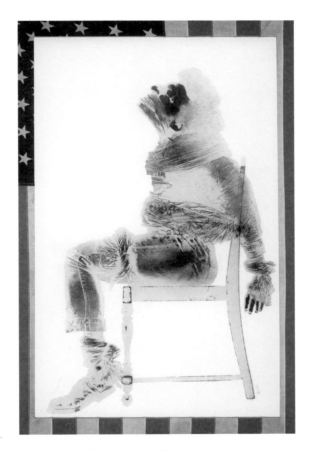

David Hammons, *Injustice Case*, 1970.
Body print (margarine and powdered pigments)
and American flag, 63 × 40 ½ in.
Los Angeles County Museum of Art, Museum
Acquisition Fund

What happens in my work is like I'll be working on piece (A) but I'll do some little aside things on my way across the studio to get to piece (A) and these aside things will be more important because they are coming out of my subconscious. These aside pieces will become more interesting and haphazardly

loose and piece (A), that I've been working on for months, will be real tight. . . . Doing things in the street is more powerful than art I think.[7]

What is particularly striking here is the casual ease through which Hammons marginalizes the supposed centrality of the studio as the place where art happens. Instead, while the studio might make for a "real tight" work, he considers the street works to be "more important" and "more powerful." While the studio marks a place for art to be made, it is also a fluid space that spills into the streets—as they spill into it, too. As artist and maker, Hammons dematerializes the boundaries of the studio by culling materials from the outside and bringing them in. These materials of Black life—from hair to bottle caps to basketball imprints—exceed the studio and draw their energy from the street. Hammons, as collector and assembler, reconceptualizes what these materials can do indoors, probing whether the studio is a place where they can do anything at all.

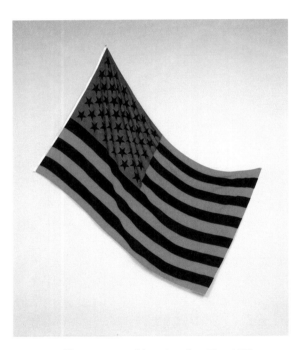

David Hammons, *African-American Flag*, 1990.
Dyed cotton, 56 × 88 in.
The Museum of Modern Art, New York. Gift
of the Over Holland Foundation

The unbound nature of Black artistic practice during these years is perhaps best exemplified by a later work, Hammons's *Traveling* (2002).[8] The print was made by bouncing a used basketball on a large sheet of paper: in this sense, it is one of the artist's "Harlem earth on paper" pieces. One can also faintly make out impressions of a suitcase that is the only representational object in the work, which otherwise appears as an abstracted set of speckled and textured grays and blacks that look like cloud or light studies. One would hardly believe

that it is made by throwing a basketball onto the surface of paper. In fact, there are few clues pointing to this reality, barring a couple of key areas in which one can make out the basketball manufacturer's brand on the page. The work thus troubles the boundary between indoor and outdoor, activity and stillness, performance and document, and studio and streets. One wonders, for example, whether it was made on the basketball court or on the floor of Hammons's studio. Both spaces seem interchangeable in Hammons's hands: in his work, as in other Black art practices of the time, the street is always already part of the studio. There is no need to grapple with the reconfiguration of the studio as a live/work space, as for the Conceptualists in SoHo. In Hammons's Harlem, the studio and streets were always one and the same. As he said to Jones: "The art audience is the worst in the world. . . . I'll play with the street audience. That audience is much more human and their opinion is from the heart."[9]

This is why the studio/streets was a logical coupling for so many 1960s and '70s Black artists. But while Hammons was activating a more clearly Conceptual and dematerialized practice, Ringgold's practice exceeded the constraints of more traditional modes toward an activation of social critique. As she states in the epigraph to this essay, she suspended her artmaking from 1968 to 1970 in order to prioritize activism. In light of the shift in modes of studio practice detailed above, Ringgold's insistence that she "didn't produce much art during this time" is also a sign of the fluid and interchangeable space of the Black studio/streets, where the making of traditional art objects becomes less important than interactivity, collectivity, and activism. The relationship between the studio and the streets thus opens up an expanded field where Ringgold's practice takes place, where politics and aesthetics meet to make an indictment of American racism and its attendant manifestations.

<div align="center">

1963–69:

From the Streets to the Studio

</div>

The paintings Faith Ringgold made from 1963 to 1969 capture the quotidian and spectacular terrors of American race relations.[10] While her aesthetic certainly developed traditions associated with the figurative in a broader canon, her particular approach necessitates a harmony, if not interchangeability, between the figurative and abstract in relation to Black artistic practice. Formally speaking, what is evident in her works during this time is an attention to flatness, compositional repetition, and seriality. The titles of her works in this period, for example, all include the series name, the number of the work in the series, followed by a specialized title for each of the individual works—as in *The American People Series #17: Artist and his Model* (1966). This series, painted at the height of the civil rights movement and continuing through the beginnings of Black Power, created a space for reflecting on this intense period in American race relations. The figures she depicts revel in graphic lines that are contrasted by pockets of shade detailing hands, torsos, and faces. These faces are long and worn, their eyes sometimes vacant, sometimes overflowing with emotion. The figures are

quotidian subjects—those everyday, anonymous Black and white people from nowhere in particular. Critic (and Ringgold's daughter) Michele Wallace notes that the first five panels of the series only feature six Black American figures; the rest of the figures are white.[11] Ringgold's political commitment to casting light on the experiential qualities of racism is reflected in her white subjects' "mask-like faces[,] absolutely fascinating in their precise emotional pitch." They are, she writes, "almost frozen in motion," yet "poised for decisive action" against the significantly fewer Black subjects pictured with them.[12]

These generic, everyday figures can be substituted in and out of specificity; they call attention not to the uniqueness of individual experience, but rather to broader collective experiences that play out through *categories* of personhood—most significantly, those of Black and white. In other words, Ringgold's subjects are *subjects* in the truest sense—they are the formal centerpieces of the work in order to bring political subjectivation into view. This emphasis on the *category* of her subjects rhymes with a prioritization of the *formal* as a structure through which an artist, and by extension her viewer, can reflect upon the world of a given work. Ringgold deploys this formalist logic against its intended grain, refusing to separate out the internal from its external present to suggest that the world of the work is already deeply social, if not political.

This relationship between the categorical and the formal can be seen in Ringgold's use of the flag as a structuring logic that reappears throughout her works of this period. As a semiotic system, the flag structures the multitude of experiences captured within its lines. It can be understood as a "connective sign" in the sense Franco "Bifo" Berardi speaks of when he writes that language "is drawn into [the] process of automation, so we find it frozen and abstract in the disempathetic life of a society that has become incapable of solidarity and autonomy."[13] While there is something to be said about the flag representing an idealized and impossible promise, Ringgold's adaptation of the flag as a semiotic structure invites us to consider the categories it brings into play. Her deformations of the flag point to the ways in which it is violent in both structure and form. Ringgold drew inspiration from Jasper Johns's *Flag* (1954–55), in which he combined fabric, oil, collage, and encaustic (a method of painting that involves adding pigment to a hot wax base, which encases and thus makes permanent the gesture of every brushstroke). The flag is preserved, cast into a past tense, frozen as a thoroughly complete idea and transformed into an archeological relic.[14] Ringgold took a radically different approach:

> I was particularly inspired by Jasper Johns's flag series for two reasons—I liked the regularity of the position of the forty-eight stars as opposed to the uneven position of the fifty stars (which our flag actually had in 1967), and also I felt that Johns's flag presented a beautiful, but incomplete, idea. To complete it I wanted to show some of the hell that had broken out in the States, and what better place to do that than in the stars and stripes?[15]

Ringgold responds to Johns's *Flag* by pointing to its incompleteness. Her formalist emphasis on composition is imbued with the mess of subjectivity: in the terms above, the formal crashes into the categorical. There is a generative analogy between Ringgold's frozen white figures in "American People Series" and Johns's frozen *Flag*—as if one belongs to the other, makes the other, stands in for the other. They can both be read as a particular understanding of whiteness as a kind of stillness—something trapped in the past (even if it is what accounts for its power in the present). We can think of Ringgold's insistence on the incompleteness of Johns's *Flag* as a thorough critique of such stillness, and hence also of whiteness and its inability to account for the present tense—in which Black people were taking to the streets for everything from civil rights to Black Power.[16] In other words, for Ringgold, Johns's flag needed completion through activation—and, by extension, activism.

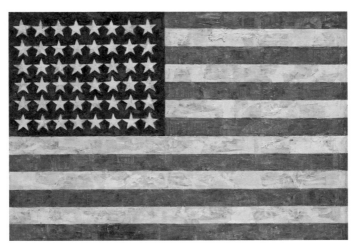

Jasper Johns, *Flag*, 1954–55.
Encaustic, oil, and collage on fabric mounted
on plywood, three panels, 42 ¼ × 60 ⅝ in.
The Museum of Modern Art, New York. Gift of
Philip Johnson in honor of Alfred H. Barr, Jr.

Ringgold bridged the formal elements of the flag—stars and stripes in red, white, and blue—with its categorical meaning in the sense described above, turning it into a contested symbol of a deeply white hegemonic kind of national belonging. The most exceptional examples can be seen in Ringgold's *The American People Series #18: The Flag is Bleeding* (1967) and *The Black Light Series: Flag for the Moon: Die Nigger* (1969). Both of these works activate the white supremacist violence preserved in the American flag in radically different ways. In the former, blood is dripping from the flag onto one Black figure and two white figures who are at once trapped beneath and made visible through the stars and stripes. The 1969 work, by contrast, excludes figures and mobilizes the flag as the geometric template through which the word *DIE*—a verb in the present tense that shocks the frame—opaquely appears in the stars on the upper left, while the more violent racial slur in the work's title structurally forms the

lines of the flag's stripes. From graphic violence to the violence of graphics, the flag becomes the compositional structure through which a categorical argument is made: white supremacy is not a historical condition relegated to the nation's past, but rather a structuring force that is formally circulated, even celebrated, by the flag itself. After all, the flag's very existence is premised upon an independence that required the enslavement of Black people. In this way, Ringgold's aesthetic deployment of the flag as structure brings history into the present, demanding that we pay attention to what historian Saidiya Hartman calls "the afterlife of slavery" and how it forms and informs race relations in the present tense.[17]

Ringgold thus unfreezes the flag's stasis and completes Johns's idea by activating white and Black in its compositional form. Whether through the use of quotidian subjects who embody the violence of race relations or through the deployment of textual cues that signal antiblack violence, Ringgold's flags activate another kind of work, another kind of history, another kind of present. In Ringgold's hands, the flag is not something to reclaim or redeem, but rather a form that should always be critiqued, demystified, and activated. This clarity in her artistic activation of the flag also helps account for her activism in relation to questions of artistic production and censorship.

1968–70:
From the Studio to the Streets

In 1968 Ringgold led a campaign against the Whitney Museum's exhibition "The 1930's: Painting and Sculpture in America," which did not include any Black American artists.[18] This protest was one of several campaigns that characterize Ringgold's work as both an artist and activist. In a political moment where radical activism seemed both urgent and necessary, Ringgold took the politics of her studio practice into the streets as an extension of her artistic interventions. The works described above insisted that the formal is always already social, and did so by pointing to the violence of categorization in everyday life. Similarly, Ringgold's activism made demands of institutions that preserved the past by ensuring the present tense outside world did not make its way in, as a hegemonic form of cultural gatekeeping. Ringgold and other activists dared to suggest that the quotidian experiences of everyday people should be accounted for within museum walls.

From 1968 to 1970, social movements had shifted national (if not global) discourse to the left.[19] In the United States, movements like the Black Panther Party for Self-Defense, Students for a Democratic Society, and American Indian Movement (to name but a few)—all youth-led and revolutionary in theory and practice—worked to dismantle capitalism and combat racism, imperialism, sexism, and homophobia at home and abroad. Aimed at eradicating the infrastructures, institutions, practices, and affects that uphold these violent traditions, political organizers worked toward the emergence of the "new"—a radical recasting of older revolutionary traditions toward a set of imagined

possibilities outside the dogmatic orthodoxy of previous forms of statehood and political economy.

During this time, artists such as Ringgold specifically saw themselves as entangled within the politics of the art market and its institutions, and often adopted the designation "art workers" in order to place themselves within a longer history of artist-based social movements and to call attention to the ways that their labor was exploited, manipulated, and implicated within the politics of the moment.[20] Out of this direct political identification, the Art Workers' Coalition (AWC) was founded in 1969, with Jon Hendricks, Lucy Lippard, Robert Morris, and Jean Toche among its members. The AWC was an ambitious and organized radical social movement in which artists mobilized activism alongside their respective practices. Its primary aims included the "public redefinition of artists and critics as workers," and by extension democratizing museums and other cultural institutions through transparency, increased public access, and the redistribution of leadership away from Board of Trustees models.[21] Quite problematically, however, the AWC's purported egalitarianism wasn't reflected in its membership, which only included two Black artists: Tom Lloyd and Ringgold, both of whom went on to work together in the Black Emergency Cultural Coalition Inc. (BECC) in January 1969.[22] Formed specifically as a place for Black artists, curators, and cultural workers to organize around their needs, the BECC was instrumental in fighting for increased visibility, inclusion, and patronage of Black artists, curators, and cultural producers. Ringgold participated in the activities of these various groups, often collaborating across racial and gendered lines.

In light of Ringgold's particular artistic and activist mobilization of the American flag, one such collaboration is particularly notable: in November 1970, Ringgold and fellow AWC members Hendricks and Toche organized "The People's Flag Show" at Judson Memorial Church.[23] The show was a response to gallerist Stephen Radich's conviction for casting contempt on the American flag by exhibiting Marc Morell's soft sculptural objects—stuffed American flags that resemble corpses and phalluses in a critique of the then-raging Vietnam War.[24] Ringgold designed the exhibition's poster, which adopted the structure of the American flag, and supplanted its stars and stripes with an informational and political text written by her daughter Michele Wallace.[25] Testing the boundaries of censorship through artworks that mobilized the American flag as source material, the show brought traditional forms of sculpture and painting together with body-based performance works, political manifestos, and poetry readings.[26] The exhibition was quickly shut down by the attorney general, and Ringgold, Hendricks, and Toche—later known as the "Judson 3"—were arrested and charged with desecrating the flag.

In Ringgold's *Judson 3* (1970), the flag appears again, in a further amplification of the strategies in her earlier flag works. The stars and stripes are transformed into red, black, and green—the colors adopted by Black liberation movements around the world—and a text that reads *JUDSON 3* is positioned perpendicularly in bold opposition to the horizontal orientation of the stripes.[27] In this work, the undeniably social qualities of the formal are made evident

through the lived experience of Ringgold and her two fellow arrested artists. Ringgold's *Judson 3* is, that is to say, a flag intended for present-tense use as a political poster. It is an object meant to be circulated, wheat-pasted, carried in protest. This work is exemplary for Ringgold's practice as artist and political organizer—because the activation it demands requires leaving the studio and occupying the streets.

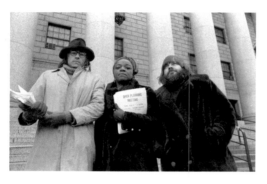

The Judson 3 (Jon Hendricks, Faith Ringgold, and Jean Toche) outside the courthouse after "The People's Flag Show" was shut down by the New York district attorney's office, 1970

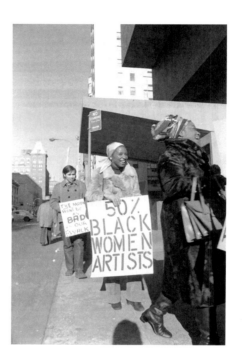

Michele Wallace and Faith Ringgold, Black Emergency Cultural Coalition (BECC) protest at the Whitney Museum of American Art, New York, January 31, 1971

NOTES

1. Faith Ringgold, *We Flew over the Bridge: The Memoirs of Faith Ringgold* (Durham: Duke University Press, 2005), 171.

2. Helen Molesworth, "Work Ethic" in *Work Ethic*, exh. cat (Baltimore Museum of Art, 2003), 25–51.

3. Ibid., 38.

4. Kellie Jones, *South of Pico: African American Artists in Los Angeles in the 1960s and 1970s* (Durham: Duke University Press, 2017), 16.

5. Ibid., 240; Robert Storr, *Dislocations* (New York: The Museum of Modern Art, 1991), 20.

6. Jones, *South of Pico*, 16.

7. "Interview with David Hammons," by Kellie Jones, *Real Life Magazine*, no. 16 (Autumn 1986): 255.

8. I am indebted to Gean Moreno for his insightful commentary on the relationship between *Traveling* and my writing on how Ringgold's artistic and activist practices are complementary.

9. "Interview with David Hammons," 255.

10. As Lisa Farrington has noted, Ringgold's "American People Series" (1963–67) "includes images of social satire and isolation, depicting African Americans as lonely figures, playing unnatural roles in a hostile societal environment." Ringgold described this series as a visual depiction of James Baldwin's writings on the relationships between whites and Blacks in the United States. For her, Baldwin best understood the cataclysmic divide between whites and Blacks. Lisa Farrington, *Faith Ringgold* (San Francisco: Pomegranate, 2004), 15.

11. Michele Wallace, "American People, Black Light: Faith Ringgold's Paintings of the 1960s," in *American People, Black Light: Faith Ringgold's Paintings of the 1960s*, exh. cat. (Purchase, NY: Neuberger Museum of Art, 2010), 26.

12. Ibid.

13. While many scholars have written on the conjoining methods of semiotic systems and symbols, Berardi offers a dynamic contemporary intervention on the relationship between sign systems and finance as they collude in the making of national and neoliberal interests. I am grateful to artist and writer Kade L. Twist for urging me to raise the deep connection between the flag as an arbiter of racism, empire, hegemony, and finance in relation to semiotics and questions of self-determination. Franco Berardi, *The Uprising: On Poetry and Finance* (Los Angeles: Semiotext(e) intervention series, 2012), 17.

14. Interestingly, Johns's flag was out of vogue with Abstract Expressionism, whose gestural and graphic emphasis on paint's materiality and movement was all action. Contrary to this, Johns's work mobilized a kind of anti-expressionism and, I might add, an anti-action-based method of artistic production. See Hal Foster, et al., *Art Since 1900: Modernism, Antimodernism, Postmodernism* (London: Thames & Hudson, 2011), 444.

15. Ringgold, *We Flew over the Bridge*, 158.

16. Interestingly, the "American People Series" bookends the transition from the civil rights movement to Black Power. The phrase emerged out of Charles Hamilton and Stokely Carmichael's 1966 call for "black power," which marked the movement's beginnings and is often represented as a fundamental split from the passive, nonviolent direct action of the civil rights era toward a more disciplined affirmation of black militancy and self-defense. Crucial to this call, however, was an emphasis on self-determination, and groups like the Black Panther Party organized around the particular needs of Black communities nationwide. This emphasis might help us think about the Black aesthetic contributions during this time, which mined various histories of Blackness as a source of beauty, affirmation, and resistance. Ringgold's own amplification from her more contemplative paintings in 1963 to heightened depictions of violence in 1967, such as Die, to map the historical trajectory or be emblematic of the transition from civil rights to Black Power. For more on the emergence of the phrase "Black Power," see: Peniel E. Joseph, *Waiting 'Til the Midnight Hour:*

A Narrative History of Black Power in America (New York: Owl Books, 2007), 272.

17. Hartman's phrase activates the historical continuity of structures, laws, practices, and affects that mark Black life in the United States from chattel slavery to today. In this work, she lucidly notes that "if slavery persists as an issue in the political life of black America, it is not because of an antiquarian obsession with bygone days or the burden of a too-long memory, but because black lives are still imperiled and devalued by a racial calculus and a political arithmetic that were entrenched centuries ago. This is the afterlife of slavery—skewed life chances, limited access to health and education, premature death, incarceration, and impoverishment. I, too, am the afterlife of slavery." Saidiya Hartman, *Lose Your Mother: Journey along the Atlantic Slave Route* (New York: Farrar, Straus and Giroux, 2007), 6.

18. Caroline V. Wallace, "Exhibiting Authenticity: The Black Emergency Cultural Coalition's Protests of the Whitney Museum of American Art, 1968–1971," *Art Journal* (Summer 2015): 9.

19. See George Katsiaficas, *The Imagination of the New Left: A Global Analysis of 1968* (Boston: South End Press, 1987).

20. See Julia Bryan-Wilson, *Art Workers: Radical Practice in the Vietnam War Era* (Berkeley: University of California Press, 2009).

21. Ibid., 14, 18.

22. For more on the BECC, see Susan E. Cahan, *Mounting Frustration: The Art Museum in the Age of Black Power* (Durham: Duke University Press, 2016), and Wallace, "Exhibiting Authenticity," 9.

23. Ringgold, *We Flew over the Bridge*, 181; Julia Bryan-Wilson, *Art Workers*, 193.

24. Ken Johnson, "Stephen Radich, Owner of Controversial Art Gallery, Is Dead at 85," *New York Times*, December 26, 2007.

25. "Michele Wallace Interviewed by Mary Lodu," *Third Rail*, no. 9 (November 2016): 32.

26. Ringgold, *We Flew over the Bridge*, 1.

27. Red, black, and green were colors first used in the development of the Pan-African flag commissioned by Marcus Garvey and the United Negro Improvement Association (UNIA). See Barbara Bair and Robert Hill, *Marcus Garvey, Life and Lessons: A Centennial Companion to the Marcus Garvey and Universal Negro Improvement Association Papers* (Berkeley: University of California Press, 1987).

Bruce Nauman
Bouncing in the Corner No. 1, 1968
cat. no. 73

Bruce Nauman
Bouncing in the Corner No. 2:
Upside down, 1968
cat. no. 74

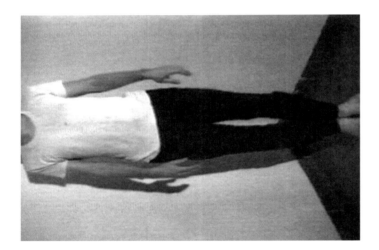 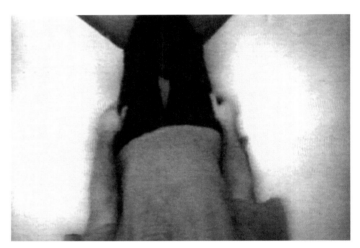

Giulio Paolini
Hi-fi, 1965
cat. no. 79

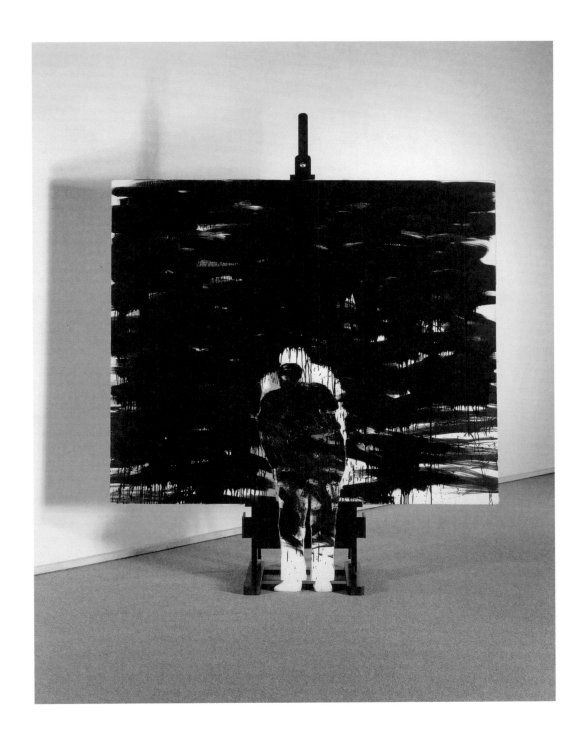

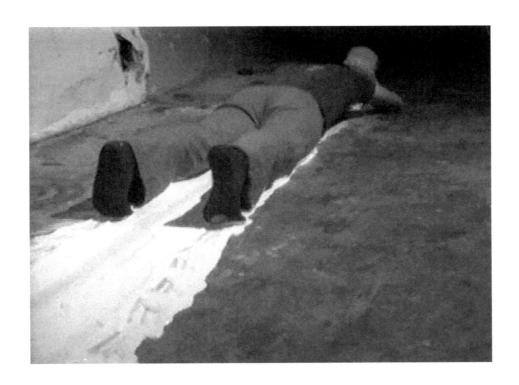

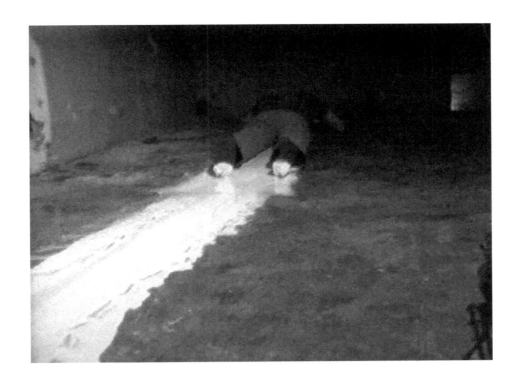

HOUSE, YARD, STUDIO, SET
Paul McCarthy's Working Spaces

Throughout Paul McCarthy's career, the different modes of production represented by his many studios and work spaces have been interleaved with the outcomes of his practice, thus subjecting the relations between place and product, set and event, to a form of mutual dissolve and creative confusion.[1] This was true during his early days in Salt Lake City in the mid-1960s, when he mostly worked directly on the ground in his garage, yard, driveway, and in the street; during his time in San Francisco at the end of the 1960s; and in Los Angeles after 1970, when he also used any available space in his house. The privileges and salience of the studio, however, were magnified during the first five years of the twenty-first century, when *Caribbean Pirates* (2001–05) was planned, made, and edited in collaboration with his son Damon McCarthy in two enormous fabrication spaces in Pacoima and Azusa (in the San Fernando and San Gabriel Valleys, respectively). At this time, McCarthy developed one of the most complex and revisionist relationships to his studio space—and to the wider nature of the studio—of any contemporary artist.

McCarthy occupied his first long-term studios in the vacant, H-shaped Broadway Building in downtown Los Angeles around 1970, when he was a graduate student at the University of Southern California (USC). It was there that he shot his "Inversions" series, including *Inverted Hallways* (1970). Around the same time, a few miles north at the newly opened California Institute of the Arts (CalArts) in Valencia, John Baldessari launched his course Post Studio Art and, slightly later, Allan Kaprow taught Happenings as Programmed Activity.

The school had self-consciously "radical" interests, which Kaprow and Paul Brach summarized in a 1971 report as "concept art, happenings, multi-media, painting and kinetic art."[2] The critic Max Kozloff, also teaching in the CalArts inaugural year, later characterized one of the effects of the Post Studio experience as "rebus modernism"[3] — the propagation of a rhetoric of indeterminacy, or, as Baldessari put it in a course description and biography, an "interest and concern" for "paradox, dilemma, serendipity."[4]

In the subsequent decade and a half, however, a whole platform of CalArts alumni (Larry Johnson, Lari Pittman, David Salle, and others) returned to quasi-traditional materials, forms, and locations, engendering an elaborate refusal of the post-studio ethos, a reactionary shift referred to by Craig Owens in a 1982 article as "Back to the Studio."[5] While this disavowal and return to the studio was played out in the LA area's most influential art school, McCarthy looked around and beyond this polarity, taking on both sides of the question, while at the same time provocatively grafting on to it a host of related issues.

McCarthy worked in an extraordinary range and scale of studio spaces during the first half of the 1970s. After the cavernous halls and corridors of the Broadway Building, he moved, around 1972, to a half-derelict space on Temple Street, also in downtown Los Angeles. The roof had caved in at one corner, allowing rain to drip inside. Grass began to grow on the floor. This was the location for such key performances as *Face Painting - Floor, White Line* (1972); in the video documentation, seeping rainwater can be both seen and heard. It was there that he almost inadvertently created a new version of the "inside-out" environment that had long structured his relation to work in and around his domestic spaces. Somewhat unusually for McCarthy, *Face Painting - Floor, White Line* seems to make direct reference to an earlier piece, Nam June Paik's *Zen for Head* (1962).[6] Yet the differences between the two works might be more significant than their superficial similarities. Rather than the floor itself, Paik uses a length of paper for support, referring to Asian traditions of calligraphy. His medium is black ink, not white paint, and it is somewhat decorously apportioned to a cup, whereas McCarthy uses a common paint can. Paik specifies the "head" in the title of his work, McCarthy the "face," and, perhaps most significantly, Paik associates the action of painting with his head with "Zen." The focus of the work is not a gesture or physical action, but something with more metaphysical dimensions: "Zen for Head." Furthermore, Paik's piece may itself represent an interpretation of La Monte Young's score *Composition 1960 # 10* (1960), which took the form of an instruction: "draw a straight line and follow it."

Interestingly, the differences between the works extend even to their documentation, for while both actions were carried out adjacent to a studio or gallery wall—seen to the left in the most frequently reproduced photographs— Paik is shown head-on, prone on the floor, his body partly cropped, and the paper seemingly marked by his body snaking backward. McCarthy, by contrast, is photographed from behind so that we see his splayed legs but not his face (the video documentation does, however, show a shot of the artist's face, pressed into a pool of white paint). McCarthy's piece has a counterpart in his *Face, Head, Shoulder Painting—Wall, Black Line* (1972), in which the marking

agents are pluralized in three corporeal locations, black is substituted for white, and wall for floor. Paik, by contrast, serializes *Zen for Head* through different manifestations of the formula "Zen for . . ." including *Zen for Film* (1962–64), an eight-minute loop of unexposed film running through a projector, and *Zen for TV* (1963/90), in which the TV picture is divided into equal halves. If Paik refers his "Zen for . . ." works to the technical and experiential effects of reduction (perhaps offering, as Hans Belting suggests, an "escape from representation"[7]) in relation to which their location is somewhat irrelevant, McCarthy sets out, by contrast, to implicate the mark-making activity in the agencies (face, head, shoulder), materials (white paint, black paint), and supports (floor, wall)—without anything, as it were, being left over. He lays bare quite precisely what is done in, into, and onto a studio by an artistic substance deployed not by fingers or hands, but by the upper registers of the artist's body in a process that seems on its own terms antagonistic to the rhetoric of emptiness.

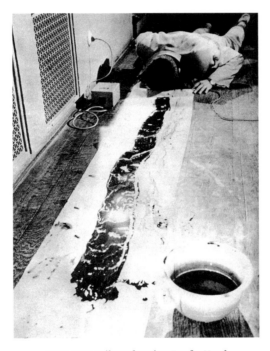

Nam June Paik performing *Zen for Head*
at Fluxus Festspiele neuester Musik in Wiesbaden, 1962

Face Painting - Floor, White Line also offers a wider set of humorous, off-kilter allusions. It refers not to children's dress-up and play, as its first words suggest, but to a literal mode of painting-by-face, a recourse that anticipates (though in utterly different terms) the technically preposterous Post-Conceptualism of Art & Language's painting-by-mouth. Made in the early 1980s in recursive relation to the group's *Documenta Index* (1972)—"what was [this piece] if not an artistic representation of a place of work?," as Charles Harrison also observed—*Index: The Studio at 3 Wesley Place Painted by Mouth (I)* (1982) was intended to deconstruct the genre of studio painting, or, as Charles

Harrison also put it, "cripple" the "spectacle" to which it gave rise.[8] McCarthy, clearly, had already tripped it up, while Art & Language remained under the spell of the bulk notational abstractions cast by indexical surrogacy. Other references in *Face Painting - Floor, White Line* are, literally, more pedestrian. McCarthy face paints a slow "white line" that seems to unfold an ironic, interior variant of the directional or spatial traffic markings on the street outside. Furthermore, the artist's commitment to applying white through the agency of the face glimpses at several historical, contemporary, and later formations, including the reallocation of the attributes of mimes or clowns into the art world by Bruce Nauman (who was living in the house of Walter Hopps, former director of the Pasadena Museum of Art, when *Face Painting - Floor, White Line* was made) in the later 1980s. Nauman himself made several works in the early 1970s titled after the contact zone between "face" and "floor," including *Elke Allowing the Floor to Rise Up Over Her Face* (1973), a thirty-nine minute color video with sound based on a "set of mental exercises" devised in 1969, "in which a live performer was to concentrate on sinking into the floor or allowing the floor to rise up over him or her"; and the companion piece *Tony Sinking Into the Floor, Face Up, and Face Down* (1973), a sixty-minute video in which the protagonist is portrayed "stretched out on the floor, sometimes face up, sometimes face down, in a series of dissolves."[9]

In another field of association, the painstaking singularity of McCarthy's line offers a valence for white inscription quite different from that developed by Günter Brus and some of his Actionist colleagues in Vienna in the 1960s. As I note in another context, they attempted to fulfill "the dream of the white sign to cross-over from form and surface to inhabit gestures, motion, and bodies where it could negotiate new emotive and social relations—and, most importantly, bear witness to a violent dispute with everything that sign had come to bear."[10] When McCarthy cycles back to white some three decades later, for *WS* (2013), it would be under the auspices of another form of personification, emblematized in the figure of Disney's Snow White.

In 1973, McCarthy moved to the Pasadena area northeast of Los Angeles, where, somewhat miraculously for a struggling artist, he found no fewer than three "studios," each of which gave rise to distinct bodies of work and reflection. The first was a twenty-one-room hotel, which he rented for one hundred dollars a month; the second, a basement in the Odd Fellows Temple, which he liked because it was an utterly quiet, windowless enclosure. When he had to leave the basement space, he acquired the third and perhaps most dramatic studio: a huge three-story building with three thousand square feet per floor. Next door was a hotel, for which he acted as a custodian of sorts until it was demolished in 1975. The ground floor of the "studio" building, with views onto the street and sidewalks, can be seen in the videos of performances such as *Whipping a Wall and Window with Paint* (1974).

As Old Pasadena began the slow journey from urban blight to modish regentrification, McCarthy lost his cornucopic studio resources. For much of the decade after 1975, he worked again from homes, in Eagle Rock and Pasadena, or rented a small office space in town. During this period he began

to use TV studios for his video productions, and commenced a relationship with advanced technologies (using one of the first portable color cameras for *Sailor's Meat* [1975], for example) that would blossom in the conception and construction of his large-scale objects, installations, and public projects of the 1990s.

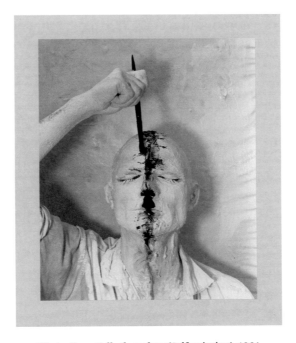

Günter Brus, *Selbstbemalung* (Self-painting), 1964.
Documentary photograph, 19 ½ × 15 ⁹⁄₁₆ in.
BRUSEUM/Neue Galerie Graz,
Universalmuseum Joanneum, Austria

The house McCarthy built near Pasadena in 1987 marked the beginning of another, perhaps defining, phase, in which the artist once again deployed several huge studio spaces. The rear half of the ground floor of this house was taken up by a fifty-foot-long barnlike studio. It was the entire contents of this space, crowded with the tools, instruments, and clutter accumulated over more than two decades that McCarthy photographed, labeled, crated, and transported to St. Gallen, Switzerland, in 1999: video editing equipment, tables, filing cabinets, storage units, household utensils, a refrigerator, a sewing machine, and a bicycle, among many other objects and materials, as well as some two hundred drawings and sketches. The entire studio was reinstalled in the exhibition "Paul McCarthy, Dimensions of the Mind: The Denial and Desire in the Spectacle" in the Lokremise, the town's old locomotive roundhouse.[11] Titling the work *The Box*, McCarthy arranged the contents of this studio into a giant, reinforced wooden crate of precisely the same dimensions. But, in a gesture of monumental caprice engendering profound spatial and object-related disequilibrium, he bolted, glued, and invisibly supported every one of the three thousand–odd items—from massive steel cabinets and their contents down to pencils and thumbtacks—so that the entire edifice could be rotated ninety degrees. The floor and the ceiling of the original studio now became the two

vertical walls of *The Box*, and the ceiling and floor of *The Box* were the walls of the original studio.

Viewers encountered this antigravitational ghost story by stepping onto a small plinth and peering through a window at one end (identical to the one in the Pasadena studio, though inverted). The perceptual dislocation that results as the observer takes in the still mass of glued and cantilevered objects is surely as marked as the vertigo induced by spinning, or the foundationless experience of an earth tremor. But it is produced through the *absence* of a precipitating movement. Or, rather, what movement there was—the fastidious relocation and bolting of the objects—has already happened and is locked into the new orientation of the studio. The result is a disorientation in the course of which visceral or somatic imbalance is not the motivating force of the experience, but is first held in suspension, then accumulated perceptually as the mind processes the physical improbability of what confronts it. It is at this point that the studio becomes a mass, literally bringing to bear on the viewer the surrogate weight of its history and aggregation. Perhaps five or ten seconds into a viewing, the halfway point between confounded recognition and conceptual understanding, between disbelief and wonder, a remarkable moment in the history of the studio is produced: an instant in which it becomes a giant totality, simultaneously physical and perceptual, thought and felt, seen and internalized, hanging in space like a monster wave about to crash . . . but never breaking.

It's tempting to see *The Box* as a summation and an exorcism, the most dramatic move McCarthy has made with respect to the geography, history, and conceptualization of the studio. It's certainly a colossal, hyperrealistic gesture of appropriation that at the same time vaporizes a career's worth of art-related deposits and conjures them up again from under the magic cloak of a fiercely precise ninety-degree rotation. There is a sense, too, in which the evacuation and turn represented by *The Box* helped free up another move in McCarthy's work, mediated by the studio spaces he uses today (and indirectly by the cleaning out of his domestic one). Around 1993, McCarthy took over an industrial space in the Los Angeles suburb of Pacoima, which he used for the fabrication of the large-scale objects—either stand-alone, like his rotating pink fiberglass *Colonial Tea Cup* (1987–94), or clustered in installations, as with the sixty-two objects (in fiberglass, urethane, rubber, and metal) that make up *Tomato Heads* (1994)—that characterized much of his work in the 1990s. The Pacoima studio became a dedicated zone for the generation of what McCarthy refers to as "big fabrications,"[12] technical productions of special effects–like props and prosthetics using Hollywood-style molds and materials. Apart from a small space near his Pasadena-area house—off-limits to everyone except himself—McCarthy's next studios in Azusa (where *Bunker Basement* and *Wild Gone Girls* were created in 2003) and Baldwin Park (where *Caribbean Pirates* was performed and shot two years later) reinforced the current orientation of his work toward the creation of giant objects and complex performative locations that accommodate his stylized annexation of low-budget film production.

For McCarthy, then, the studio has operated in a split range of functions, modifications, and detours that, considered together and in mutual

relation, offer both a summary of and a commentary on its postmodern reinvention. While traces linger in McCarthy's work of the studio's reflexive modernist appearance as representation (as, for example, in the *Red Studio* [1911] of Henri Matisse), or as an existential correlate of pictoriality—or even racialist dysfunction—in the late work of Philip Guston, the studio is no longer (simply) the privileged location of artistic creativity or the special zone of surrogate self-representation. Instead it is a symbolic location brokering what the critic and curator Ralph Rugoff refers to as the "continuous overlapping of traditional boundaries between images and concrete spaces."[13]

In the course of McCarthy's career, the studio can be considered a kind of ground zero for the enactment and repetition of his work in performance, cumulatively adding up to the "25 years of tapes" that he looked back on in a 1996 interview.[14] Rather than being simply or primarily a space, an arena, or a container, the studio's architectural specificity is destabilized, and both viewer and artist/performer are subject to several forms of disequilibrium, including the dizziness that attends the sixty-minute duration of *Spinning* (1970–71), in which the studio hosts a turning body and is made over as a centrifuge for the production of disorientation, or *Spinning Room* (conceived in 1970, realized in 2008), where the projecting apparatuses are themselves set on a spinning platform. One strand of this perceptual inquiry thus engenders kinetic experiences of spatial confusion,[15] while another culminates in the eerie, silent list of *The Box*.

But the studio also acts as a refuge or space for withdrawal, which at its extreme takes on what can be termed an amniotic quality, offering a knowingly repressive retreat in utero. In the staging of this metaphor, the studio even has a life cycle, in that it is continually rearticulated by McCarthy, first as a kindergarten for one, then in the form of a gymnasium for his low-level aerobics: that creeping, crawling, mucky spreading that characterizes his early performance pieces in which the body variously marks or inscribes the floor, walls, and windows. Yet the studio also becomes the epicenter of self-reflection and tentative space-building, what McCarthy describes as the "construction of a place." This is a process that begins with "self-absorption, the self in the room,"[16] where the studio serves as a primal arena for the defeat of the void, and it develops as a kind of Beckettian dialogic self-communing coupled with Actionist dysfunction. Here the studio is associated with a dialectics of mute action and numbness, the continuous unfolding of precharacterological dilemmas, as the artist performs his incarceration in a prison-house of doubt that serves, simultaneously, as a site for ironic, ritualized violence. The studio becomes a playpen for the generation of surrogate personae and the "confusion of social and bodily boundaries"[17] they vicariously enact.

The studio even has its "mirror stage," in the sense that McCarthy also developed it as an interactive forum in both conscious and semiconscious relation to the window or vitrine that mediates between his enclosure and the outside world. This stage accompanies what he has described as his understanding of painting delivered through architecture—painting, that is, managed through an active awareness of "mirrors, windows, and doors."[18] In this way, the studio becomes a kind of classroom, supplied at first with basic furniture, including

altar-like tables, and then with deposits of symbolic materials and props. Yet the border between the anarchic, prelinguistic space and the more settled formats of the speaking studio are never firmly fixed. McCarthy never relinquished his commitment to "polymorphous architecture," and his studio never ceased to furnish the sense that its walls, windows, and floors could at any time become canvases for his inscriptions, or a matrix of sets for performance and projection. McCarthy's studio is thus a kind of stuttering camera obscura, a place where images are made and found, overlaid and rescaled through a torrent of ceaseless inversions, then coupled with guttural emissions—the grunts and groans, for example, through which the piratic idiom is released in *Caribbean Pirates*.

In terms of scale and performative and material expenditure, *Caribbean Pirates* trumps even the grandest of the artist's dialogues with his studio environments, including the extraordinary perceptual vertigo engendered by *The Box*. Here, the studio becomes an enormous lair swarming with actors and extras, assistants and special effects experts, film crews, technicians, and hangers-on. At some moments the professional apparatus in the space is deployed as it would be in a Hollywood B-movie set; at others, the on- and off-camera worlds merge without jurisdiction, just as the sets and props shift—both in and after the performance—from backdrops and objects to take on the different valences of sculpture and installation.

By the middle of the first decade of the twenty-first century, the McCarthys' studio (now the domain of father and son) had ceased to function simply as a location or set. It had taken on the conditions of an "environment" (in the sense established by Kaprow) crossed with forms of accumulation, implied action, and agency.[19] Things left in the studio as so many contexts following the forced exodus of a piece were subject to conversion—even, we might say, enchantment—and empowered by the evacuation into a "work"-like status of their own. When animated and wholly occupied by the shifting parameters of a performance, the McCarthys' studio became a place where no lines could be drawn. This was quite literal in February 2005, when one could have walked straight through the studio door and into *Caribbean Pirates*, when the (real) boats in the parking lot were as much a part of what was going on as the (fabricated) ships inside.

At the same time the terra firma of the studio had been further shaken by the advent and refinement of McCarthy's exploration of mechanical, robotic, animatronic, and related kinetic forces. Beginning with his first fully mechanized sculpture, *Bavarian Kick* (1987), the artist created a series of highly motile spaces-within-spaces that supplement and sometimes replace the fixed coordinates of a working environment.[20] Such spaces unsettle the already provisional parameters of the "set" so that works such as *Mechanized Chalet* (1999) and *Underwater World* (2005)—one of the three zonal declensions of *Caribbean Pirates*—or *Mad House Jr.* (2011) disturb the spatial equilibrium of their locations by twisting, spinning, rocking, or rotating. *Mechanized Chalet*, for example, deploys its regimen of movements to sublimate the notion of erotic encounter by casting the apparatus in the role of both location and actor. Following a series of ambitious spatial transformations achieved by rotating

the planes of a storybook chalet facade in a routine of literal and figurative exposures, the structure is subject to a kind of architectural striptease activated by a machine-based Eros embedded in mechanomorphic action. The ghost of Disney lurks behind this technological fantasy of the robotic cultural trope in which a schematic representation is inverted and then turned inside out. If McCarthy's apparatuses complicate the relation between action and location by posing the dwelling as its own type of vulnerable subject, they also administer new rounds of putatively "expressive" capacity to the mechanized object, upping the ante by using ever more complicated animatronic techniques.

While the catalyst for McCarthy's corrosive intermediality was furnished by the presence and representation of the body in action, its locus and incubator is clearly the studio itself. We cannot understand the passages brokered by McCarthy's work between sculpture and film, on the one hand, and objects and sets, on the other, without also comprehending the complex function of the mediating environment that effectively splices them together, while at the same time providing new grounds for unfurling their disruptive figures. It is in the studio that the artist's signature *combinatoire* of objects, apparatuses, images, and performances is produced, encoded, and delivered. And what results bears the imprint of the studio, not just as a location or environment, but as a constituent material, copresent with the work itself. The relational matrix between sculpture and film, body, set, and studio is nowhere better exemplified than in McCarthy's *Pig Island* (2003–10)—a sprawling series of sculptures (George Bush with a cowboy hat, various pigs) set in a scree of sedimented studio objects (cups, containers, fabrication materials, test pieces, crates, storage shelving)—in progress in an elevated area of the studio during the *Caribbean Pirates* shoot. The emergence of *Pig Island* as "a sculpture-making machine" exemplifies the new conjugations of the studio, now figured as a hectic accumulation of functions: "A stage. A studio. A rubbish heap. A work in process and a work about process."[21]

Somehow digesting and overcoming these deformities, the studio is an envelope that stages, strives to contain, and effectively summarizes the cascade of media modifications on which McCarthy's work is premised. The studio is the primary site for his obsessive rethinking of the relations established by art practices in the twentieth century between the things and actions initially located within it (stages, props, actors, media apparatuses, directors, research materials, works-in-progress, onlookers, and performances) and the products and locations (exhibitions, screens, projections, and publications) it generates and through which it is distributed.

NOTES

1. This essay draws on my previous essay "Haus, Hinterhof, Atelier, Kulisse: Paul McCarthy's Arbeitsräume," *Texte zur Kunst* 13, no. 49 (March 2003): 105–11 (German). See also "Risks Between: Trauma and Studio, Tape and World: Paul McCarthy in Conversation with John C. Welchman," in *The Aesthetics of Risk*, ed. John C. Welchman (Zurich: JRP/Ringier, 2008), 315–48.

2. See Paul Brach and Allan Kaprow, "The Report of the California Institute of the Arts to the National Association of Schools of Art," January 29, 1971. The details in this paragraph were first described in John C. Welchman, "Cal-Aesthetics," *Flash Art* 141 (Summer 1988): 106–07.

3. Max Kozloff, in conversation with the author, University of California, Los Angeles, March 1988.

4. Brach and Kaprow, "The Report of the California Institute of the Arts," 28.

5. Craig Owens, "Back to the Studio," *Art in America* 70, no. 1 (January 1982): 99–107.

6. Paik's *Zen for Head* was first performed at the invitation of Karlheinz Stockhausen during Paik's appearance in performances of *Originale* (*Originals*) in Cologne on October 26, 1961. See Media Art Net, http://www.medienkunstnetz.de/works/zen-for-head/.

7. Hans Belting, "Beyond Iconoclasm: Nam June Paik, the Zen Gaze and the Escape from Representation," in *Iconoclash*, ed. Bruno Latour and Peter Weibel, trans. Charlotte Bigg (Karlsruhe: ZKM, 2002), 390–411.

8. Charles Harrison, *Conceptual Art and Painting: Further Essays on Art & Language* (Cambridge, MA: MIT Press, 2003), 58.

9. These descriptions are borrowed from Electronic Arts Intermix, https://www.eai.org/titles/elke-allowing-the-floor-to-rise-up-over-her-face-up and https://www.eai.org/titles/tony-sinking-into-the-floor-face-up-and-face-down.

10. John C. Welchman, "Of(f) White," in *Günter Brus: Nervous Stillness in the Horizon*, exh. cat. (Barcelona: Museum of Contemporary Art, 2005), 19: "Between around 1962 and the end of the decade the Viennese group, but Brus in particular, digested and reallocated the attributes of quasi-aesthetic whiteness, clinching its ambitions, making its conceits fully operative and, in effect, finalizing and rezoning its discursive overspill. The main coordinates of this reinvention brought together the surfaces of the human body, the institutional environment within which modernity had entombed it, and an apocalyptic battle between the pinkness and redness of viscera and blood and the sterilized uninflection of(f) white (clinic, ice, bandage, fluids)."

11. For images and a critical description of *The Box*, see *Dimensions of the Mind*, ed. Eva Meyer-Herman, exh. cat (Cologne: Oktagon, 1999); and Anthony Vidler, "Panoptic Drives/Mental Spaces: Notes on Paul McCarthy's *Dimensions of the Mind*," in *Paul McCarthy*, exh. cat (Ostfildern, Germany: Hatje Cantz, 2000).

12. Paul McCarthy, in conversation with the author at his Pasadena-area studio, January 28, 2003.

13. Ralph Rugoff, "Mr. McCarthy's Neighborhood," in *Paul McCarthy* (London: Phaidon, 1996), 82.

14. Paul McCarthy, interview with Kristine Stiles, in ibid., 20.

15. *Spinning Room* was first shown in the exhibition "Paul McCarthy: Central Symmetrical Rotation Movement, Three Installations, Two Films" at the Whitney Museum of American Art in 2008. See "Central Symmetrical Rotation Movement," Art 21, http://www.art21.org/videos/short-paul-mccarthy-central-symmetrical-rotation-movement.

16. Ibid.

17. Rugoff, "Mr. McCarthy's Neighborhood," 82.

18. Paul McCarthy, interview with Kristine Stiles in *Paul McCarthy* (London: Phaidon, 1996), 17.

19. See Allan Kaprow, *Assemblage, Environments & Happenings* (New York: Harry N. Abrams, 1965).

20. I discuss the relation of McCarthy's kinetic objects and spaces to ideas of temporality and media forms in an essay in progress, "Prop, Studio, Action: Paul McCarthy's Cuts," from which this and the following paragraphs borrow.

21. Paul McCarthy, interview with Anne Ellegood, "The Island of Porcine Romance," *Mousse Magazine* 24 (Summer 2010).

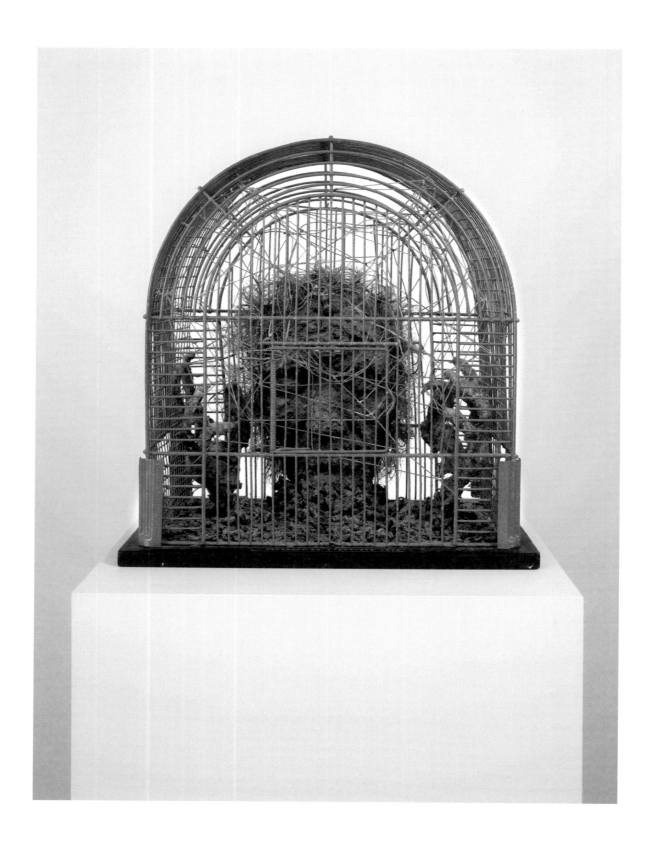

Tetsumi Kudo
Portrait d'artiste dans la crise
(Portrait of an Artist in Crisis), 1980–81
cat. no. 63

Tetsumi Kudo
*Meditation between Memory
and Future*, 1978
cat. no. 65

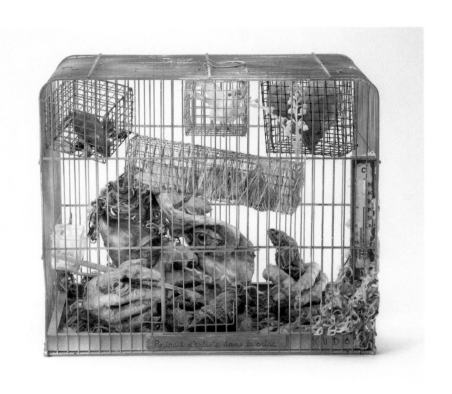

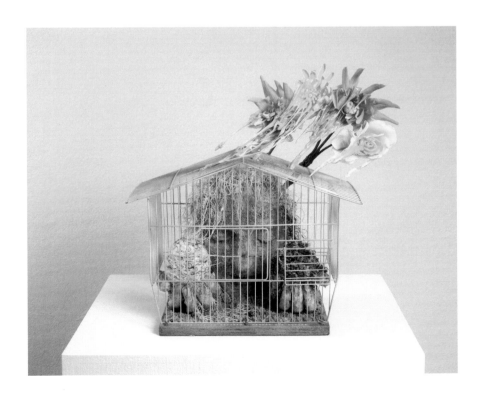

WHOSE PORTRAIT IS IT?
Tetsumi Kudo's Turn from Object to Subject in the 1970s

Japanese artist Tetsumi Kudo (1935–1990) was based in Paris and worked in Europe from the early 1960s to the mid-1980s. He gained renown, in Paris at first, for his grotesque, object-based artworks such as the "Your Portrait" series, begun in 1962 and consisting of everyday articles, found objects, and trash. Around 1967, he broadened his concerns to social structures and embarked on the "Pollution" series, inspired by environmental issues and the nuclear age. By the "Portrait of the Artist in Crisis" series, however, which he produced in the mid-1970s, the sense of repulsion that his previous works aroused in their beholders eased—these works are more introspective, and carry a softer expression.

Around this time, with the birth of his daughter, the death of his mother, and alcoholism eroding his health, Kudo's personal life was beset with challenges, which led his concerns away from the "other" to himself, that is to say, from "Your Portrait" to "Portrait of the Artist." Reflecting on that period of his life, Kudo stated:

> If I had begun by studying the fundaments of French, and entered fashionable society in Paris, I would have been completely spineless by this point. The thing that saved me was alcohol. . . . But although alcohol was an ally in battle, it was also a terrible enemy. Finally, in 1980, I collapsed. . . . About three years before I fell apart, it had gone from being a fight with Europe to being a fight with myself.[1]

In parallel with his deteriorating physical condition, the tenor of his work shifted from one that offended others to one that confronted his inner self. The social criticism in his work reached its culmination in the first half of 1970s, and then seemed to wane. If this is true, the peaceful and introverted impression created by his works after the mid-1970s is, we might say, a sign of the surrender of a man exhausted from his fight against society.[2]

Such a biographical interpretation of Kudo's work might be accurate from the perspective of the themes of the works. In view of their formal or aesthetic properties, however, it is insufficient. This essay thus scrutinizes the shift between "Your Portrait" and "Portrait of the Artist in Crisis." Comparing these two series allows us to see a fundamental shift from theatrical to antitheatrical within Kudo's oeuvre. While the former series is representational, adopting the mechanism of mirror image, the latter relinquishes references to the real world to achieve the subjectivity of pure portraiture. Such portraiture, as French philosopher Jean-Luc Nancy points out, escapes its theatrical and representational roles and stands by itself as an autonomous work.[3] And while the former expands the concept of the studio as the place to create the work of art by establishing a dialogue with the audience, the latter excludes that dialogue, with the "artist" instead going about his business in an enclosed cage.

Background and Context

When Kudo moved to Paris in 1962, four years after graduating from Tokyo University of the Arts, he had already attracted attention in Japan as an emerging young artist of the "anti-art" movement, presenting work at the Yomiuri Independent exhibitions for avant-garde art. Not only did these artists eschew conventional approaches to making paintings or sculptures, instead creating works made of everyday objects and trash, but they also attempted to overturn the notion of the studio as isolated from everyday life, bringing artistic practice into the public sphere directly—for example in Ushio Shinohara's "boxing paintings," for which he dipped boxing gloves in ink or paint and punched paper or canvas to distribute the pigment, or Kudo's own demonstration of "action painting" in the exhibition space.

Soon after arriving in Paris, Kudo reunited with Friedensreich Hundertwasser, whom he had met at an exhibition in Tokyo the previous year, and became acquainted with artists such as Jean-Jacques Lebel and critics such as Pierre Restany and Alain Jouffroy. He often participated in events and exhibitions organized by them, and photographs of one of Kudo's happenings in fact appear in Allan Kaprow's *Assemblage, Environments & Happenings* (1965), in a section describing an event planned by Lebel.[4]

Paris in the 1960s saw the rise of avant-garde movements including Nouveau Réalisme, in which artists incorporated everyday objects and trash into their artworks and staged performances on the street, linking everyday life with art; and Nouvelle Figuration, a revival of figurative art in a period dominated by abstraction. Because Kudo was also making figurative works using everyday

objects and trash, he was often invited to participate in exhibitions of those movements, who considered him an artist with similar tendencies, albeit an *étranger* hailing from Japan.[5]

A few years later, in the "Pollution" series, Kudo launched a critique of European humanism and its attempt to maintain a belief in the dignity of man when humans, nature, and science had already become inseparable. He participated in "Science Fiction" (Kunsthalle Bern, 1967) and "Happening and Fluxus" (Kölnischer Kunstverein, Cologne, 1970), both organized by Harald Szeemann, and he had solo exhibitions at the Kunstverein Dusseldorf (1970) and the Stedelijk Museum in Amsterdam (1972), all of which indicate that he had gained a measure of recognition in Europe at the time.

The shift from work that provokes others to introspective work such as "Portrait of the Artist in Crisis" took place around 1975. In the 1980s, his works became more abstract, delicate, and even elegant. In 1987, he took up a professorship at his alma mater, Tokyo University of the Arts, and relocated to Tokyo, but only three years later, in 1990, he died of colon cancer.

"Your Portrait" as Mirror Image

Taking the title "Your Portrait" literally, we can assume "your portrait" is the beholder's portrait: a kind of mirror image. Many of the works in this series consist of a box or combination of multiple boxes, whose small, limited space acts as a metaphor for social systems and modern lifestyles that confine us. Later, a birdcage was sometimes used in place of the box, although Kudo saw the birdcage as not so different, describing it as a "box with many openings."[6] This can be understood as showing Kudo's intention all the more clearly, since a birdcage is literally designed to keep its inhabitant in a small enclosure.

Take *Your Portrait* (1963), for example. The work consists of four stacked boxes, posing as giant dice. Inside each box is an object reminiscent of a dismembered sensory organ—from top to bottom: the top of a head, an eyeball, a mouth, and an ear. Affixed on the inside of the door to each box are articles intended to stimulate the respective organs—a crossword puzzle, a TV screen, medications, and radio components—with which Kudo was ridiculing contemporary life. Receiving information from mass media like TV or radio as spectacle, ingesting chemical drugs, or racking their brains to solve preprogrammed games, people were not living as single integral subjects, but rather kept alive within a social system, a consumer society that was fragmenting them organ by organ. And yet, despite living under these conditions, Europeans appeared to Kudo to be clinging to humanist ideas of an essential human dignity.[7] As a mirror reflecting how wrong these ideas were, *Your Portrait* had to exaggerate in order to correct the "distorted" image its beholders had of themselves.

When *Your Portrait* was originally displayed, visitors could open and close the doors of the boxes on their own accord. Viewers perceived the work through actions that they themselves performed. Seen thus, the work was incomplete when it left Kudo's studio and became effective only when its

beholders "touched" it. Here, too, the concept of making art was drawn out of the isolated, private studio into the public sphere.

From the start of his career, Kudo placed great importance on process. Even in the late 1950s, when he was making abstract paintings reminiscent of Abstract Expressionism or Art Informel, he made his work in performative, public events he called "actions," and defined the completed work as the residuum of a struggle between self and materials.[8] After he moved to Paris, this struggle became a dialogue between artist and audience; he insisted that his work be "a trigger for communication."[9] At an exhibition held in conjunction with the Munich Olympics in 1972, for example, he stood beside his work and engaged in discussion with visitors, implying that this was also part of his exhibition.[10] Each of Kudo's works, that is to say, calls for participation on the part of the audience.[11] Rather than being completed in a closed-off studio, his artistic practice was one where the public sphere became a kind of expanded studio for communication between artist and audience.

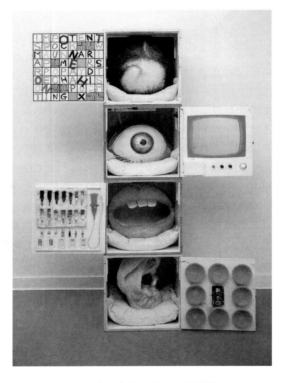

Tetsumi Kudo, *Your Portrait*, 1963.
Wood, plastic, and polyester, 78 ¾ × 19 ¾ × 19 ¾ in.

Kudo's work at the time was something akin to the set or prop in a theater play, in that it demands the existence of the artist as the performer and an audience to see it in order for the work to unfold its effect. Kudo's box and/or the space in which his work is placed sets the stage for an encounter between viewer and artist; that encounter is what Kudo considered his "artistic practice." Take, for example, another rendition of *Your Portrait (Votre Potrait)* (1966): a single large die,

the inside of the door and ceiling of which are covered in cash-register receipts, alluding to how contemporary society is structured around consumerism. The inside of the box is otherwise empty. There, clad in sunglasses and a fluorescent-green suit, Kudo concealed himself, surprising and embarrassing viewers each time the work was exhibited. Used this way, like the set or a prop in theater play, the work manifested its radical power in the exhibition space—which here itself became the studio.

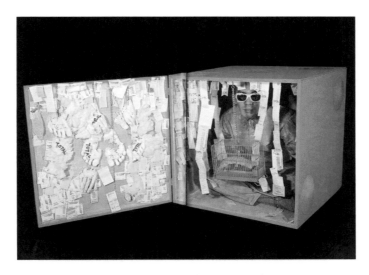

Tetsumi Kudo, *Your Portrait* (*Votre Portrait*), 1966.
Painted wood case, cage, cotton,
plastic, polyester, chains, receipts, tram tickets,
and condom, 29 ½ × 29 ½ × 29 ½ in.

This allows us to make two observations: First, Kudo's work was a medium for building a direct relationship between the artist and viewers. It is more of a theatrical work than an autonomous object because it is premised on the existence of audience. Second, "Your Portrait" is also a portrait of the artist himself, in disguise, for example in *Your Portrait*, the "you" in the dice is Kudo himself. In the closed-circuit mirror image created by the convergence of Kudo (artist) and "you" (artist), the viewer is told that the image in front of him or her is "you" but it is also Kudo; thus the viewer begins to ask him- or herself why it is also his or her portrait

The Portrait as Subject

The works in "Portrait of the Artist in Crisis," made just over a decade later, each feature a human head in a birdcage. The figures are often knitting, making cat's cradles, or have their eyes lowered as if in meditation. The materials used in these works differ little from the materials Kudo had used in his previous works, but the aggressive, offensive mode in which they engaged with the audience has softened: the figures are absorbed in their own business, ignoring

the existence of the viewer completely. Yarn and string function as metaphors for genetic transmission and memory in Kudo's later work, suggesting that the artist had turned his concerns to "inner others" such as ancestors, descendants, and himself.

As the title of these works suggests, the portrait here is the artist's—i.e., Kudo's. As he explained, "I got tired of bullying Europeans, because they were beyond saving. . . . And once that seemed absurd, I had to turn my spearhead towards myself."[12] If we consider that he was reflecting on himself in the context of personal and health concerns, then the crisis of "Portrait of the Artist in Crisis" can be regarded as Kudo's crisis.

If this series is a form of self-portrait, however, it is interesting that the face does not resemble Kudo's visage. In fact, it was often the face of Eugène Ionesco, the Romanian-born French playwright of "anti-theater." Kudo became acquainted with Ionesco in 1970, when film director Heinz von Cramer, who was impressed by Kudo's solo show at the Kunstverein Dusseldorf in 1970, asked Kudo to create the set design for *La vase* (1971), for which Ionesco was both scriptwriter and leading actor. Both men were avant-garde artists— "anti-art" and "anti-theater" respectively—but nevertheless, Ionesco, who was twenty-six years Kudo's senior and had been elected to the French Academy that very year, appears to have dealt with Kudo in arrogant manner. In response, Kudo created *Portrait of Ionesco* (1970–71), a sculptural portrait of the playwright together with an object that resembles a turd. Later, he explained that it was not an attack on Ionesco himself, but rather on the typical Western intellectual, using Ionesco's image.[13]

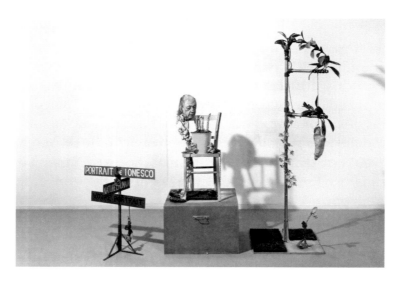

Tetsumi Kudo, *Portrait of Ionesco*, 1970–71.
Mixed media, 78 ⅔ × 78 ⅔ × 27 ⁹⁄₁₆ in.
National Museum of Modern Art, Kyoto

At first, Kudo adopted the face of Ionesco to criticize him, but from a certain point on he no longer appears as the target of Kudo's attack. The early series "Portrait of Ionesco" (1970) gave way to the more ambiguous "Portrait

of the Artist in Crisis." Furthermore, in the series "Waiting for the Revelation in the Rain of Heredity Chromosome," which followed around 1976, Kudo adopted the death mask of Pascal, which he had discovered by coincidence, in lieu of Ionesco.

And yet, from the viewer's standpoint, I don't suppose it really matters whose portrait it is or whom it looks like. The degree of resemblance cannot be a criterion for evaluating the works in this series, because the face withdraws itself from scrutiny. Not only is it screened by the birdcage, but there are also hands knitting or playing cat's cradle in front of it, and masses of yarn or string entwined with the birdcage and the face. There are no attributes that identify the portrait as that of an artist: the figure wields knitting needles, not a paint-brush. Thus, the only certainty regarding the face in this series is that it is a human face. Kudo explained: "This is my portrait as well as Pascal's, so it could really be whoever."[14] That nobody can be accurately identified with it means that anybody can be identified with it. In this respect, "Portrait of the Artist in Crisis" is a nonrepresentational, nonobjective portrait, and it therefore becomes an autonomous subject. In the words of Jean-Luc Nancy: "In resembling someone or a singular aspect of someone, a portrait does not at the same time resemble anyone, but resembles the resemblance itself, or resembles the 'person (persona)' as long as the person resembles itself."[15]

The Turn in the Portrait

Nancy regards the mirror image as the object of representation and the portrait in the painting as the subject, and contrasts them.[16] The latter type of portrait escapes the representative role of resembling someone and establishes autonomous subjects as the resemblance of resembling. As such, Nancy's scheme accords with the difference between "Your Portrait" and "Portrait of the Artist in Crisis." The former relates to the beholder through the economy of the mirror image. It portrays "you" as a representative object via a theatrical structure, evinced by the fact that Kudo used "Your Portrait" like a set or prop in a play in his performances.[17] Kudo insisted that "Your Portrait" was a trigger for communication. Rather than being about the creation of an autonomous art object in an isolated, closed-off studio, Kudo's artistic practice became manifest in public, in the exhibition space, where there is dialogue between the artist and the beholder. "Portrait of the Artist in Crisis," by contrast, is immersed in its own activity—it is, so to speak, self-preoccupied, and ignores its beholders. As portraiture is freed from its role as a tool or prop for the artist, the figure is free to knit, play cat's cradle, or meditate subjectively on behalf of the artist.

Perhaps Kudo's greatest achievement in "Portrait of the Artist in Crisis" is that it becomes independent not only from both representation and the viewer but also from the artist himself. While it may seem as if he had retreated to his small, cloistered studio, I would argue that what has happened is that the portrait has achieved autonomy. It is as if Kudo contrived the work so as to keep functioning after the death of the author. The intuition about

death that Kudo gained "in crisis" may have enabled him to create autonomous portraits that continue their own artistic practice after his own mortal passing. What is certain, at any rate, is that "Portrait of the Artist in Crisis" represented not only a change of subject matter, but also a turn in portraiture—from the representation of the object to the manifestation of the subject. And in the time that passed between these two events, the studio as the site of Kudo's artistic practice was opened up and then closed again.

NOTES

1. Tetsumi Kudo, "Reaching a Spiritual 60th Birthday," *Tetsumi Kudo 1977–81*, exh. cat. (Tokyo: Sogetsu Art Museum, 1981).

2. Atsuhiko Shima, "A Guide to Tetsumi Kudo, Part 16: Portrait of the Artist in Crisis," in *Your Portrait: A Tetsumi Kudo Retrospective*, exh. cat. (The National Museum of Art, Osaka, 2013), 285–286.

3. Jean-Luc Nancy, *Le Regard du portrait* (Paris: Galilée, 2000), 32.

4. Allan Kaprow, *Assemblage, Environments & Happenings* (New York: Harry N. Abrams, 1965), 236.

5. Exhibitions in which Kudo participated in Paris in the 1960s are listed in Tomohiro Masuda, "When the Box Is Presented to You: Tracing the Development of Tetsumi Kudo in Paris, 1962," in *Your Portrait: A Tetsumi Kudo Retrospective*, exh. cat. (The National Museum of Art, Osaka, 2013), 439–45.

6. Tetsumi Kudo, "Box," *Kudo*, exh. cat. (Paris: Galerie Vallois, 1977).

7. Tetsumi Kudo, "Dear Mr. Beeren (Dear Europeans)," *Kudo*, exh. cat. (Paris: Galerie 20).

8. Kudo wrote the following in his notebook (unpublished) in the last half of the 1950s. "Reaction itself is the art, so the remaining thing (what used to be called art work) has no meaning. It is the trace or the residue of the reaction. Through the trace, beholders can presume the reaction and even sense it."

9. Ichiro Hariu and Tetsumi Kudo, "Dialogue=30," *Mizue* 814 (December 1972): 69.

10. Masaharu Saito, "Discussed with audiences on the side of the artwork," *Bijutsu techo* (January 1973): 247–54.

11. Jean-Jacques Lebel planned his happenings without any scores, and they were executed in an unplanned way, ending with discussion involving the audience. He also stated that all people involved in happenings—from performer to audience—were "participants." See Claire Bishop, *Artificial Hells* (London: Verso Books, 2012), 93–101. Kudo's orientation was similar to Lebel's.

12. Tetsumi Kudo and Yujiro Nakamura, "Dialogue: Strategies in Contemporary Art," *Gendai shiso* (November 1981): 50.

13. Ibid., 49.

14. Tetsumi Kudo, "Self-portrait and me," *Shin bijutsu shinbun* (February 21, 1989).

15. Jean-Luc Nancy, *Le Regard du portrait*, 50.

16. Ibid., 44.

17. From the second half of 1970s, Kudo called his performances "ceremonies" to strengthen the meditative and ritualistic atmosphere. That Kudo brought his artworks into his performances remained unchanged. But after becoming "ceremonies," in most cases, the works stood beside him, as if both the artist and the artwork were in meditative states.

Daniel Spoerri
Fallenbild – Tableau Piege aus dem Restaurant Spoerri
in Düsseldorf vom 28. Oktober 1972, 1972
cat. no. 107

Lucas Samaras
Still Life, July 26, 1979
cat. no. 102

Lucas Samaras
Still life, July 26, 1979
cat. no. 103

Gean Moreno

ANTINOMIES OF THE STUDIO
Artistic Production in the Social Factory

By the mid-1960s, the tendency to the theatrical in Yves Klein's public painting spectacles or in the Jackson Pollock that Hans Namuth caught on film ferociously flinging paint and chewing on cigarettes had opened the door to radical gestures of disappearance. A few years before the "death of the author" was announced, Minimalist artists made it clear that art could come into being through phoned-in instructions to the manufacturing shop or the steel yard. Artworks became indices of the performance that brought them into existence, while in turn casting a sharp light on the stages on which these performances were enacted. Or better yet: they became indices of the performance of being an artist at a moment when the role was undergoing important reconfigurations. This performance often worked by reifying the missing producer. Two works serve as telling examples, each of them recalibrating in a different way the place of meaning in art, with far-reaching consequences for the figure of the artist and, indeed, the studio: Lucas Samaras's *Room #1* (1964) and Giulio Paolini's *Hi-Fi* (1965).

To make *Room #1*, Samaras simply moved all the contents of his bedroom-studio to the Green Gallery in New York. Tools, notes, knick-knacks, underwear, bed, unfinished works—it was all there. As Brian O'Doherty writes:

> By placing the studio in the gallery, he forced the two to coincide, thereby subverting their traditional dialogue. Samaras exhibited a lifestyle—frugal, messy, indifferent to the gallery-person's etiquette of taste. . . . By putting on display a lifestyle embalmed in the gallery's artificial time, Samaras was imaging an absent artist: himself. By declaring the residues of the artist's life as art, he reified the image of the absent artist. . . . So, in this work, the gallery framed the studio, which in turn framed the way the artist lived, which in turn framed the artist's implements, which in turn framed the artist—who was missing.[1]

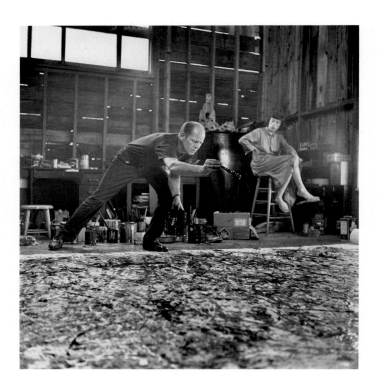

Jackson Pollock, 1950.
Photo: Hans Namuth

This absence, O'Doherty asserts, is a way to "avoid the difficulties of art." By this he means that in generating a recursive loop of self-referentiality—"the studio stands for the art, the artist's implements for the artist, the artist for the process, the product for the artist, the artist for the studio"[2]—the artist skirts the pressure of having to produce autonomous objects.

In *Hi-Fi*, made the year after Samaras's *Room #1* was presented, Paolini painted the painter into the picture. The cut-out figure of the artist and his easel are both incorporated into the painting, camouflaged in thick black brushstrokes that make producer and output nearly identical. Germano Celant has described the work's integration of the artist and his production as a transcendent union, "a single global reality."[3] Celant approaches the mystical—or at the very least turns against any materialist understanding of cultural production—in his assertions: "Thus Paolini's work, from 1965 on, 'contains' him: the artistic inquiry is no longer capable of being separated from the 'figure' of the artist. Both live in a historical complex which causes the work to be the author and the author the work."

This is a "concrete osmosis . . . in which the subject is no longer expressed in the application of signs, but actually is the relationship between the work and the author." If seen from a less ebullient place, and taking into account the presentational conditions in which this work is encountered—which seems a fundamental part of what is at stake in it—Paolini's re-enactment of the studio situation may, however, in fact come closer to parody: the artist spoke of it as "a union as mysterious as it is meaningless."[4] The New Age-y continuity of author, object and context as "concrete osmosis" finds its opposite: a caustic disaggregation of these things that obtains precisely in the evacuation of meaning from two elements—artist and output—so as to better highlight and interrogate the third: the studio, most immediately, but also in more general terms the frame, the institutional apparatus as a whole.

Proposing it as a precursor to works that more pointedly interrogate institutional frames and protocols, Craig Owens has spoken of *Hi-Fi* above all as a staging of the death of the author, in a follow-up to the way this demise was discussed in the work of Roland Barthes.[5] This is easily sustained by the fact that Paolini's self-dissolution knows few bounds and follows a discernible trajectory of intensification. In 1961, he exhibited a can of paint on a wooden frame, backed with a sheet of transparent plastic; in 1963, a painting facing the wall; in 1970, a 1917 Francis Picabia collage under his own name, making no effort to hide this fact. These increasingly more dramatic acts of disappearance shift the focus of his work further and further in the direction of the context of presentation and display. In a foreshadowing of what would become known as institutional critique, the artist's theatricalized vanishing opened a void that new politicized questions would fill.

In Samaras's *Room #1*, in keeping with ideas then current, the artist personalizes things fully, draining artistic production into life itself, rendering the two indistinguishable. In this way, he challenges whatever exceptional quality may have once been attributed to the making of art, adding to the modernist dream to turn living itself into a poetic endeavor. In Paolini's case, tugging on a different set of shared feelings that also characterize

that moment, the artist plays with the possibility of eradicating authorial signature by subsuming the figure of the artist into the work and thus parodying the excessive value that has been attributed to artistic subjectivity. Through such a gesture, he leaves the work vacant and available to be employed in probing the very conditions in which it functions.

It is in relation to parameters established by art's circumscribed discursive field that the critical import and historical novelty—and perhaps their pertinence as more than historical examples—of Samaras's and Paolini's work can be ascertained and judged. It is also here, despite constant challenges to the relevance of intentionality in cultural production, that the artist claims critical and self-reflexive agency, motivation being legible in gestures, results, solidarities, and reactions to previous practitioners and positions. However, if one alters the perspective so that the focus turns from the specialized discourse of the field to the structural changes in the larger socioeconomic ground,

Lucas Samaras, *Room #1*, 1964 (detail)

an antimonic cleaving immediately asserts itself in these works.[6] On one side of this irreconcilable gap there is the conventional meaning—or at least the contest of meanings—established by art discourse; on the other there are the operations of a mutating capitalism, which engulf and overwrite the meaning of the work. Samaras's lifestyle on display and Paolini's stagings of the evacuated author are thus riven by incompatible but synchronous descriptions, none fully negating the other, while simultaneously articulating an insurmountable gap that bars them from coming together.

* * *

In 1962, Mario Tronti published "Factory and Society," an essay that mapped capital's subsumption of the activities that make up our lives beyond work, organizing and controlling more and more time and space. "At the highest level of capitalist development," he writes, "the social relation is turned into a *moment* of the relation of production, the whole of society is turned into an *articulation* of production, that is, the whole of society lives as a function of the factory and the factory extends its exclusive domination to the whole of society."[7] This subsumption of the social increasingly splits things from themselves, making everything two things at once: namely, a perpetual value-generator—a function of capital, produced by it, regardless of its content—*and* whatever else it is. The difference is not between one thing and another, but between a thing and itself, marked by an internal non-coincidence or cleave. The thing remains and the thing is totally different. Slight shifts in perspective alert us to a gap in the object, a paradoxical interstice without geography. Its identity is determined by the two incommensurable sides that it delaminates from— and that it delaminates from each other.

In relation to our concerns here, the artist is *both* a critical actor—part of the interrogation of institutional protocols in the wake of "the death of the author"—*and* an involuntary manifestation of an emergent tendency, determined by the new generic relations of the social field, in disregard of motivation and desire. (The *and* here is less a

Giulio Paolini, *Senza titolo* (Untitled), 1961.
Tin of paint, stretcher,
and polyethylene, 8 ¼ x 8 ¼ in.
Fondazione Giulio e Anna Paolini, Turin

connector than a provisional stand-in, an unsustainable X-replacement, for a subjectivity-structuring gap.) Both possibilities cannot hold simultaneously, but they do. There is no synthesis to be had, and yet there they are. Pulled between these inexorable conditions, the artist begins to inhabit, as a symbolic structure, the fracture between the sphere of agency and a plane of structural determinations.

In other words, if the artist involuntarily assumes the formal function of a crystallization exfoliated from the historical process in motion, the artist as a critical agent also remains. Rather than being somehow buried in the new configuration, or struggling to emerge, the critical, self-reflexive stance is part of the performance. We can see it doing effective work, but it is artistic production itself, independent of the objects or repertoire of gestures that can be linked to critical art, that establishes the artist as a crystallization of a tendency, the provisional bearer of its truth, insofar as a kind

of structural causality makes this production value-generating in itself. This means, at the very least, that in the historical moment we are parsing—schematically time-lined between, let's say, the emergence of logistics with the standardization of the container in 1961 and the post–Bretton Woods, global oil crisis of 1973—the artist challenges the very tendency he embodies and in some way perpetuates, staking out a space of antagonism to capital, or at least to the incursion of capitalist imperatives into cultural production. The fact that the ground of capital can never fully dissolve the figure of the artist as critical agent, and at the same time this criticality is secondary (or trivial) to the way artistic production can be made to generate value independent of subjective or political motivation, ultimately brings the parallax gap into focus as the "location"—the non-site that is looking for positive articulation—that the studio with a missing or vanishing producer allegorizes.

112

* * *

As one set of artists was staging disappearances, another set started showing up to the studio, moping around unsure of what to do, trying this and that. Bruce Nauman bounces against the corners of his studio (*Bouncing in a Corner, No. 1* [1968]). He paints his testicles tar-black. He walks in an exaggerated manner around a square. "I spent a lot of time at the studio kind of re-assessing," Nauman recalls, "or assessing, why, why are you an artist and what do you do, and finally that's what the work came out of—that question, why is anyone an artist and what do artists do[?] . . . I paced around a lot, so I tried to figure out a way of making that function as the work."[8]

John Miller has invited us to a thought experiment: "let's suppose that Nuaman's nine-minute film, *Walking in an Exaggerated Manner around the Perimeter of a Square* [1967–68], were to be remade as *Walking in an Exaggerated Manner so as to Prevent Incontinence*."[9] It doesn't take Miller much to convince us that the second version of the film would find a natural place among Nauman's desublimatory exercises. In the film (in either version), not much happens: Nauman walks in an exaggerated manner around a square that has been outlined on the studio floor with masking tape. Nothing else seems to have occurred to him to do. He is killing time, or fighting boredom, or countering the anxiety that coming up with nothing swirls awake. He's assessing and reassessing. Miller subtly probes a number of elements at play in this work—the mannered title; the use of the floor in relation to Minimalism's own dismissal of the pedestal; the missing sculpture evoked by the inviolable space that the tape borders off; the connotations of "walking funny" in the broader culture; the way that Nauman, before a stationary camera, often has to walk out of the frame to stay on task—tellingly appearing and disappearing, alerting us that this swap in conditions may go deeper than it at first seems. While Miller wraps things up by linking Nauman's work to a feminist reconfiguration of patriarchal culture, let us stay for a moment with the image of the incontinent personage that Nauman's

Giulio Paolini, *Delfo (Delphos)*, 1965.
Photo emulsion on canvas, 71 × 35 ½ in.
Walker Art Center, Minneapolis, Gift of the T. B. Walker
Foundation by exchange, 2003

"funny walk" conjures, the subjectivity that may be appended to this figure, and the inevitable accident that is coming as the task of walking the perimeter of a square, convict-like, continues indefinitely, perhaps forever, without bathroom breaks.

Nauman, it turns out, may be something like the soiled-shorts figure at the bottom edge of Salvador Dalí's *The Lugubrious Game* (1929), who is himself pondering a good old (and unreachable) pedestaled sculpture in the distance. Diagrammed by Georges Bataille into a heuristic to explore the inferiority complex, this painting proves a rich magnet of meanings.[10] But what one imagines made Bataille the most excited and gleeful about it was discovering that the shit-stain on the shorts is both a renewably injurious trace of and a remedy for the sense of

Salvador Dalí, *The Lugubrious Game*, 1929.
Oil on canvas, 17 ½ × 11 ⁹⁄₁₀ in.
Private collection

Georges Bataille, *Psychoanalytical
Schema of the Contradictory Representation of the
Subject in Salvador Dalí's* The Lugubrious Game

emasculation that suffuses the painting, marks its characters, and explains its symbols. This may also be what the stain that will burden Nauman's incontinent may turn out to be—a trace of and remedy for his suspension at or over, figuratively speaking, the irreconcilable split staking a claim on the artist: the irreconcilability of agency and structural determination. If it's a pharmakon, this "ignoble stain," it is one that paralyzes. It is, after all, paralysis—of imagination, let's say, deferring any conclusion or a plan of action from all the assessing—that marks the gap that allows the artist, on the one hand, to make a claim for what he is doing and to do this in relation to the coordinates of valid and valued in-field discourse and expectation, allowing Nauman to be contextualized in relation to progressive dance practices (Meredith Monk, Merce Cunningham) and novel interrogations of sculptural production (one thinks of Richard Serra flinging molten lead in the studio), and, on the other, serving as a crystallization, in highly concentrated form, of a general

dynamic that is spreading across the social plane in disregard of any claim the artist makes whatsoever. Hobbled by this double condition, endeavoring to fend off a sense of general inadequacy but hamstrung by paralysis and uncertainty, while simultaneously supported by the nearby validating efforts of peers, a subjective recomposition—or a recalibration, at least—seems unavoidable. But it's one that is perplexingly ungrounded, inextricable from life at the X of the parallax gap. This may just be what has Nauman throwing himself against corners, as if he can't figure out not only what to do but what an artist, as a coherent and synthesized unit, may be at the particular conjuncture in which he is working.

The perplexity of a subjectivity hamstrung by this gap loses all measure, becomes something else, in Paul McCarthy's work. In fact, it crescendos to that sweet spot where confusion becomes meltdown, where grasping for something becomes a suicide plunge into a swirling morass underfoot, an intemperate desire to meld with the confusion, only

114

to find that there is no real morass to land in (there's no there there, only a gap) or become one with. It's a *salto mortale* that becomes endless free-falling. More than this: the arousal that comes from the plunge, the libidinal investment in this meltdown, once one has committed fully to it, leads to a teen break-up with the Big Other for whom we always try to keep it at least a little bit together, hoping that an untarnished and elusive normality will be assigned to us. If Nauman pressed his butt-cheeks as a way to keep things from unravelling altogether, McCarthy lets it all go. The gush is of such potency, so intractable, that it won't restrict itself to the proper orifice. In *Face Painting - Floor, White Line* (1972), McCarthy, lying on his belly, slithers across his studio floor, holding in front of him with arms outstretched a gallon of white house paint. He pours the paint and drags his face over it, pushing himself with his feet. The mark-making, brushstroke-surrogates are traces of the trajectory of his face, followed by the rest of his body, across the floor. It's like an Yves Klein anthropometry performance with the glam spectacle swapped for B-movie self-debasement and disparagement.

One imagines McCarthy rising when he is done. He must have looked like a sloppy and deranged clown, huffing and puffing to catch his breath, nostrils flaring, the house paint looking like grease make-up melting off his face and over his clothes. He anticipates some of the clowns that are tortured in Nauman's later works—and perhaps even more so the questionable characters in John Wayne Gacy's paintings, doubling as an emblem

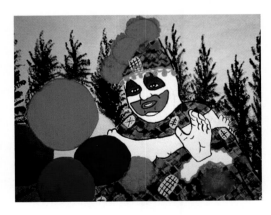

John Wayne Gacy, *Pogo the Clown*, 1993

of the paralysis not of imagination, but of certain regulating inner and shared criteria. Not only is McCarthy transmuted into this deranged clown, but one can imagine the residual paint in his mouth, saliva-mixed, assuming the runny texture that the incontinent knows all too well. Anal and oral—their confusion, the split and suture between them: which hole is where? and what is coming out of it?—become a stand-in for the perplexing gap that the artist is now determined by, and also a harbinger for the value-canceling, runny substance that will impudently fill and flood this gap.

Of course, the confusion also registers in other ways. The Icarian free-fall flickers, like a faulty hologram or a hacked lenticular print, into a wallowing in the mud. If Nauman was the character in the soiled shorts, McCarthy is more like Bataille's coprophagist pig, "who rummages in manure and mud uprooting everything with his snout" as an obstinate response to "a great poetic impotence"—an animal whose "repugnant voracity is unstoppable."[11] He explodes the inferiority complex, turns the lugubrious game on its head, by assuming the split condition so fully that intellectual paralysis and repetition turn into desubjectifying over-stimulation and delirious squandering. McCarthy twists the exercise of walking funnily around a square or bouncing into corners into an explosion of taboo-busting manic energy, rendering inoperative criteria of taste, value, decorum. Agency and structural determination meet in an excremental prodigality that cancels value. If production loses its edges in the social factory, in McCarthy's hands it becomes irrevocably indistinguishable from wasteful proliferation. There is nothing to recover, nothing to extract. Manic energy bubbles over the edges of the gap that structures artistic subjectivity, but the dehiscence is all shit. Unfortunately, this all happens on the way to being scooped up, as we come into the mid-1970s, by an emerging and newly spirited configuration of capital—a coming neoliberalism—that embraces expenditure and excess, splitting McCarthy's abject profligacy from itself by recharging it with value and utility, turning it into the sort of thing that the depredatory times which we are looking back from indefatigably call for.

115

NOTES

1. Brian O'Doherty, *Studio and Cube: On the Relationship Between Where Art is Made and Where Art is Displayed*, (New York: Princeton Architectural Press, 2008), 4–5.
2. Ibid., 5.
3. Germano Celant, *Giulio Paolini: 1960–1972* (Milan: Fondazione Prada, 2003), 136.
4. Giulio Paolini in a 1966 interview, reprinted in ibid., 180. Originally published in *Marcatré*, nos. 19–22, April 1966.
5. Craig Owens, "From Work to Frame, or, Is There Life After 'The Death of the Author'?" in *Beyond Recognition: Representation, Power, and Culture* (Berkeley: University of California Press, 1992), 123–26. See also Roland Barthes, "Death of the Author," in *Image Music Text* (New York: Hill and Wang, 1977), 142–48; and Michel Foucault, "What is an Author?" in *The Foucault Reader* (New York: Pantheon Books, 1984), 101–20.
6. "The common definition of parallax is: the apparent displacement of an object (the shift of its position against a background), caused by a change in observational position that provides a new line of sight. The philosophical twist to be added, of course, is that the observed difference is not simply 'subjective,' due to the fact that the same object which exists 'out there' is seen from two different stations, or points of view. It is rather that, as Hegel would have put it, subject and object are inherently 'mediated,' so that an 'epistemological' shift in the subject's point of view always reflects an 'ontological' shift in the object." Slavoj Žižek, *The Parallax View* (Cambridge, MA: MIT Press, 2005), 17. The current text benefits greatly from Žižek's materialist treatment of the parallax.
7. Mario Tronti, "Factory and Society," trans. Guio Jacinto, *Operaismo in English* (blog), June 13, 2013, https://operaismoinenglish.wordpress.com/2013/06/13/factory-and-society/.
8. "Oral History Interview with Bruce Nauman," *Archives of American Art*, Smithsonian Institute, May 27–30, 1980, https://www.aaa.si.edu/collections/interviews/oral-history-interview-bruce-nauman-12538.
9. John Miller, "The Body as Site," in *The Price Club: Selected Writings (1977–1998)* (Zurich: JRP|Ringier, 2005), 87.
10. Georges Bataille, "The 'Lugubrious Game'" in *Visions of Excess: Selected Writings, 1927–1939* (Minneapolis: University of Minnesota Press, 2005), 24–30. In 1999, John Miller produced a work also titled *The Lugubrious Game*. It is a strangely generic game-show set with a dirt mound full of dildos and dollars and lubricant tubes and tabloids at the center of it. The only thing that one can win—and who knows what it really is—when one spins the large wheel, à la *The Price is Right*, is signaled by a tight-crop portrait of Charles Manson.
11. Ibid., 24

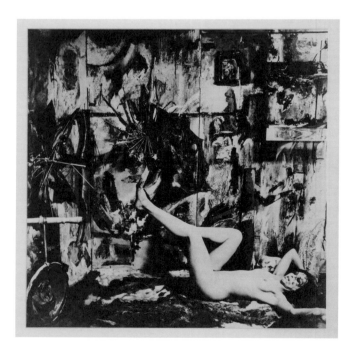

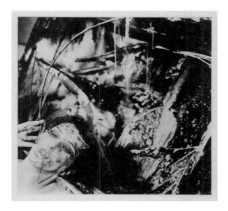

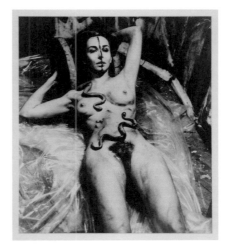

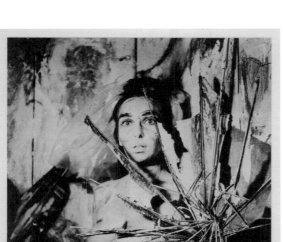

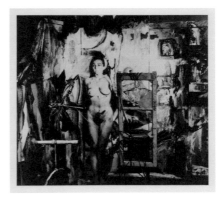

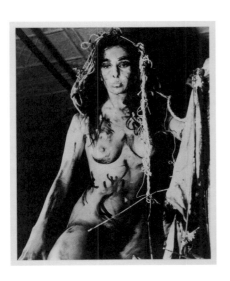

Jay DeFeo
Lotus Eater No.1, 1974
cat. no. 22

Jay DeFeo
Untitled, 1973
cat. no. 27

Jay DeFeo
Untitled, 1975
cat. no. 23

Jay DeFeo
Untitled, 1971
cat. no. 26

Jay DeFeo
Untitled, 1971
cat. no. 28

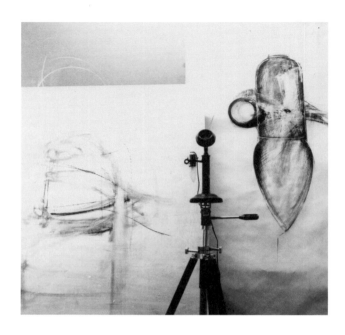

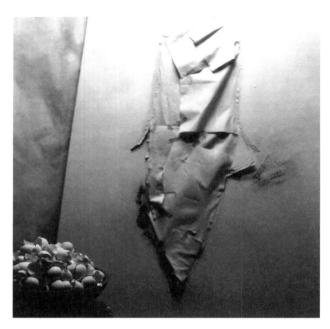

Jay DeFeo
Untitled, 1973
cat. no. 25

Jay DeFeo
Untitled, 1973
cat. no. 29

Jay DeFeo
Untitled, 1973
cat. no. 30

Jay DeFeo
Untitled, 1976
cat. no. 24

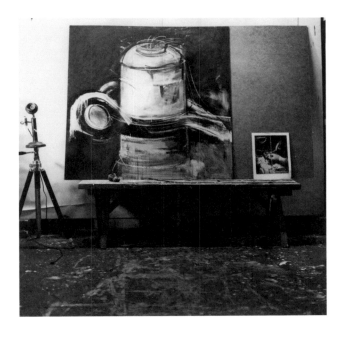

Stephanie Seidel

POSE AND EXPOSURE
Feminist Studio Practices of the 1960s and 1970s

Investment in the look is not privileged in women as in men. More than the other senses, the eye objectifies and masters.... The moment the look dominates, the body loses its materiality.
—Luce Irigaray[1]

In the corner of an empty room, we see a cast silhouette of a female body lying on the floor. The figure is covered with a white sheet and a thick layer of plaster; the naked lower half of a female body—presumably the model for the cast—stands to the side. Funereal, bleak, and plangent, this image—depicting artist Francesca Woodman in her studio, and taken between 1975 and 1978—is as distinctively intimate as it is enigmatic. Curiously, though, it is not one of a kind, but bears a striking similarity to a constellation of similar images. Take, for example, Carolee Schneemann's photographic suite *Eye Body: 36 Transformative Actions* (1963), which contains a picture of the artist lying naked on the floor, arms and legs spread,

covered by a semitransparent tarp revealing only her silhouette. Or consider a set of photos of Heidi Bucher from 1982 depicting the Swiss artist covered in a membrane-like sheet of latex that she peels from the walls of a room. What are we to make of these parallels, separated by nearly twenty years? All these photographs center on representations of the female body in the studio. This site of production—simultaneously a private space and public stage—becomes, through photography, an interface of representation. Meanwhile, the sheet, tarp, or latex functions as a membrane that gives a provisional visibility to a sort of representation—a woman in her studio—that had long been occluded entirely.

In the 1960s and '70s, women artists took possession of the studio in a new way. In so doing, they raised questions about the conditions of art production in a field in which men made the rules. "The freedom of the studio is always already impaired," writes art historian Caroline A. Jones. "Who owns it and what happens with the works

Carolee Schneemann, *Eye Body: 36 Transformative Actions for Camera*, 1963.
Photo series taken in Carolee Schneemann's studio.
Gelatin silver prints, 24 × 20 in. each.
Photos: Erró

Francesca Woodman, *Untitled (Providence, Rhode Island)*, 1975–78.
Gelatin silver print, 5 ¼ × 5 ¼ in.

that are made in it is already predetermined."[2] Linda Nochlin's 1971 text "Why Have There Been No Great Women Artists?" is a key document from this era. In this essay, Nochlin concludes that, contrary to modernist myths of artistic genius, "art is not a free, autonomous activity of a super-endowed individual,"[3] but is, rather, inextricably bound to a range of social structures and institutions. Historically, these have served as a barrier to women, keeping them from achieving visibility comparable to men.

The studio—traditionally coded as masculine—was a crucial battlefield in this fight for recognition. In the '50s, magazines such as *LIFE*, *Vogue*, and *Harper's Bazaar* featured photo spreads of male modernist painters at work, through which the studio began to gain visibility in the public imagination. Most famous among these were shots of Jackson Pollock by Hans Namuth showing the artist in blue-collar clothes—boots and jeans—dripping paint on a floor-bound canvas, solitary in his industrial studio space. Magazines also widely circulated photographs by Alexander Liberman and Brassaï portraying figures such as Willem de Kooning, Henri Matisse, and Pablo Picasso. Such images contributed substantially to disseminating what art historian Mary Bergstein calls the "mystique of the artist's atelier"[4]—one containing what Caroline A. Jones considers an "artist (solitary, white, male, and free) . . . unburdened by tradition or conventional society, autochthonic and alone, his works created from a deeply private inner source to achieve an individuating sublimity. His studio was empty, undomestic, and male, a solitary sanctuary."[5]

If Namuth's photos of Pollock reasserted the painter's status as an untouchable "master of creation," female artists such as Schneemann began to break with the false assumption of neutrality and transcendence. The studio, accordingly, became a dynamic, contested zone, rather than

autonomous, mysterious, and aloof. In her *Eye Body* images, Schneemann positioned her body in her studio—a former fur cutter's loft in New York—presenting it in such a way that served as emancipatory means of self-historization: not only did she visualize her own production context, but she also displayed her own (female) body's deep entanglement in the process of creation. The photos—shot by a fellow painter, Icelandic artist Erró—portray Schneemann naked, covered in paint, grease, chalk, ropes, and various other supplies; she seems to physically merge with her surroundings, including the multiple paintings and assemblages that form the backdrop—most prominently her work *Four Fur Cutting Boards* (1963).[6] "Having moved away from actually painting on flat canvas," the artist recalls, "I could now submerge myself, becoming part of the material from which a work took form."[7] Her "self" in these images is mutable, at times even fragmented, as her face appears behind shards of glass or mirror.

As if in opposition to the modernist authority of Pollock as depicted by Namuth, Schneemann harnesses her own body as a counterargument against masculinity, resolutely disavowing values of "objectivity" and "disinterestedness" by merging her own body with her work—which, in her own words, had "to do with cutting through the idealized (mostly male) mythology of the 'abstracted self' or the 'invented self'—i.e., work involving another kind of glorification/falsification where … you retain power and distancing over the situation."[8] This endeavor brings to mind the writings of Lacanian theorist Kaja Silverman, who states: "The pose always involves both the positioning of a representationally inflected body in space, and the consequent conversion of that space into a 'place.'"[9] Within this "place" of the studio, Schneemann conflates subject and object: she is both image and what she calls "image maker."[10] Her studio becomes at once a frame and part of the work itself.

* * *

Art historian Amelia Jones has linked the increasingly performative aspect of studio production in

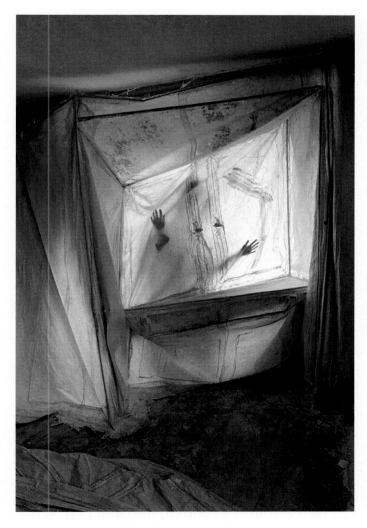

Heidi Bucher, *Hautraum from the Ahnenhaus, Obermühle* (Skin Room from the House of Ancestors, Obermühle), 1980. Documentary photo

the '60s and '70s to the formation of a new, plural type of "author function"[11]—one brought about through novel, open-ended processes of art making. Few artists complicated this author function like Jay DeFeo. After leaving her San Francisco studio in 1965 and finishing her monolithic painting *The Rose* in 1966 at the Pasadena Art Museum, where it was eventually exhibited, DeFeo did not produce any works of art for three years. When she returned to art making in 1969, she experimented with new materials and procedures, putting photography at the forefront of these investigations. If *The Rose* had resulted from a process of continually applying layers upon layers of paint—a kind

ny model out of my own head!

Jay DeFeo, *Study for Crescent Bridge (my model...*
out of my own head!), 1971.
Gelatin silver print with typed labels, 3 1/16 × 4 1/4 in.

of continual revision of the painting's surface—photography now served as a means by which DeFeo could revise the painterly process itself. She would photograph her paintings as she made them; the subsequent accumulation of images would then inform how she "completed" the work. Interrupting and decomposing her process and her own authority as author, the camera served at times as a sketchbook, a way to create preliminary images of future works. As the artist wrote in 1977:

> I worked on photography alone . . . and gave it nearly as much attention as painting in the early 1970s. . . . Most of the work at the time was concerned with photographing various objects that later became "models" for the paintings to come. . . . It is worthy of mention because it has had a most important role in my work as a whole.[12]

In this way, DeFeo did not produce one discrete, finished "masterpiece," but rather a number provisional constellations—what artist Walead Beshty called a "cycle of formations and deformations."[13] As DeFeo said, "painting is an endless growth of continuing images."[14]

As in Schneemann's *Eye Body* images, DeFeo's photographic constellations extend to and encompass her own (fragmented) body in the studio. In many images, a tripod appears, acting as an anthropomorphic stand-in for the body with one Cyclopean eye; other photos depict a headless, female upper torso; another set features DeFeo's dental prosthesis. On one of the images from this last group, *Study for Crescent Bridge (my model... out of my own head!)* (1971), the artist annotated "my model . . . out of my own head!"—a wry, self-aware remark noting the work's conflation of subject and object. Beshty writes that the prosthesis "share[s] this proximity to the body, as bodies that were not one, a synthetic appendage, incomplete without her, something that at once fit her without being her."[15] The desire among women artists to incorporate one's own body, however fractured, is inextricable from the desire to "be seen" as an author and producer. As Schneemann wrote:

> Using my body as an extension of my painting-constructions was to challenge and threaten the psychic territorial power lines by which women were admitted to the Art Stud Club, so long as they behaved enough like the men, did work clearly in the traditions and pathways hacked out by the men.[16]

* * *

Occupying a studio is a privilege—one that is commonly more accessible to men than women. This disparity was the core concern for Judy Chicago and Miriam Schapiro as they shaped the Feminist Art Program at CalArts in 1971. Their approach stemmed from Chicago's experience visiting the studios of a large number of women artists the previous summer. She found that many of the women lacked "classic" studio spaces—such as commercial lofts or warehouses—and instead worked in kitchens or backrooms. These domestic locations negatively influenced how their work was perceived:

Lloyd Hamrol, Vicki Hodgetts and Robin
Weltsch, *Womanhouse*.
Gelatin silver print, 9 $^{15}\!/_{16}$ × 7 $^{15}\!/_{16}$ in.

Miriam Schapiro, *Dollhouse*, 1972.
Mixed media, 84 × 40 × 9 in.
Smithsonian American Art Museum,
museum purchase through the Gene Davis
Memorial Fund

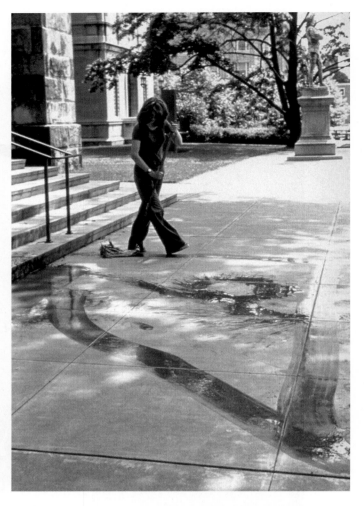

Mierle Laderman Ukeles, *Hartford Wash: Washing,
Tracks, Maintenance (Outside)*, 1973. Part of Maintenance
Art performance series, 1973–74. Performance
at Wadsworth Atheneum, Hartford, Connecticut

One thing we discovered on our visits was that we all had certain notions about what a studio was, based on our involvement with the male art community and our adaption to it. . . . I found it difficult, at first, to "see" the work, because it was not in the kind of space that I had learned designated importance and seriousness. . . . The bedroom studio or the back-room studio both marked the women artists with the stamp of dilettantism, even if their work was good, for if an artist's work is not surrounded by the kind of studio that men view as the mark of professionalism, it is not taken seriously.[17]

To explore these issues further, Chicago and Schapiro, together with twenty-one female students of the Feminist Art Program, began renovating a derelict old house on Hollywood's Mariposa Avenue.[18] *Womanhouse*, as the space would be called, would, as Chicago put it, establish "an alternative structure that would allow women to take control of the entire artmaking process."[19] It sought to provide exhibition and performance spaces for women artists, and to equip them with practical skills;

the bedrooms, bathrooms, and kitchen would act as exhibition areas.[20] The space embraced the gendered inflections of the home; students were encouraged to regard their daily domestic life and tasks as legitimate subject matter for art. Chicago recalls, "We wondered if it would be possible to deal with the problems women have making art *in* the context of work, rather than separate from it."[21] As Schapiro wrote in her diary: "No longer confined to enacting practical family needs 'House' will become the repository of female fantasy and womanly dreams."[22]

Unfortunately, most works made for display at *Womanhouse* were not preserved. *Dollhouse* (1972), by Schapiro and Sherry Brody, is one of the few that exist today, and it encapsulates many of the themes embedded in the larger project.[23] The work mimics a classic children's dollhouse, but featured among its rooms is an artist studio that evokes the cliché Bohemian loft. The studio's window looks on to a photo of Moscow's Red Square, pointing to Schapiro's ongoing fascination with the women of the Russian avant-garde.[24] On top of the easel sits a tiny reproduction of Schapiro's minimalist *Sixteen Windows* (1967), one of her early abstract paintings. In an inversion of the male gaze, we do not see a female model in the studio, but a small white man on a platform, naked, clad in nothing but black boots. *Dollhouse*, in this way, suggests the power that a woman artist might gain by occupying her own studio.

In New York, meanwhile, Mierle Laderman Ukeles also began to reimagine the role of women's work in artistic production. Since 1969, Ukeles had been creating her "Maintenance Art" series, conceptual performance works whose content was the artist's own domestic labor and everyday life: mopping the floor, changing diapers, brushing teeth, and doing laundry. For the performance *Washing/Tracks/Maintenance: Outside* (1973), she famously scrubbed the steps of the Wadsworth Atheneum Museum of Art in Hartford, Connecticut, with her bare hands, turning the public space into her site of production—conflating art making, exhibition, domestic labor, and its display in one act.[25] In a letter to art critic Lucy R. Lippard, Ukeles wrote, "What I am talking about is a new revolution in the labor movement . . . questioning the meaning of 'work' altogether."[26] This mode of art making has impacted the spaces in which she made her art. Early on, Ukeles made nearly all of her work on site—at her home or directly in the gallery space. Since 1977, however, she expanded her idea of maintenance into the urban structure, taking a position as artist in residence at the New York City Department of Sanitation (DSNY). To date she keeps an office in the administrative building of the DSNY, now located in the Financial District of Lower Manhattan, effectively abandoning the studio entirely.

* * *

While Ukeles expanded the studio from the home to the offices of the city's infrastructural services, Swiss artist Heidi Bucher focused on historically charged spaces and their architectural features.[27] In the mid-1970s, shortly after her return to Zurich from Los Angeles, Bucher began dipping items of clothing, such as aprons, into rubber, transforming relics of female domestic labor into fully formed sculptural objects. Soon, however, she started exploring a radically new technique: embalming entire rooms and facades with liquid latex and caoutchouc, pigments, and thin cotton fabric, and used the weight of her body to strip the dried, leathery "skin" from the walls. These *Raumhäutungen*, or "room skinnings"—first undertaken at her studio, a former butcher shop that she referred to as the "Borg," and later at her grandparents' home—formed a thin, dermis-like shell of the original architectural space. The works, conjuring themes of memory and extrication, documentation and transformation, radically fused space and the bodies therein: "Through the skinning of the walls, the corporeality of the experienced surrounding space (*Umraum*) is perceived intensely," writes philosopher and art critic Armin Wildermuth. "The inner aspect of the surrounding space, the being in the surrounding space, is intensified in a way that makes the latter become part of the human body."[28]

Emphasizing the performative aspect of these skinnings, Bucher commissioned

photographers and videographers to record the laborious and intensely physical process. Importantly, the resulting documents came to function in the artist's oeuvre as independent works—a fact that places "process" on the same plane as the finished object. Additionally, this fusion of sculpture and performance through the medium of photography (and video) further underscored her body's close relationship to the architectonic reality.[29]

For Bucher, each space is charged with the past, embedded with histories as personal as they are ideological. In fact, the skinnings contain an element of what Roland Barthes, speaking of photography, described as a "having-been-there": they are marked by "spatial immediacy and temporal anteriority."[30] Accordingly, the skinnings made at the Borg, such as *Türe zum Borg* (Door

to the Borg, 1976), record not only the history of her studio space, but also its previous function as the butcher shop's refrigeration room. Likewise, Bucher's skinnings at the *Ahnenhaus*, her family's ancestral home, was her way of addressing the social histories and overpowering memories contained in the physical traces of multiple generations of inhabitants.[31] Bucher's interventions do not simply record the past, but seek to assume a purifying function: "The skinning of rooms was an act of cleansing them of traces of the past."[32]

What unites all these artists is that they conceived the studio or site of production as a frame rather than a place. Within this frame, women artists could reimagine—and subvert—historically male modes of production; the female body, in turn, was no longer an object in a frame, but the

Carolee Schneemann, *Four Fur Cutting Boards*, 1963. Wooden boards, oil paint, light bulbs, string of colored light, plastic flowers, photographs, fabric, hubcap, tights, and motorized umbrellas, 90 ½ × 131 × 52 in. The Museum of Modern Art, New York

Mierle Laderman Ukeles's artist in residency
office at the New York City Department of Sanitation, 2016

producer of its own frame—one defined by a multitude of fragmented subjectivities and a multifaceted authorship. This frame could take a variety of forms: for Chicago and Schapiro, it was a physical structure outside the (male-dominated) CalArts campus; for Bucher, it was a space rich with personal and familial memories. Ukeles radically expanded the studio, inventing new modes of artistic labor and production, while Schneemann and Woodman conflated the subject and object of production in an image of the female body. Rather than abandoning the studio, these women set out to fundamentally recreate it; in so doing, they reinscribed the studio's potential as a space of production, a shift that had its own deeply consequential effects, laying the groundwork for the growth of plurality in the field of art production that would emerge in the decades to come. The ensuing rise of the "post-studio condition" did not bring full parity to male and female art production, however. Though it redistributed some of the privileges formerly reserved for men and opened production to female authors and other marginalized identities, equality is still far from reach. Ultimately, the system of representation remains as critic Craig Owens has described it: a "system of power that authorizes certain representations while blocking, prohibiting, or invalidating others,"[33] and deserves continued attention and continual revision.

NOTES

1. Luce Irigaray, quoted in Craig Owens, "The Discourse of Others: Feminists and Postmodernism," in *Beyond Recognition: Representation, Power, Culture*, ed. Scott Bryson, et al. (Berkeley: University of California Press, 1992), 179.

2. Caroline A. Jones, "Die Ökonomie des Executive Artist. Ein E-mail-Austausch mit Caroline A. Jones," *Texte zur Kunst* 49 (2003): 70 (translation by the author).

3. Linda Nochlin, "Why Have There Been No Great Women Artists?," in *The Feminism and Visual Culture Reader*, ed. Amelia Jones (New York: Routledge, 2003), 233.

4. Mary Bergstein, "The Artist in His Studio: Photography, Art, and the Masculine Mystique," *Oxford Art Journal* 18, no. 2 (1995): 45. Here,

Bergstein provides a detailed analysis of how photos by Brassaï and Lieberman of male artists working in their studios reinforced the assumption of unbounded male creativity and corresponding female passivity.

5. Caroline A. Jones, *Machine in the Studio: Constructing the Postwar American Artist* (Chicago: University of Chicago Press, 1996), 57.

6. Also visible in *Eye Body* are Schneemann's painting-constructions *Fur Wheel* (1962), *Ice Box* (1963), *December Remembered* (1960), and *Colorado House* (1962) among other works, as well as works-in-progress, collage materials, motorized umbrellas, fur, paint, shattered glass, transparent plastic, live garter snakes, a cow skull, a plaster-covered dress form, assorted detritus, and tools.

7. Carolee Schneemann Papers 1959–1994 (No. 950001), Eye Body, Dec 1963, Box 1.7, Folder Eye Body 12/63, Series I. Projects, 1960–1994, Special Collections, The Getty Research Institute.

8. Carolee Schneemann, quoted in Branden W. Joseph, "Unclear Tendencies: Carolee Schneemann's Aesthetics of Ambiguity," in *Carolee Schneemann: Kinetic Painting*, ed. Sabine Breitwieser (Munich: Prestel, 2015), 34.

9. Kaja Silverman, *The Threshold of the Visible World* (New York: Routledge, 1996), 203.

10. Carolee Schneemann, on *Eye Body: 36 Transformative Actions*, http://www.caroleeschneemann.com/eyebody.html. Schneemann's work can be read as a response to Pollock, as she herself started from a painterly practice and continues to refer to herself as a painter: "I say I must insist I am a painter / as if that gives you understanding of what that means / to every any other process I evolve or use / that dancing is drawing with the body." Carolee Schneemann Papers 1959–1994 (No. 950001), Box 1.7, Folder June 1973, Series I. Projects, 1960–1994, Special Collections, The Getty Research Institute.

11. Amelia Jones, *Body Art: Performing the Subject* (Minneapolis: University of Minnesota Press, 1998), 52.

12. Jay DeFeo, quoted in Corey Keller, "My Favorite Things: The Photographs of Jay DeFeo," in *Jay DeFeo: A Retrospective*, ed. Dana Miller (New York: Whitney Museum of American Art, 2012), 73.

13. Walead Beshty, "The Ritual of Everyday Life: On the Migrating Objects of Jay DeFeo," in *Jay DeFeo* (New York: Mitchell-Innes & Nash, 2014), 14.

14. Jay DeFeo, quoted in ibid., 18.

15. Beshty, "The Ritual of Everyday Life," 14.

16. Carolee Schneemann, "Eye Body: 36 Transformative Actions," in *The Studio*, ed. Jens Hoffmann (Cambridge, MA: MIT Press, 1963), 77.

17. Judy Chicago, *Through the Flower: My Struggle as a Woman Artist* (Lincoln, NE: Author's Choice Press, 2006), 98.

18. Art historian Natalie Musteata has discussed the sociohistorical context of *Womanhouse*, describing it as "provocative, chimerical, personal, and political . . . an outgrowth of its volatile moment. It came in the wake of the civil rights movement, the peak of the Vietnam War, and a series of seminal events for second-wave feminism and women in the arts, including the Miss America protest in 1968; the formation of the Redstockings and Women Artists in Revolution (WAR) (an offshoot of the Art Workers' Coalition) in 1969; the first march on Washington for women's equality (otherwise known as the Women's Strike for Equality) and the protests against the Whitney Museum by the Ad Hoc Women Artists' Committee for greater representation of women artists in 1970; as well as the establishment of the National Women's Political Caucus and Women in the Arts (WIA) 1971." Natalie Musteata, "Judy Chicago, Miriam Schapiro, and the CalArts Feminist Art Program, Womanhouse," *Mousse Magazine* 51 (2015): 15.

19. Chicago, *Through the Flower*, 187.

20. In 1973, together with Sheila de Bretteville and Arlene Raven, Chicago founded the Feminist Studio Workshop, an independent alternative organization in Los Angeles open to women only. Soon the workshop joined a larger organization called the Woman's Building, housed in a disused building in Los Angeles. The Woman's Building also hosted a feminist bookshop and performance groups, and published a network of women's journals, fostering an all-female community while radically expanding the "studio" to encompass all activities related to artistic production and dissemination.

21. Chicago, *Through the Flower*, 104.

22. Miriam Schapiro, quoted in Thalia Gouma-Peterson, *Miriam Schapiro: Shaping the Fragments of Art and Life* (New York: Harry N. Abrahams, 1999), 27.

23. Chicago re-created *Menstruation Bathroom* (1972) in 1993 for an exhibition at the Museum of Contemporary Art, Los Angeles, and Faith Fielding remade her *Womb Room* (1972) in 1995 for a show at the Bronx Museum of the Arts, New York.

24. See the artist's work *Mother Russia* (1994).

25. This piece was part of "c. 7,500," Lucy R. Lippard's traveling 1973 exhibition of Conceptual art by women. As curator Cornelia H. Butler emphasizes, "in the history of Conceptual art globally, the project represents the first attempt at presenting a narrative of a feminist Conceptual language." Cornelia H. Butler, "Women-Concept-Art: Lucy

R. Lippard's Numbers Shows," in *From Conceptualism to Feminism: Lucy Lippard's Number Shows, 1969–74* (London: Afterall Books, 2012), 23.

26. Mierle Laderman Ukeles, quoted in Laura Raicovich, "The Work We Do," in *Mierle Laderman Ukeles: Maintenance Art*, ed. Patricia C. Phillips (New York: Prestel, 2016), 7.

27. Bucher returned to Zurich from Los Angeles, where she had been living since the 1960s, in 1975. Swiss curator Bice Curiger remembers: "Heidi told us that in California they do these amazing feminist exhibitions in houses, they fill them with stuff, and we should do the same." Subsequently, Bucher opened her studio to a group of women, allowing them to hold regular feminist meetings there. Bice Curiger, "Women Seeing Women," in *Heidi Bucher*, ed. Karen Marta and Simon Castets (New York: Swiss Institute), 92.

28. Armin Wildermuth, "Hauträume," in *Heidi Bucher* (Zurich: Buchs ZH, Waser Druck AG, 1983), 7 (translation by the author).

29. Another European artist experimenting with the body in space, performativity, and video is German artist Rebecca Horn. For *Scratching Both Walls at Once* (1974–75), part of the series "Berlin Exercises in Nine Pieces," Horn wore long "finger prosthesis," scratching along the opposite walls of a room in her Berlin apartment as she walked back and forth, transforming the space into studio and set.

30. Roland Barthes, "Rhetoric of the Image," in *Image, Music, Text*, trans. Stephen Heath (New York: Hill & Wang, 1977), 44–45.

31. Another site for her skinnings was an institution for the mentally ill—the Bellevue Sanatorium in Kreuzlingen, Switzerland, where Sigmund Freud's patient Anna O. had been treated.

32. Heike Munder, "The Act of Shedding the Skin," in *Heidi Bucher*, ed. Marta and Castets, 57.

33. Owens, "The Discourse of Others: Feminists and Postmodernism," 168.

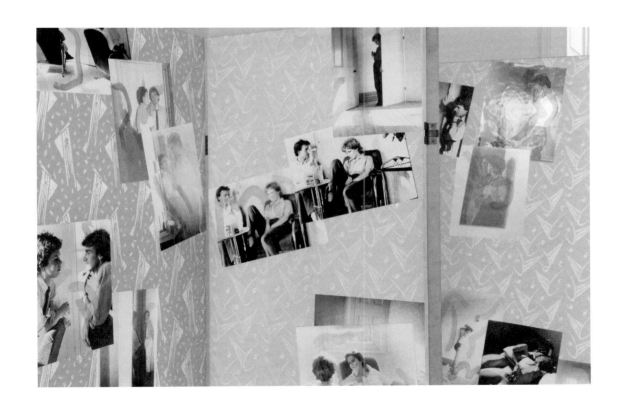

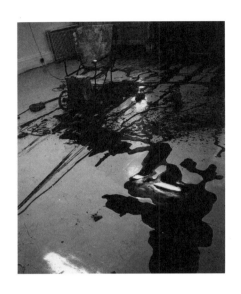

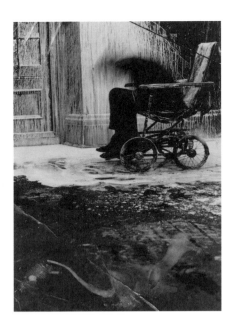

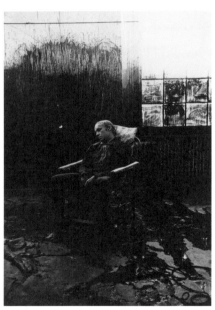

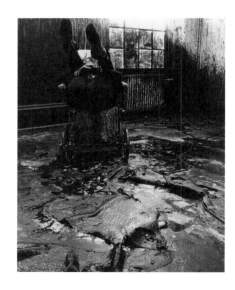

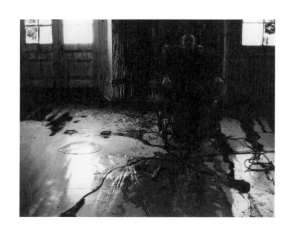

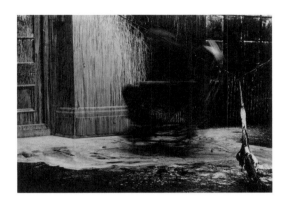

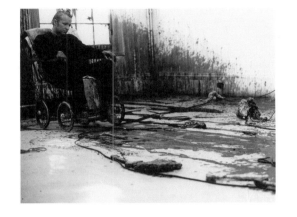

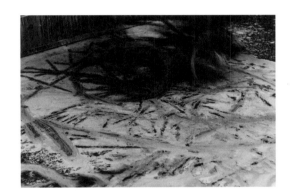

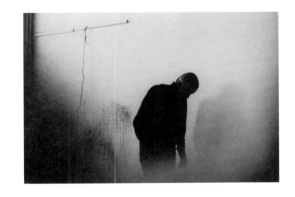

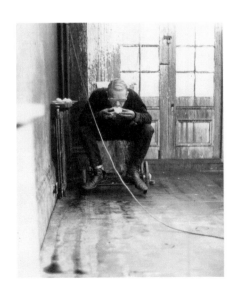

ZL656395C

For seventeen days and nights, I lived and worked at 50 Princes Gate, in London, without once leaving the building. For this period of time, I had my name changed by a notary public to my National Insurance number: I was to be known as ZL656395C, on the assumption that the figure I would represent a reduced sense of the self.

I saw the title *ZL656395C* as a conceptual enabling device somewhat akin to the "waiting room" I created in the space—an intermediary zone, a means of transference from one condition to another. Acting assertively against the slow, shapeless, destabilizing performance, the title helped to shape the conditions of life and work in the space.

The property had previously been occupied by Mormon missionaries. After it was sold it, too, became a conduit leading from one condition to another. While awaiting redevelopment, it was offered to an independent experimental contemporary art space, Gallery House, and became a short-lived publicly funded art center for staging exhibitions of work that did not sit easily in the art market at that time.

The rooms toward the back had originally been adapted for office use. The door in the corridor opened on to a small room with a door in the back wall leading to an identically sized room. On the back wall of this room, a letterbox-sized hole at standing height revealed a view of the larger room which the figure occupied. This was where I chose to be for the seventeen days and nights during which the building was continually open to the public.

The figure tried to do as little as he could. Nothing to be done (Godot).

Stagnation

Inaction

Stasis
Dormancy

He was stained gray, sitting in an old wheelchair among scattered detritus in the room that had been disturbed—its pattern of normalcy and everydayness broken. On the floor stagnant water and some white powder could be seen. There was black paint raked across the floor, walls, and windows. The light in the room was low, and there was a strong sense of unsettledness.

He could hear the front door open, then footsteps coming closer, a door opening, then another and another, followed by part of a face appearing in the letterbox hole, often followed in turn by a camera placed in front of the face. In the dim light, he often felt compelled to focus on that hole.

A few days before the completion of the slow work, he began to see the camera as a gun, a cameragun, an obvious metaphor. The idea of doing as little as possible did not account for the workings of the mind, which was resistant to the attempt to slow everything down. He began to hallucinate, dreaded hearing the footsteps coming closer followed by doors being opened one by one and part of a face or cameragun abruptly pointing at him from the hole.

A bedraggled entity, a soiled being dragged in the wet, in the dirt.

On the wall I wrote: NOT ACHIEVED. It is an expression of doubt and an acknowledgement of not having great expectations.

The work implies that the world of work, like much else, can be fraught with difficulty upon difficulty, as lives are spent in conditions unfavorable to life. A state of alienation is understood as an inevitable consequence of social inequality. The embeddedness of estrangement creates a deep rupture at odds with ideas about "civilized society."

ZL656395C derived part of its content from the above. Throughout, however, the residual flow of narration was interrupted by the emergence of punctuated moments of expression.

No failure, no success.

The thing being what it is.

Broken one hour before completion. No end,
no completion.
Formless.

In the afterlife of *ZL656395C*, its central concept of alienated work has become common knowledge; acknowledging the impact of commodity fetishism is no longer a seditious call. The notion of reification, in which social relations, including work, are conceived as relations between things, is indispensable to understanding how we live now.

Following on from *ZL656395C* and performances of the early '70s, I worked on what could be described as expanded performance: I decided that wherever I lived was to become the subject of a project.

These projects include the *Peterlee Project/History Within Living Memory* (1976–77), where I lived and worked in a mining community in northeast England; *Georgiana Collection* (1981–91), named after the street where I lived in northwest London. This work engages with homelessness, both because I lived at the end of a street which housed a homeless persons' hostel and I got to know them, but also because through day-to-day activities I questioned the vanishing idea of a collective society that was being replaced by conspicuous consumption and singular individuality.

The most recent such project is the *Museum of Ordure* (2000–ongoing) which is an immaterial museum that was first located in Spitalfields, in the East End of London, where I moved after Georgiana Street, and since relocates to wherever I might be. In 2003 I wrote the experimental novel *Beyond Reason: Ordure*, which contains the fictional musings of my alter ego, R. Y. Sirb, the Curator of Ordure. The book seeks to reveal what it is like to live, think, and work in relation to performative attitudes and behaviors in the day-to-day flow of things.

These projects, as well as being centered in the neighborhoods where I lived—which were the studios in which I worked—are examinations of the commonplace and the everyday. They reflect my intuitive understanding of a spiritual homelessness; the sense that something has ended, whether utopias, known historical frames that support certain narratives, universal shared values, promises of liberation, or collective consciousnesses.

When I made *ZL656395C*, I was projecting my doubts about an affirmative world-view, particularly after the events of 1968, in which I was involved. And I was realizing (without clarity) that representations of positivism and tendencies toward optimistic narratives may have ended—and, with them, ideas about artistic avant-gardes. In any case, I was already much more engaged with the idea of "derrière-garde," which would be reflected in the formulation of the *Museum of Ordure*, whose curator R. Y. Sirb is himself a derrière-gardist.

Looking back, *ZL656395C* signals a feeling of exhaustion and a gasping for air. It anticipates the debris from the fall of the Berlin Wall.

Gilbert & George
Bad Thoughts No. 8, 1975
cat. no. 39

Gilbert & George
Bad Thoughts No. 1, 1975
cat. no. 37

149

Art & Language
*Study for Index: The Studio at 3 Wesley
Place in the Dark (IV) and Illuminated by
an Explosion Nearby (VI)*, 1982
cat. no. 3

Art & Language
*Index: The Studio at 3 Wesley Place
Painted by Mouth (I)*, 1982
cat. no. 1

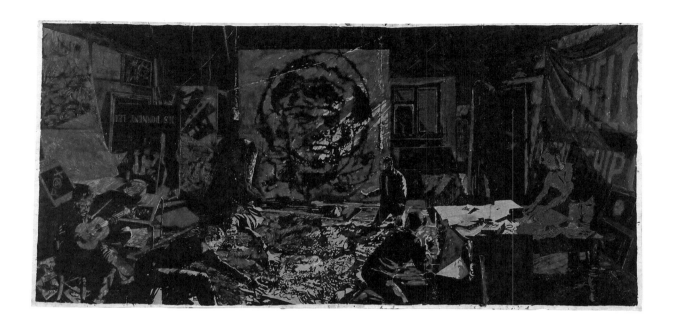

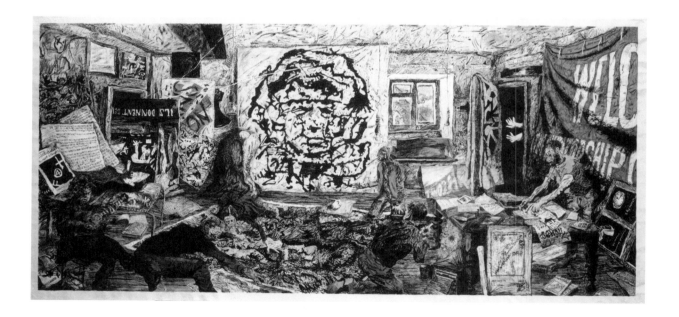

Art & Language
*Study for Index: The Studio at 3 Wesley
Place in the Dark (IV) and Illuminated by
an Explosion Nearby (VI)*, 1982
cat. no. 3

Art & Language
*Index: The Studio at 3 Wesley Place
Painted by Mouth (I)*, 1982
cat. no. 1

John Miller

HOW TO MAKE AN ARTWORK
Some Imaginary Relations to Relations of Production

On May 20, 1978, *Saturday Night Live* featured a skit with the provocative title "Bad Conceptual Art." Ironically, it was not funny, even if its premise was. Dan Aykroyd poked fun at a relatively obscure movement that, at about ten years old, still seemed new and promising, and was known for its rejection of old standards of quality. Just concluding its third season, *SNL* had cultivated an avant-gardistic vibe of its own: the closing act for that episode was a musical performance by Sun Ra and his Arkestra. When it aired, I was a graduate student at CalArts, enrolled in the school's Post Studio program. Then, as now, the name of that program seemed preemptive, an attempt to foreclose a site of production that remained very much in play. In terms of resources, it simply meant that students got small offices instead of the larger workspaces ordinarily reserved for painters and sculptors.

In *Wit and Its Relation to the Unconscious* (1905), Sigmund Freud maintains that jokes are a means of expressing thoughts that are otherwise unacceptable.[1] If that is the case, what sort of repression might "bad Conceptual art" represent? As an object of long-standing popular suspicion, art has served as the routine butt of jokes in entertainment and mass media. Many of these jokes concern the project of deskilling, a project that, despite its democratizing pretentions, the lay public hates: "A monkey could do it!" Rightly or not, the skill associated with the conventional studio-based artwork conveys legitimacy. Conversely, no skill implies no studio.

In its first phase, the term *Conceptual* offered an aspirational, utopic promise: to rescue art from its unwanted status as commodity, to liberate the artwork from market constraints. At the same time, it demoted what Marcel Duchamp called "purely retinal" work. Duchamp also famously declared that tools that require skill are no good. Yet Conceptualism's meta-art pronouncements sometimes could devolve into novelty gestures. A good joke meant good art—or at least something better than painting. It didn't matter if you were a huckster, an opportunist, or someone yearning for a better

world. Anyone could glom on to Conceptualism. Thus, as a prestige form, it acquired a whiff of disreputability. This double-edged aspect was not lost on Gilles Deleuze and Félix Guattari:

> The depths of shame were plumbed when computing, marketing, design, advertising, all the communications disciplines, seized upon the word "concept" itself: this is our business, we are the creative people, we are *conceptual*! . . . It is profoundly depressing to learn that "concept" now designates a service and computer engineering society.[2]

Seth Price too tracks the vagaries of the term:

> [The Conceptual project in art] has been almost too successful: today it seems that most of the work in the international art system positions itself as Conceptual to some degree, yielding "the Conceptual painter," the "DJ and Conceptual artist," the "Conceptual web artist." Let's put aside the question of what makes a work Conceptual, recognizing, with some resignation, that the term can only gesture toward a forty-year-old historical moment. . . . What does seem to hold true for today's normative conceptualism is that the project remains, in the words of Art & Language, "radically incomplete": it does not necessarily stand against objects or painting, or for language as art . . . it does not stand for anything certain.[3]

For this reason, perhaps, Dan Graham rejects the label. Instead, he avers, "My work has always been about comedy."[4]

What made "Bad Conceptual Art" unfunny? As Aykroyd, playing the pompous, tuxedoed Leonard Pinth-Garnell, points out, "No one can exactly explain what Conceptual art means because in many cases the artists that produce it themselves don't know what it is in the first place that they're trying to express." Yet the artwork that

was supposed to be so preposterous in this skit turned out to be somewhat intriguing; at the very least, it presented possibilities. It was the fictitious Helen Trova's *Pavlov Video Chicken I*, a performance supposedly "presented in 1969 at the Life Space Gallery in Los Angeles." Pinth-Garnell describes it: "It forces one to consider the juxtaposition of Zen poetry on video against a woman dancing like a chicken for 378 consecutive hours." The "excerpted" dance, performed by Laraine Newman, was awkward yet residually erotic in a kind of stultified way. The idea that video commands could trigger a Pavlovian response even reflects something of Conceptualism's cybernetic potential. The skit parodied not only the ostensible artwork, but also the commentator, Pinth-Garnell.[5] The choice of a female artist to represent Conceptualism is curious, especially considering the near absolute exclusion of women from the early Conceptualist canon. The durational logic of Trova's dance, however facetious, resonates with performances from that period by Chris Burden or Ulay and Marina Abramović or, more recently, Georgia Sagri's *Antigone Model* (July 3–5, 2015), in which, based on Bertolt Brecht's *Antigonemodell 1948*, the artist performed marathon dances for three successive days. With their irreverence toward the pretentions of contemporary art, the *SNL* scriptwriters seemed to have anticipated the incoherence Price would question twenty-four years later. Perhaps the humor of "Bad Conceptual Art" is also "radically incomplete."

As an idealist movement, Conceptualism promised to transcend the material conditions of everyday life. If artists refused to produce objects, this would leave nothing to sell. The market would collapse on its own irrelevance. Lucy R. Lippard and John Chandler's utopic term "dematerialization" holds out this hope because few yet understood that information—the stuff of Conceptual art—can also become a commodity. Lippard and Chandler's essay, "The Dematerialization of Art," centers on production as the production of ideas:

> Judgment of ideas is less interesting than following the ideas through. In the process, one might discover that something is

either a good idea, that is, fertile and open enough to suggest infinite possibilities, or a mediocre idea, that is, exhaustible, or a bad idea, that is, already exhausted or with so little substance that it can be taken no further.[6]

Here, a good idea is one that leads to further ideas. The failure to generate more ideas is bad. That is the critics' quantification of quality. This contrasts with the normative expectation that "to follow an idea through" would be to make something. Lippard and Chandler attribute the turn toward ideas as ends in themselves to a shift in means of artistic production:

> As more and more work is designed in the studio but executed elsewhere by professional craftsmen, as the object becomes merely the end product, a number of artists are losing interest in the physical evolution of the work of art. The studio is again becoming a study.[7]

This idea may seem far-fetched, but they were not much off the mark—at least as far as Douglas Huebler is concerned. In 1974 I saw him give a visiting artist lecture at the Rhode Island School of Design (RISD), where he explained how, working as a relatively provincial artist in Massachusetts, he had assumed that Minimal sculpture was solid. The revelation that it was hollow initially disappointed him, yet he concluded that if a work could be constructed in such a way, then the concept was what was really at stake.

Benjamin H. D. Buchloh's landmark essay "Conceptual Art 1962–1969: From the Aesthetic of Administration to the Critique of Institutions" attributes changes in artistic facture of the 1960s to social forces: namely, the collapse of autonomous

Donald Judd's loft, 101 Spring Street, 5th floor, New York.
Claes Oldenburg, *Soft Ceiling Lights at La Coupole*, 1964–72.
Canvas stuffed with kapok, pencil, ink, and rubber
stamp on wood support. Three elements, 7 ½ × 3 ft. each

art into the culture industry and the rise of an administerial middle class. He maintains that Conceptual art reflects the values of this ascendant class in an "aesthetic of administration."[8] Conceptual art, however, offered more than just an *aesthetic* of administration; it offered a *means* of administration by rehearsing new forms of cybernetic control central to a burgeoning information economy. Thus, the tension between Conceptualist practices and studio-based artwork reflects not only an aesthetic debate, but also, to paraphrase Louis Althusser, a debate concerning the imaginary relationship of individuals to their real conditions of existence.[9]

The rise of Conceptual art roughly coincided with the transformation of New York City's SoHo district from an area zoned for light manufacturing into an artists' neighborhood. With this, the paradigmatic image of the studio shifted from a garret or a repurposed apartment to a postindustrial space. The lifestyle of loft live/work spaces became an index of legitimation, i.e., a signifier of seriousness and commitment, regardless of the kind of work produced therein. Many early loft-dwellers, in fact, were Conceptualists.

Donald Judd lived and worked in SoHo; his loft at 101 Spring Street is now home to the Judd Foundation. He is also one of the first artists whose work was to be characterized by professional fabrication. He contracted the Bernstein Brothers workshop to make many of his "specific objects," and this outsourcing at first scandalized viewers. While these works seemingly epitomize an industrial ethos, they entail a split between conception and execution that is fundamentally postindustrial and postmodern. Here, the role of information—as a design plan, as a means of controlling production—is key. In response to this shift, Jan van der Marck, the director of the Museum of Contemporary Art in Chicago at the time, put together the 1969 exhibition "Art by Telephone." The show featured works produced by instructions that artists simply phoned in. This degree of detachment not only highlighted the division in artistic facture broached by Judd, but also heralded the prospect of information-driven production. From the 1960s on, information increasingly would function as a means of technical control as well as administration. The turn toward information, in this way, leads to automation. In theory, if the generative information is sufficient, execution ought to be automatic. An artist completes her or his plans and turns them over to a fabricator. From the artist's subjective vantage point, it matters little whether laborers or machines complete the work.[10] If the execution is competent, it happens automatically, without further intervention. This, at least, is the ideal. The artist's studio, in this mode, becomes part of a network. In "Postscript on the Societies of Control," Deleuze notes that, "Even art has left the spaces of enclosure in order to enter into the open circuits of the bank."[11] In contrast, Lippard had hailed automation, however naively, as a form of liberation:

> When automatism frees millions of hours for leisure, art should gain rather than diminish in importance, for while art is not just play, it is the counterpoint to work. The time may come when art is everyone's daily occupation, though there is no reason to think this activity will be called art.[12]

That was the 1960s expectation. Now, unemployment has usurped leisure. Now, where robotic factories have displaced whole sectors of industrial workers and, in the process, hastened a rising income inequality that in turn triggers populist political reaction, where drone warfare increasingly becomes the norm in international conflicts and killing becomes robotic, liberation looks ever more elusive. Yet Lippard is right about how automation could broaden the popular scope of art activity and, in so doing, render cultural hierarchies less relevant. Consider how iPhone photography and video, information technologies par excellence, dominate the production of images today: a continuous stream that pulses throughout culture, largely indifferent to any overlaps with what's otherwise designated as art.

Huebler's best-known proclamation, which became a dematerialist rallying cry, can be understood as championing the manipulation of

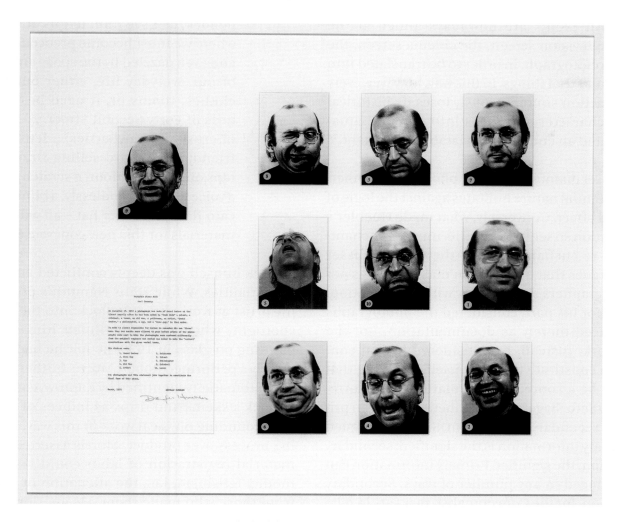

Douglas Huebler, *Variable Piece #101*, 1973.
Gelatin silver prints and typewritten
sheet mounted on board, 31 ½ × 37 ⅕ in.
Private collection

information in lieu of the production of things. He even mocks the boredom of the old order:

> The world is full of objects, more or less interesting. I do not wish to add any more. I prefer, simply, to state the existence of things in terms of time and/or place.[13]

This statement established Huebler as Conceptualism's most radical proponent. For this reason, in 1974 students awaited his visiting artist lecture at RISD with expectancy and excitement. That lecture made a deep impression me. The first thing Huebler told us was that he had stopped working, that he was depressed, and that, now, he mostly played tennis. The reason: one of his artworks had been sold. Years later, after he had resumed making drawings, he complained that his early manifesto had come back to haunt him. Whenever he showed his new work someone would inevitably raise the accusation, "You said you wouldn't make anything."

To show the state of things without adding objects to the world, Huebler turned to the camera. He used it to map interrelationships, which underscored artistic operations as an unfolding "open circuit" or network. While artists of the 1960s and 70s embraced the camera as a supposedly value-free recording device, and thus as an instrument of demystification, Vilém Flusser notes:

All events are nowadays aimed at the television screen, the cinema screen, the photograph, in order to be translated into a state of things. In this way, however, every action simultaneously loses its historical character and turns into a magic ritual and an endlessly repeatable movement.[14]

Here Flusser maintains that the photograph's inherently existential nature militates against the logic of cause and effect. Conversely, what made Huebler's proclamation so seductive was its implied enchantment, or re-enchantment, of the world. Flusser further argues that, rather than making things per se, photographers simply "play with" information. Huebler, for his part, considered the photographs he produced merely as documentation, not the actual work. Instead, he considered logical constructs to constitute the work itself, stressing that art could be a source of information. This corresponds to Seth Siegelaub's distinction between primary and secondary information. Siegelaub argued that primary information is the signified; secondary information, the signifier. Primary information can be reproduced in any number of ways. Secondary information, for the Conceptualist, may vary in relation to that.

Although formalists—notably Clement Greenberg—cast Jackson Pollock as a quintessential "painter's painter" and an exemplar of flatness, Pollock's way of working ultimately called the studio into question. On one hand, the studio looms large. The 1998 Pollock retrospective at the Museum of Modern Art in New York even featured a Disneyesque recreation of his East Hampton studio barn. On the other hand, Pollock's technique points beyond it. Indeed, the indexicality of his gestural painting could count as a kind of protomapping. Allan Kaprow interpreted Pollock's canvases as a staging ground, noting, "the direct application of an automatic approach to the act makes it clear that . . . this [is] not the old craft of painting."[15] Kaprow went on to describe Pollock's technique as a kind of performance that implicates an expanded context (a condition that Michael Fried would condemn as "theater"). This prospect led Kaprow to conclude:

Pollock, as I see him, left us at the point where we must become preoccupied with and even dazzled by the space and objects of our everyday life, either our bodies, clothes, rooms or, if need be, the vastness of Forty-Second Street. . . . An odor of crushed strawberries, a letter from a friend, a billboard selling Drano, three taps on the front door, a scratch, a sigh or a voice lecturing endlessly, a blinding staccato flash, a bowler hat—all will become materials for this new concrete art.[16]

Pollock himself was deeply conflicted about such potentialities. While Hans Namuth's portraits of the artist at work thrust Pollock into the national spotlight, when Namuth filmed him outdoors painting on glass in 1950, he felt he had become merely a performer. Robert Morris further analyzed the automaticity identified by Kaprow, considering Pollock's skeins and drips as indices of labor. By foregrounding physical work in this way, by stressing process over product, Morris asserted that the material registration of labor could resist commodity fetishism, i.e., the alienation of products from those who made them. He goes on to note, "Any process implies a system, but not all systems imply process. What is systematic about art that reduces the arbitrary comes out as information."[17] Arbitrariness, for Morris, means composition, namely the subjective arrangement of parts within the whole of the canvas. As an automatic process, Pollock's technique treated paint more as a material subject to gravity and bodily gesture than as a medium to be mastered by the trained nuances of the artist's hand. What Morris failed to account for, however, is that this logic of automation, as he said, pushes toward a form of information. That, in turn, may sideline manual labor. Perhaps what so threatened Pollock was the prospect that Namuth's camera could convert his otherwise deeply embodied art into an easily transmissible form.

The monochrome, derived from the Russian avant-garde, functions as a counterpart to Pollock's gestural painting. Buchloh cites monochrome painting as a distinct stage in the trajectory

from easel painting to the Conceptual artwork as a self-validating proposition, i.e., "This is art if I say it is." The statement alone, as in some of Joseph Kosuth's tautologies, is held to be sufficient. In Buchloh's schema, Minimal sculpture is the intermediary: "The visual forms that correspond most closely to the linguistic form of the tautology are the square and its stereometric rotation, the cube."[18] Here, recall that in 1965 Richard Wollheim had introduced the term "Minimalism" to designate both the readymade and monochrome painting.[19] A readymade is an artwork if someone says it is. As a complete mental paradigm, the monochrome seems to exist before it is made, and thus promises to automate painting. The monochrome also, like Minimal sculpture, displaces the presumption of aesthetic interiority with a more public form of address. As such, it renegotiates the boundary between the artwork's inside and outside, putting pressure on the frame as the guarantor of autonomy. Even so, it invokes a paradoxical blindness. It presents itself as an unthinkable—or at best dubious—proposition, yet viewers easily can imagine a monochrome in advance; it is as if they have seen it already. Here, reductivism and redundancy culminate in an ultimatum: "This is the last painting." By prophesying the end of painting as we know it, the monochrome approximates a Conceptual art agenda. These are, at least, some expectations surrounding it.

What qualifies as the first monochrome? Accounts differ. One might argue that every canvas begins as a monochrome. In 1882, the poet Paul Bilhaud painted an all-black work titled *Combat de nègres dans un tunnel*, apparently as a joke or provocation that anticipated the spirit of the coming Dada movement.[20] However, Kazimir Malevich's *Suprematist Composition: White on White* (1918) counts as the most influential

Kazimir Malevich, *Black Square*, 1913.
Oil on linen, 31 $\frac{19}{64}$ × 31 $\frac{19}{64}$ in.
Collection of the State Tretyakov Gallery, Moscow

modernist monochrome. The Museum of Modern Art's entry on this work notes that "Malevich imagined Suprematism as a universal language that would free viewers from the material world." It goes on to state, "the picture is not impersonal: we see the artist's hand in the texture of the paint, and in the subtle variations of the whites."[21] Three years later Alexander Rodchenko produced three paintings, each in a different primary color, and titled the series "The Death of Painting" (1921). Sherrie Levine inverted this endgame logic with a monochrome of her own, *After Kazimir Malevich* (1984).[22] In so doing, she made the monochrome's readymade logic explicit while stressing its contextual and differential nature, i.e., that an artwork reproduced after an interval of sixty-seven years necessarily acquires a new meaning. Although Levine ostensibly endeavored to repeat a historical work, instead of using oil and canvas like Malevich, she used casein and mahogany. If "White on White" exists primarily as a mental paradigm, are these materials secondary information? Maria Eichhorn's *Toile/Pinceau/Peinture, Leinwand/Pinsel/Farbe, Tela/Pennello/Colore* (1992–2015) further qualified the heroics of zero-degree painting as a routine and open-ended operation. First realized at the Musée d'Art Moderne de la Ville de Paris, Eichhorn supplied museum workers with a table, a chair, seventy-two canvases, seventy-two brushes, and seventy-two tubes of oil paint. The exhibition ran for seventy-two days and a different worker would produce a new canvas in a new color each day.[23] The work is cumulative; each iteration extends it. This gesture acknowledges that the monochrome has become a familiar part of contemporary art's working vocabulary. Gone is the apocalyptic rhetoric. Instead, Eichhorn's work transforms the museum—at least temporarily—into a studio where those who typically work to present art now produce it. For the art installers or technicians, perhaps painting a monochrome differs little from repainting the wall on which it would hang.[24] In any case, if Buchloh's "stereometric" square suggests reciprocity between monochromes and their architectural enclosures, it also suggests reciprocity between the studio as a site of production and the exhibition space as a site of display. *Toile/Pinceau/Peinture . . .* joins these. Brian O'Doherty has clarified this relationship further: "The studio (the agent of creation) is inside the white cube (the agent of transformation); the gallery 'quotes' the studio it contains."[25]

On March 23, 1968, the collective Art & Language wrote a letter titled "Concerning the Article 'The Dematerialization of Art'," a sharp

Maria Eichhorn, *TELA / PENNELLO / COLORE*, 2014.
56 Esposizione Internazionale d'Arte: *All the World's Futures*

response to Lippard and Chandler's, which states: "All the examples of art-works (ideas) you refer to in your article are, with few exceptions, art-objects."[26] Rejecting the notion of "empty space," they stressed that matter includes gases as well as solids and liquids. In this sense, for example, even a work in which Robert Barry would release a quantity of inert gas into the atmosphere comprises a material substance. Formed one year earlier by Terry Atkinson, David Bainbridge, Michael Baldwin, and Harold Hurrell—all art teachers at Coventry University's School of Art and Design—Art & Language initiated a dialogic critique of modernist and Minimal art that became one of the earliest Conceptualist practices. The group proposed criticism as a form of art and, accordingly, the difference between seeing and reading emerged as one of its key concerns. One cannot do both at the same time; a painting that includes text, for example, must either be viewed or read. This approximates the either/or status of Ludwig Wittgenstein's duck-rabbit, an ambiguous drawing that can been as either a duck or a rabbit, but not both at once. Here, what concerned Wittgenstein was the division between the object of perception and the process of cognition, namely that the self-same object could trigger different modes of recognition. The art historian Charles Harrison, who also became a member of Art & Language, cites Pablo Picasso's collage *Bottle and Wine Glass on Table* (1912) in this regard. This work includes a piece of newspaper and Harrison asks: "[should we] literally read the text of the newsprint, with its story of a former soldier who, twenty-six years after being shot in the head, spat out the bullet which had wounded him?"[27] Ultimately, Art & Language turned to painting in part as a rejection of what they regarded as Conceptual art's administrative imperatives. In the 1980s they embarked on a series of works collectively titled "Index: The Studio at 3 Wesley Place." Harrison notes that, as indices, these works record not only the workspace but also individuals, activities, and products associated with it. Art & Language raised the question of what it means to paint something and what it means to represent the same thing with paint. Can this process embed one artwork inside another and,

in turn, register a discourse? The series includes works allegedly painted "by mouth." In other words, the artists claim to have held the brushes in their mouths while painting these works. Not surprisingly, the resulting image appears wobbly and distorted. This absurdist approach contrasts with Pollock's free-form drips in that the mouth is ordinarily the site of articulation, not the opposite.[28] Leading up to this act of ineffability, Art & Language had produced a series of portraits of Lenin "in the style of Jackson Pollock."[29] Among other things, these suggested a fusion of otherwise antithetical Cold War aesthetics. In their 1999 essay "Making Meaningless," Art & Language noted that they had not produced a single ambitious painting since 1992, facetiously equating this impasse to an endgame scenario:

> Some time ago at a conference in Vienna we had occasion to trot out the old joke-cum-story of Newman's shutting the door, Rothko's pulling down the shade and Reinhardt's turning out the light. The punch line is that we've been going on in the dark ever since. . . . The meta-punch line is that we've been stuck with the joke ever since. . . "Can Conceptual Art go stand-up?"[30]

I visited Art & Language's studio in 1988. By this time they had moved from Wesley Place to the village of Banbury, about an hour outside London. This studio bore no resemblance to the one depicted in their paintings, which, after all, was an allegory. They proudly pointed out that they used no power tools to produce their 1986 "Incident in a Museum" series, which, with canvases often embedded within other canvases, sometimes required carpentry skills. These works presented Art & Language within the Whitney Museum's distinctive, Breuer-designed exhibition rooms that, at the time, were reserved for US artists only. In other words, the series depicted Art & Language's exclusion from a then dominant source of institutional legitimation. "Making Meaningless" continues this inquiry: "Power in the institutions is traced through various unattractive

forms of mimesis—the enforcing of house styles or house options which are sanctioned by the concordat of stars and time-serving administrators."[31] However, as with an aesthetics of administration, here too it is more than just a question of style: museums have learned to cultivate even nominally adversarial practices such as institutional critique because they allow them to function, for better or worse, as more efficient neoliberal institutions. In this way the "house style" of critique can assume an apparatus function; the institution uses the artist's critique as a form of feedback that enables it to be more resilient.

Today, the opposition of Conceptualist and studio practices presents a false dichotomy; we are stuck neither with the same joke nor with the same punch line. On one hand, the studio is useful but hardly indispensable. On the other, the information economy concerns not just pure information, but the interface between information and things. Seth Price stakes out some of the aesthetic boundaries in this landscape: "A painting is manifestly art, whether on the wall or in the street, but avant-garde work is often illegible without institutional framing and the work of the curator or historian."[32] Art & Language made this plain by once constructing a rabbit hutch from their old paintings, leaving its status as an artwork open to question. This, of course, was a joke about aesthetic autonomy and instrumentalization. Just as Conceptualism points to its frameworks and meta-frameworks, its very recognizability—and thus its significance—depends on these. Conversely, Helmut Draxler argues that the paradigmatic (apparatus) function of painting as art informs not only painting per se, but also the very avant-garde practices that ostensibly would disavow it. This paradigm entails aesthetics vis-à-vis morals, perspectivism as cultural articulation, and symbolic representation as a political concern. According to Draxler, the mythic "end of painting" narrative can only be sustained by divorcing the concrete act of painting—as "artisanal painting"—from this discourse.[33] What, then, would be the point in stigmatizing painting as an artisanal, i.e., merely studio-based, practice? If aesthetics is a form of conspicuous consumption, as Thorstein Veblen contends, an ostentatious renunciation sublates this logic. Since the heyday of Conceptual art, we have become more sophisticated about gestures of renunciation. To paraphrase Pierre Bourdieu, renouncing immediate monetary gain characteristically yields a gain in cultural capital that, after a sufficient period, ultimately can be converted to financial capital.[34] The beginning of a politically informed position, then, would be to recognize the immanence of the market, and its attendant forms of capital, both inside and outside the studio.

NOTES

1. Sigmund Freud, "The Tendencies of Wit," *Wit and Its Relation to the Unconscious*, trans. A. A. Brill (New York: Moffat, Yard & Co., 1916), 147.

2. Gilles Deleuze and Félix Guattari, quoted in Armand Mattelart, "The Fracture: Toward a Critique of Globalism," in *Networking the World, 1794–2000*, trans. James A. Cohen and Liz Carey-Libbrecht (Minneapolis: University of Minnesota Press, 2000), 119.

3. Seth Price, *Dispersion* (self-published manuscript, 2002), http://www.distributedhistory.com/Disperzone.html.

4. Dan Graham, in discussion with the author, circa 2010.

5. Earlier in *Saturday Night Live*'s third season, Aykroyd appeared as Pinth-Garnell, "E. Buzz Miller's Art Classics," where he played a cable-TV host whose lewd jokes about paintings of nudes provoked obligatory titters from his scantily clad partner, Christy Christina, an exotic dancer played by Newman. Here, Christina's "Pavlovian" laughter (as a stand-in for the viewer's own) registered a painful, ungainly version of sexism.

6. Lucy R. Lippard and John Chandler, "The Dematerialization of Art," in *Conceptual Art: A Critical Anthology*, ed. Alexander Alberro (Cambridge, MA: MIT Press, 2000), 49.

7. Ibid., 46.

8. See Benjamin H. D. Buchloh, "Conceptual Art 1962–1969: From the Aesthetic of Administration to the Critique of Institutions," *October* 55 (Winter 1990): 105–43.

9. See Louis Althusser, *On the Reproduction of Capitalism: Ideology and Ideological State Apparatuses*, (London: Verso, 2014).

10. In practice, however, digital production requires more skill and more fine-tuning than one might expect.

11. Gilles Deleuze, "Postscript on the Societies of Control," *October* 59 (Winter 1992): 6.

12. Lucy Lippard, quoted in Buchloh, "Conceptual Art, 1962–1969," 141.

13. Douglas Huebler, catalogue statement, *January 5–31, 1969*, Seth Siegelaub, New York, cited in *Conceptual Art*, ed. Ursula Meyer (New York: E.P. Dutton & Co., 1972), 137.

14. Vilém Flusser, "The Technical Image," trans. Anthony Matthews, in *Towards a Philosophy of Photography* (London: Reaktion Books, 2000), 20.

15. Allan Kaprow, "The Legacy of Jackson Pollock," in *Essays on the Blurring of Art and Life*, ed. Jeff Kelley (Berkeley: University of California Press, 1993), 4.

16. Ibid., 9.

17. Robert Morris, "Notes on the Phenomenology of Making," in *Continuous Project Altered Daily: The Writings of Robert Morris* (Cambridge, MA: MIT Press, 1993), 83.

18. Buchloh, "Conceptual Art, 1962–1969," 130.

19. Richard Wollheim, "Minimal Art," in *Minimal Art: A Critical Anthology*, ed. Gregory Battcock (Berkeley: University of California Press, 1995), 387.

20. The title is overtly racist, translating as, "Negroes fight in a tunnel." "Monochrome painting," https://en.wikipedia.org/wiki/Monochrome_painting.

21. "Kazimir Malevich, Suprematist Composition: White on White (1918)," https://www.moma.org/collection/works/80385.

22. See *Sherrie Levine*, exh. cat. (Kunsthalle Zürich, Westfälisches Landesmuseum Munster, Rooseum—Center For Contemporary Art, Malmö; Hôtel des Arts, Paris, 1991), 91.

23. Maria Eichhorn, "*Toile/Pinceau/Peinture, Leinwand/Pinsel/Farbe (1992/94),*" in *Abbildungen, Interviews, Texte, Maria Eichhorn, 1989–96* (Munich: Verlag Silke Schreiber, 1996), 70–76. The entry for this work puts the number of paintings at 44, but in an email to the author dated February 2, 2017, Eichhorn states the correct number is 72.

24. Bob Nickas suggested this idea to me.

25. Brian O'Doherty, *Studio and Cube: On the Relationship Between Where Art Is Made and Where It Is Displayed* (New York: Buell Center/FORuM Project, 2007), 5.

26. Lucy R. Lippard, *Six Years: The Dematerialization of the Art Object from 1966 to 1972* (Berkeley: University of California Press, 1997), 43.

27. Charles Harrison, "Reading the Museum," in *Essays on Art & Language* (Cambridge, MA: MIT Press, 2003), 215.

28. This also echoes the "rectal realism" of Neke Carson who produced paintings holding the paint brush in his rectum. A jack of all trades, Carson also played in a band with the comedian Martin Mull. See Keith Seward, "Neke Carson," *Artforum International* 31, no. 7 (March 1994): 89–90.

29. *Art & Language: The Paintings*, exh. cat. (Brussels: Société des Expositions du Palais des Beaux-Arts, 1987), 43–49.

30. Michael Baldwin, Charles Harrison, and Mel Ramsden, "Making Meaningless," in *Art & Language in Practice*, vol. 2, ed. Charles Harrison (Barcelona: Fundació Antoni Tàpies, 1999), 233.

31. Ibid., 235.

32. Price, *Dispersion*.

33. Helmut Draxler, "Painting as Apparatus," *Texte zur Kunst* 20, no. 10 (March 2010): 106–11.

34. See Pierre Bourdieu, "The Forms of Capital," in *Handbook of Theory and Research for the Sociology of Education*, ed. John G. Richardson (New York: Greenwood, 1986), 241–58.

166

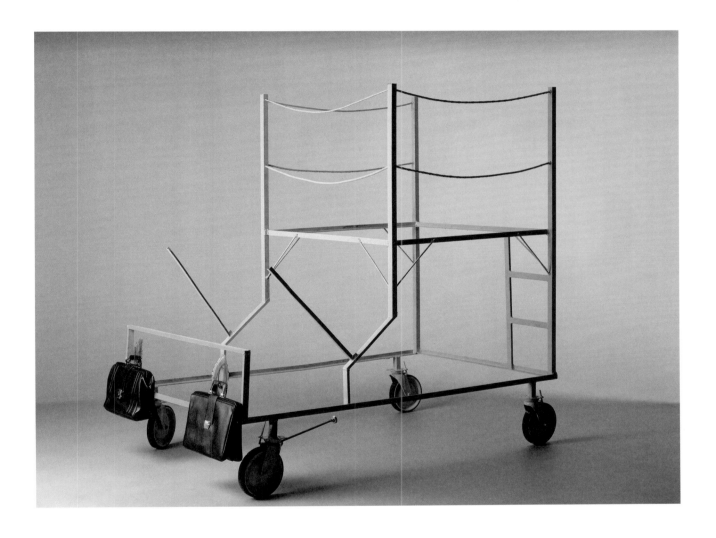

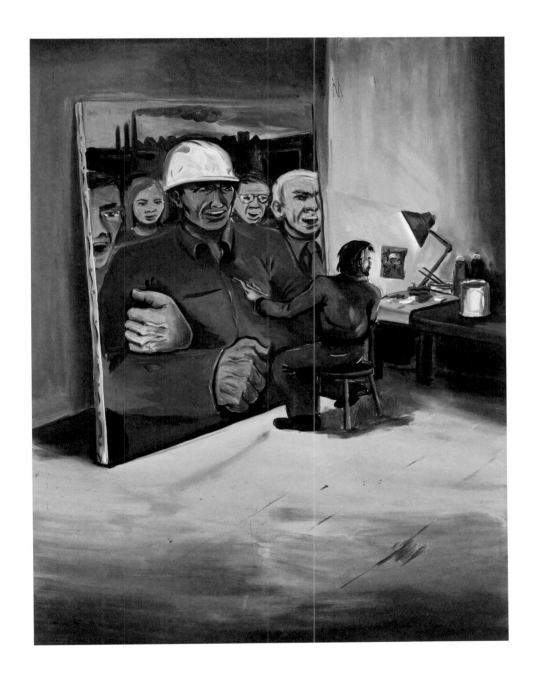

172

Anna Oppermann
Paradoxe Intentionen (Das Blaue vom Himmel herunterlügen)
(Paradoxical Intentions [To Lie the Blue Down from the Sky]), 1988–92
cat. no. 78

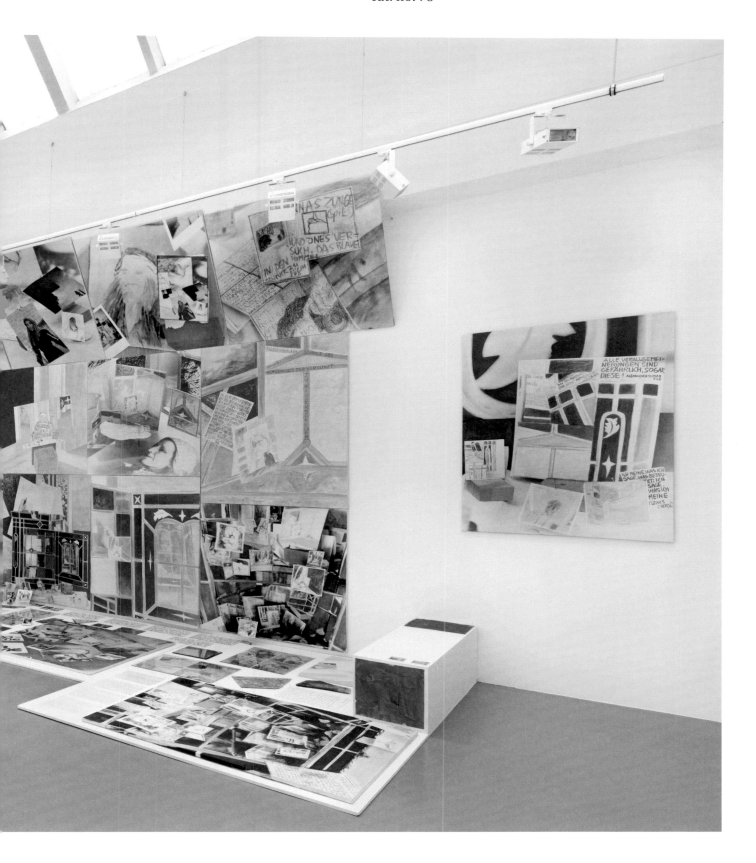

REHEARSING PAINTING

The desire for art to break out of its own domain and "cross over" is subject to periodic resurgence. This tendency, as was recently illustrated by documenta 14, typically comes with a preference for hybrid forms of exhibition making, in that traditional displays of painting, sculpture, and other modalities are performatively combined with documentary and archival modes of presentation. The juxtaposition and blurring of "primary" and "secondary" mediums that characterized Conceptual art as well as *Kontext Kunst* and installation art[1] from the 1960s to 1990s not only led to the familiar feedback-based formats intended to break down the hierarchy between high and low culture, but as time went on also increasingly involved bringing together artistic and nonartistic objects and materials. It is not by chance that these types of crossover, occasionally associated with artistic research[2] and Actor-Network Theory (ANT), feature politically and scientifically charged metaphors such as "parliament," "network," and "laboratory."[3] These metaphors suggest a transformation of the artist's studio into an inter- or postdisciplinary environment that finds its lowest common denominator in the form they take: a mixture of scenographic props and educational displays serving as "interfaces" between art/theater, everyday/mass culture, and science/media technology.[4]

Against this background, it is particularly worthwhile to look again at "Ensembles" (1968–92) by Anna Oppermann (1940–1993). Influenced by Pop and Conceptual art, but also marking out a feminist-inflected distinction from both, this Hamburg-based artist found her signature style in idiosyncratic and

often overwhelming combinations of images, found objects, paintings, and texts arranged in sprawling installation-like formats. Like today's environments, her "Ensembles" are characterized by an interest in the experimental networking of disciplines, materials, and mediums. They are, however, focused less on technologically connoted concepts such as "interface" or "network" and more on the polyphonic interplay between individual and collective within a performative context based on improvised or rehearsed interactions—as also suggested by the word *ensemble* and its evocations of theater and music. The environment *Paradoxe Intentionen* (*Das Blaue vom Himmel herunterlügen*) (Paradoxical Intentions [Lying the Blue Down from the Sky], 1988–92) is a good example that has much in common with a jazz improvisation or theater rehearsal. It is a dramatically staged confluence of harmonies and disharmonies, points of convergence and tipping points, where the assembled (image-)objects encounter and clash with one another via montage, doubling, mirroring, juxtaposition, layering, and arrangement in complementary or antagonistic ways.

In other words, Oppermann's model of the ensemble is based more or less on provisional connections that show the gathered (image-)objects in a plethora of relational forms. As in "real" theater, Oppermann's presentation strategies distinguish between leading and supporting actors as well as between stage and backstage. One can, however, also discern a preference for upsetting hierarchies by flipping the front and back or reversing the gaze, which is in turn closer to so-called post-dramatic theater.[5] Objects usually regarded as secondary (Polaroids, sketches, drawings) are in the foreground, while the actual protagonists (the paintings) function as elements of the set or décor. Hence, the presentation of the individual (image-)objects—i.e., the question of whether they are hung or placed higher or lower, in the front or the back, in the middle or to one side, alone or in groups, or whether they are fully or merely fragmentarily visible—has less to do with conforming to the principles of a harmonious composition or user-friendly interface than with the idea of interaction between structurally unequal performers, in keeping with the model of the ensemble. *Paradoxe Intentionen* is fraught with tension because it challenges the hierarchy of mediums and content by employing a seemingly makeshift mode of presenting individual (image-)objects—which allows us to see the environment as one among many, as something that can always itself be changed. As with improvisation (whether in theater or music), Oppermann's ensemble is characterized by an experimental oscillation between following rules and breaking them, which challenges and hones the viewers' perception, for example, by having certain imagery carry through the work serially while being constantly "recoded" through breaks and discontinuities in material and mediums.

Borrowing a formulation by the literary scholar Sandro Zanetti, who applied it to Hans Christian Andersen's 1835 autobiographical novel *The Improvisatore*, one could speak of Oppermann's work in terms of "post-genius improvisation poetics."[6] This phrase concisely sums up how traditional aesthetic ideas based on the cult of artistic genius have been replaced by situational experiments acknowledging the constitutive nature of perception, while also encompassing how Oppermann keeps the artistic process open to unconscious

decisions able to both expose and subvert internalized rules, whether in the sense of aesthetic conventions or sociocultural value systems. Within a context of post-genius improvisation poetics, the list of materials for *Paradoxe Intentionen* points to the artist's predilection for experimental combinations of everyday archaeology, reproduction aesthetics, and prefabricated means of presentation. In contrast to male-coded claims to genius, she focuses on the inventiveness that results from the meeting of aesthetic/artistic and everyday objects that "come to" her and—in keeping with the agenda of her "paradoxical intentions"—are thus only to a limited extent determined through authorial control: "Glass shrine, various found objects, marigolds, glass and mirror shards, windowpanes, drawings, black-and-white and color photographs, Polaroid photos, graphic prints, printed and handwritten texts, paintings, watercolors, colored photo canvases, pedestals, various construction elements such as wooden blocks and straight pins, lamp, light bulb, cable."[7]

In a way it brings to mind both Marcel Duchamp and John Cage—this accumulative montage of objects, materials, and mediums is a method that functions to undermine the binary of (planned) intention and (unplanned) chance, (unfinished) production process and (finished) artwork: an approach that can be understood, in accordance with Zanetti's thinking, as the transfer from author-centered production to a perceptual experiment, a reception-oriented play with meaning and (surprising) points of view. Such an interpretation seems bolstered by the hybrid character of the "Ensembles," which represents a simultaneously topological and metaphorical mixture of studio, rehearsal stage, and exhibition space for which *Paradoxe Intentionen* is a paradigmatic example.

In this respect, Oppermann's "Ensembles" anticipate the dissolution of distinct artistic formats and mediums by preempting the inter- or postdisciplinary exhibition scenarios established by Post-Conceptual installation aesthetics in the 1980s and '90s. Instead of a linear and hierarchical sequence of production, work, presentation, and reception, *Paradoxe Intentionen* can be seen, simultaneously, as a pictorially conceived *mise en abyme* and a spatio-temporally conceived mise-en-scène. When viewed from a distance, the art-historical motif of the *Bildbühne*, i.e., paintings from an art collection arranged to form a theater stage, comes to mind.[8] Upon closer inspection, however, the ensemble appears as a synthesis of environment and stage set, also in light of the double function of the space-within-the-space structure, which is at once the frame and the subject matter of this kaleidoscopic picture-within-the-picture panorama[9]—thus linking the *dispositif* of the exhibition with that of performance. Meanwhile, references to cabinets of curiosities, house altars, and staggered sideboards used for storing and presenting devotional objects, keepsakes, and handcrafted ornaments cast the post-genius improvisation poetics of *Paradoxe Intentionen* as various provisional "stagings." The motif of the exhibition-as-performance therefore marks the conversion or tipping point from authorial intention to experimental arrangement that undermines the distinction between the aesthetics of production and the aesthetics of reception. In contrast to the serial and linguistic methods of Minimal and Conceptual art,

Oppermann's structuring principle of the ensemble does not set the formal aspects of her work (basic geometric forms, diagrams, typewriter font) against the personal and biographical, or the literary and narrative. In the text provided with the work, one can find, for example, entries in the section "Subject matter, key words" that once again reveal Oppermann's method of mixing structurally incompatible elements: "Paradoxical intention: »I never lie«. I can't bewitch things and turn them blue; certain theories of German Romanticism: (the blue flower, Heinrich von Ofterdingen), compared and placed in the context of the methodology of my ensembles; »A.O.—portrait—ugly—of Alex. O.«; a beautiful receptacle; reflected, self-estranged reality; touched-up reality; a kaleidoscope."[10]

Anna Opperman

Oppermann's paradoxes evidently have far more to do with the proximity of postmodern image languages to allegorical palimpsests than with the claims to purity of modernist and Conceptual image and object languages. It is perhaps no coincidence that what Craig Owens calls "postmodern allegory" is associated with the structuring principles of the "Ensembles": noncausality, discontinuity, ephemerality, seriality, the situational, and ironic exaggeration. The revaluation of artistic practices based on such strategies was one of the accomplishments of Owens's seminal essay "The Allegorical Impulse: Toward a Theory of Postmodernism" (1980), in which he referenced Walter Benjamin's *The Origin of German Tragic Drama* (1928) to argue that they could no longer be seen as the unreflecting expression of an antimetaphorical or antinarrative and categorically antitheatrical aesthetic.[11] (It is the last of these that is decisive for Oppermann's work.) Indeed, Oppermann's "appropriations"[12] of image-based

178

idioms—such as *das Blaue vom Himmel herunterlügen* ("lying the blue down from the sky"), which means: lying one's head off, charming the birds out of the trees, promising heaven and earth—can be understood in this sense of an allegorical palimpsest in their metonymic layering and superimposition of art-historical topoi and conventions. This accords with Oppermann's reworking and overworking of found imagery, for example, where the phenomenological games of deception involve enlarging and reducing, folding and condensing, cropping and extracting, showing and concealing. A similar method of comparative combining is also evident in her montages of images and texts. Xeroxed pages from books and magazines are complemented by handwritten or painted texts, a method of mixing heterogeneous formats that stands in contrast to the standardized typography of Conceptual art. Owens's observation that "the allegorist does not invent images but confiscates them" appears relevant here, as does his description of allegory as "rewriting a primary text in terms of its figural meaning."[13] In other words, modes of presentation, enunciation, and signification have an essentially secondary character, because they cite and translate, even if this takes on a life of its own in a recursive ensemble of pictures, texts, and objects, as is the case with *Paradoxe Intentionen*. The statement *Postmoderne hab' mich gerne* ("Postmodernism, please like me") painted on two small-format canvases is the most literal example of Oppermann's double game of personal involvement and distancing irony—and thus of everything that characterizes the programmatic paradox of postmodern allegory as the expression of a dialectic of emptying and recharging something of and with content and meaning. Oppermann's "rewriting" is performed on the level of the aesthetics of mediums, and materials, too. For instance, she lets the classic panel painting that has been replaced by the large-format, unframed canvas return in the form of classic, i.e., illusionistic, window pictures as well as in the form of a real window frame (as readymade, as objet trouvé). It is, then, surely not by chance that the art-historically fraught question of illusion and reality is reflected in the ambiguous nexus of *Bildbühne* and *Bühnenbild*—a stage made up of pictures and an actual stage set. Linking the three-dimensionality of the set with the illusion of depth in painting, it is precisely through the vacillation between material and fictive (image-)object that a real space is constructed for the beholder. The integration of mirrored glass thus appears as a possibility to "perform" painting as an allegory of itself, so to speak—as if it were about using its literally reflective status to take in the standpoint of the viewer.

Theatricality has traditionally been frowned upon in visual art,[14] but for Oppermann it enabled the production of illusionistic, viewer-centric, hybrid forms of art. If the artist was thus prompted to elevate the *Bildbühne* into a privileged site of post-genius improvisation poetics, it is because she attempted to gauge the tension between illusion and reality that was so crucial for her not only in the production of images, but also in their reception. It is not by chance, then, that Oppermann's minimalistic pedestals alternate between being autonomous objects and functional infrastructure, once again manifesting her mixing of real and illusionistic space. The attendant montage of studio, stage, and exhibition space is characteristic of the attempt to connect the aesthetic object with

its social environment in a way that does justice to society's transformation—something that Oppermann shares with artists such as Robert Morris, Ree Morton, Bruce Nauman, and Yvonne Rainer, although we know little about her exposure to or reception of their works. While Rainer, in 1968, observed "changes in ideas about man and his environment,"[15] Oppermann in the mid-1980s spoke of how "somewhere in this world, complexity must still be valued. It is impossible to tackle a problem without taking into consideration that every problem is linked to other problem areas."[16]

As we know, the awareness of an ever more complex world went hand in hand with the insight that art is situated not outside but within society, which it has a distance from in classic claims for art's autonomy. Accordingly, Oppermann performs the "fall of the studio"[17] in an allegorical sense, with her ensembles transforming the classic topos of the artist's studio into a mise-en-scène that integrates the sphere of labor, and thus the production of the artwork and of value, into the sphere of art's reception—an endeavor that sought to replace *poiesis*, i.e., the production of objects, with *praxis*, i.e., executing and realizing action, here in the sense of arranging pictures and objects to (inter)act like "performers." Her work bears comparison with what was happening in performance art around 1970, yet in Oppermann's case, one cannot speak of the naive belief in the possibility of replacing fetishistic, commodified "representation" with the ephemeral act of "presentation." Instead, her method of accumulating objects and materials is capable of getting to the bottom of how art overlaps with the structures and mechanisms of what in a postmodern reading is understood as female-connoted, everyday consumer culture. The vertiginous multiplication of perspectives in *Paradoxe Intentionen*, created by the at once mimetic and fragmenting mirroring of imagery—with, for example, photographic reproductions of painted, real objects or the overwriting of a photographic self-portrait the artist considered unflattering—reveals the significance of the image as the core of Post-Fordist production. The economization of culture means that author-centered production is replaced by a feedback-based circulation of images, signs, and Baudrillardian simulacra.

Yet unlike the ways in which today's interface aesthetics are part and parcel of cybernetic control logic, the meandering sequences, fraying edges, and open ends of Oppermann's ensembles evoke a post-genius improvisation poetics drawn from paradoxical comparisons of art-historical narratives (the blue flower of German Romanticism) with colloquial idioms (*Das Blaue vom Himmel herunterlügen*). This does not represent an avant-gardist claim to truth, but a palimpsest-like increase in complexity of those relations that Oppermann's "Ensembles" improvise in and for the moment they are viewed. Her list of "the most important, fundamental objects, with various associations" begins with "expressions and slogans using the adjective 'blue,'" which then exist among and between plants like the marigold (tagetes), chosen because it "has a scent of carnations, crème caramel, sweat, sperm, and fresh bread rolls," and the Indigofera tinctoria "from which a blue dye was made by adding the urine of boys approaching puberty." Instead of interfaces and feedback, *Paradoxe Intentionen* confronts us with synesthetic experimental arrangements that seek

to abolish the modern separations among the functions of culture, nature, society, and technology: "The blue," Oppermann writes, "slipped into the »pudding-soap-sheep« image through the associations of soap, cleanness, honesty, innocent little lamb, bellwether, silly sheep, scapegoat etc."[18]

Here, at the latest, Oppermann's post-genius improvisation poetics reveals her predilection for the Dadaistic/Surrealistic critique of rationalism, which she "confiscates" by staging a semiotic attack against formalistic media specificity, an attack that collapses the hierarchical binary of male-coded production (high culture) and female-coded reproduction (low culture). Under point 4 of the text accompanying *Paradoxe Intentionen*, "A glass shrine (found-object)," Oppermann states that "no-one can imagine its former use, except that it is beautiful," and then goes on to praise the "blue tinted glass" for how it integrates "reflected reality, parts of one's face, endlessly repeated, changed by light, the surroundings and the mood in the face of the viewer."[19]

Anna Oppermann in the *Ivory Tower*, Musée d'Art
de la Ville de Paris, 1981

Once again, *Paradoxe Intentionen* shows that it is able to challenge the aesthetics of the cult of genius and its claims to autonomy through the materials and methods of an aesthetics of perception. Curator and writer Ute Vorkoeper, who has played such an important role in making Oppermann's oeuvre accessible, emphasizes the significance of the "movement of perception" in

Oppermann's "Ensembles," which I also understand in this vein: the implied dialectic of distant vision and near vision, Vorkoeper writes, "derives" from "the ensemble itself" in the manner of an "unresolvable contradiction."[20] Grasped as a paradoxical intention, it doubtless marks a moment of emancipation, since it allows us to choose between involvement and distance—a freedom that the financialized feedback and network logic of today's interdisciplinary, "cross-over" practices seem merely to simulate.

NOTES

1. (Anti-)works by Fareed Armaly, Renée Green, Christian Philipp Müller, Fred Wilson, and others come to mind here.

2. See Elke Bippus, "Forschen in der Kunst. Anna Oppermanns Modell der Welterschließung," in *Anna Oppermann, Ensembles 1968–1992*, exh. cat., ed. Ute Vorkoeper (Berlin: Hatje Cantz, 2007), 55–64, especially 59–64.

3. See, for example, Bruno Latour, *We Have Never Been Modern*, trans. Catherine Porter (Cambridge, MA: Harvard University Press, 1993).

4. Examples include the Berlin Biennale (2016) and exhibitions at the House of World Cultures (HKW), Berlin, oriented toward cultural studies.

5. Stefanie Diekmann, *Backstage. Konstellationen von Theater und Kino* (Berlin: Kulturverlag Kamos, 2013), 19.

6. Sandro Zanetti, "Zwischen Konzept und Akt. Spannungsmomente der Improvisation bei Quintilian und Andersen," in *Improvisieren. Paradoxien des Unvorhersehbaren. Kunst – Medien – Praxis*, ed. Hans-Friedrich Bormann, Gabriele Brandstetter, and Annemarie Matzke (Bielefeld: transcript Verlag, 2010), 105; 95–106.

7. See the specifications on *Paradoxe Intentionen* (*Das Blaue vom Himmel herunterlügen*, 1988–92) in *Anna Oppermann*, 136.

8. See Ivan Nagel, *Gemälde und Drama. Giotto Masaccio Leonardo* (Frankfurt: Suhrkamp, 2009); for an example, see *The Tribuna of the Uffizi* (1772–78) by the neoclassical painter Johann Zoffany.

9. See Ute Vorkoeper, "Revisionen der Ensemblekunst. Vorwort zur Dokumentation," in *Anna Oppermann*, 116–18.

10. English translation by Linda Maar and Bernice Murphy, http://bthumm.de /wp-content/uploads/AOp_2016_GBT _Paradoxical-Intentions_XS.pdf.

11. See Craig Owens, "The Allegorical Impulse: Toward a Theory of Postmodernism, Part I," *October*, no. 12 (Spring 1980): 67–86; "Part II," *October*, no. 13 (Summer 1980): 59–80, especially his discussion in the latter of Laurie Anderson's performance *Americans on the Move* (1979) and Cindy Sherman's performative photography, 58–62 and 77–79 respectively.

12. This is another concept associated with postmodern allegory.

13. Owens, "The Allegorical Impulse: Part 1," 69.

14. See Michael Fried, "Art and Objecthood," in *Minimal Art: A Critical Anthology*, ed. Gregory Battcock (New York: E. P. Dutton, 1968).

15. Yvonne Rainer, "A Quasi-Survey of Some 'Minimalist' Tendencies in the Quantitatively Minimal Dance Activity midst the Plethora, or an Analysis of Trio A," in *Minimal Art*, 264.

16. Cited in *Anna Oppermann*, 12.

17. See *The Fall of the Studio: Artists at Work*, eds. Wouter Davidts and Kim Paice (Amsterdam: Antennae Valiz, 2009).

18. See *Anna Oppermann*, 136. English translation by Linda Maar and Bernice Murphy, http://bthumm.de/wp-content /uploads/AOp_2016_GBT_Paradoxical -Intentions_XS.pdf.

19. Ibid., 138.

20. Ute Vorkoeper, "Therapie und Revolte der Gegenwart," in ibid., 19–28.

A–Z Time Trials

What would it be like to live without any source of imposed time? You could sleep whenever you felt tired and eat whenever you were hungry. How would your body react to such total freedom? Would it regulate itself in a sensible pattern? Or would it create extremes of behavior such as sleeping for a whole day straight, or reading a book from beginning to end? Would different peoples patterns resemble one another, or would each persons own inner timetable be completely different than the standardized social routines?

"Free Running Rhythms and Patterns" was conducted from October 31 to November 6th 1999 in Berlin, when one week was spent living purely on "my own time", doing whatever I wanted, whenever I wanted, without any interference from "external" time. A timeless environment was established by blocking out all sources of natural light and sound, clocks and any other time referents such as T.V, radio, or time settings on the computer. Since I was curious to know what sorts of patterns would emerge, a time lapse video recorder was used to record this week-without-time. I learned that the perception of time has nothing to do with a scientific understanding of it. Living without time was both exhilarating, exciting, and a little stressful.

Matthew Barney
Drawing Restraint 2, 1988
cat. no. 8

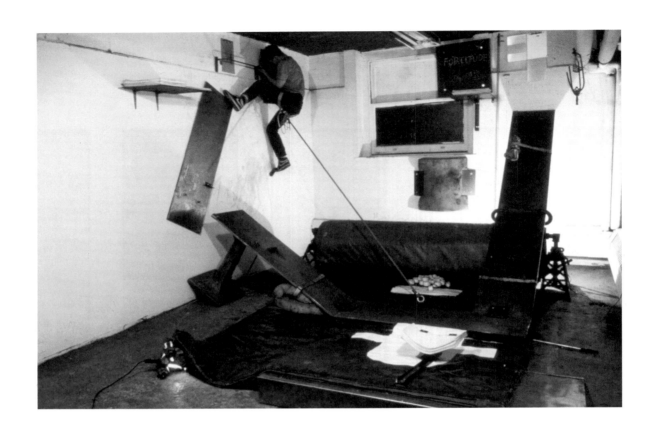

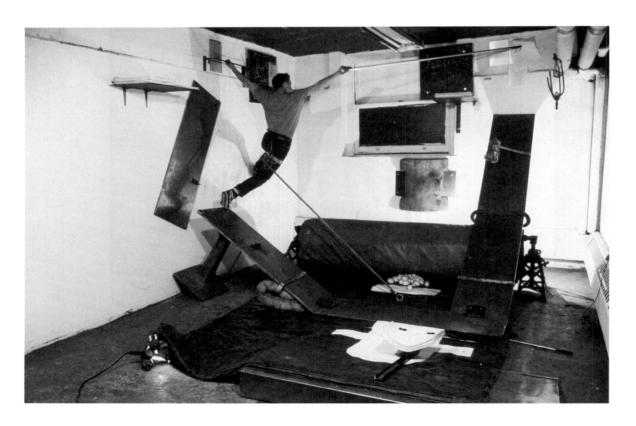

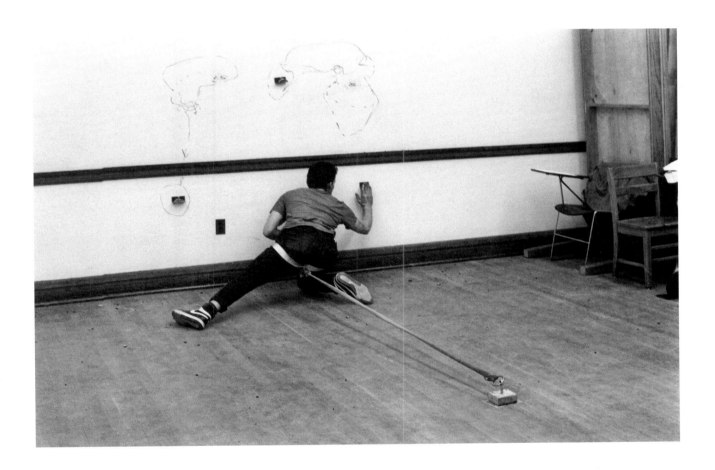

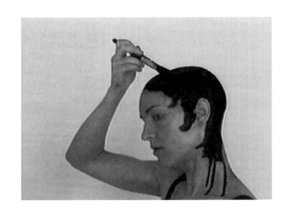

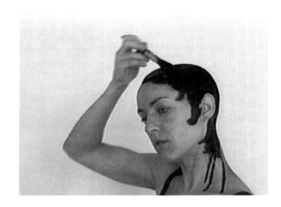

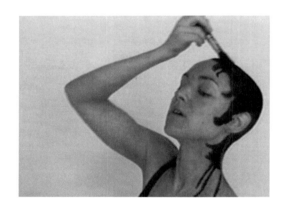

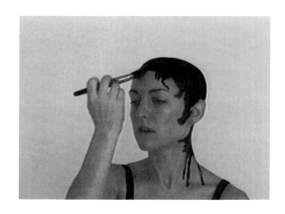

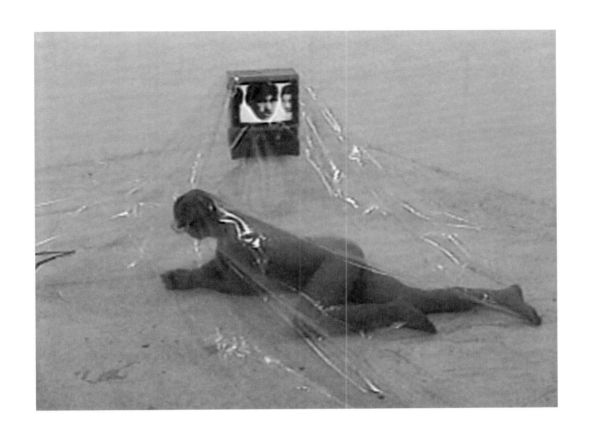

David Hammons
Traveling, 2002
cat. no. 51

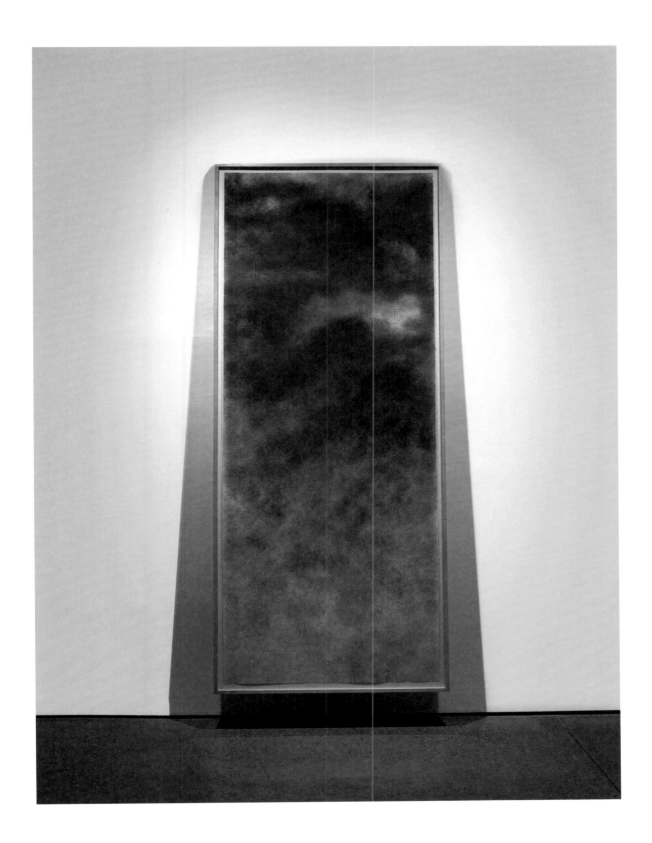

WORK/OUT

Therefore, our present in its universal condition is not favorable to art.
—G. W. F. Hegel[1]

Of the many critical responses to documenta 14, the exhibition project I spent the past three years of my life working on, I will long cherish this particular insight, first glimpsed somewhere online soon after the opening in Athens in April 2017, and taken down shortly thereafter: "One could be forgiven, walking around this documenta, for believing the Internet does not exist." (I am paraphrasing here.) With this good-natured remark, dropped in passing in a generally favorable and enthused review, the critic in question chose to express her or his befuddlement at the overwhelmingly analogue feel, look, and spirit of the exhibition, which apparently existed in a parallel universe untroubled by any awareness of the Internet's very existence, and blissfully as well as defiantly ignorant of the larger ramifications of present-day digital culture, (a)social media and all. It was a show of, by and large, computerless art, and

a computerless show. I had, tellingly perhaps, never really considered this particular perspective—and I'll happily confess that said remark filled me with a discernible degree of curatorial satisfaction, professional pride even. Here we were, in the dark depths of 2017 and its seething cauldron of 24/7 networked life, having managed to organize one of the most prestigious recurring art events in the business without even the slightest trace, it seemed, of the single most transformative technological, socio-economic development of the past quarter century. Of course, this assessment was not exactly meant as the unilateral praise I have since taken it to be, and subsequent critical responses were much more direct in their charge that, in places, documenta 14 felt overly nostalgic and "out of touch"—meaning, perhaps, that it did not include any so-called post-Internet art (much less Internet art proper), or plainly too little that was emphatically digital to be of its digital time. Ours, in this reading, was a celebration of antediluvian art: art predating the digital culture deluge—and with that, a survey show

of global contemporary art was immediately made to feel historical.

I have allowed myself this introduction as a means for discussing the changing relationships of art to work, art practice to Fordist and post-Fordist labor regimes, and the artist's studio to the vagaries of production, in part because the above anecdote has enabled the crystallization, in my mind, of a long-held suspicion concerning the larger relationship between art and the information and communications technology complex—one of deepening disconnect, and possibly mutual exclusion: a clear-cut case of either/or. Perhaps a certain idea of art—one intimately bound up with the ideological subtext of an exhibition such as documenta, and the idea of art that, for better or worse, continues to reign supreme—is facing certain death, in the Hegelian sense of the "end of art," because it cannot, or can no longer, be reconciled with 24/7 networked life. Perhaps the complete and total digitization and virtualization of culture, economy, politics, and society (indeed, of life as such) has made art, in the historical sense of what we have known this noun to denote throughout the modern and postmodern era, superfluous—a historical phenomenon or, in Hegel's literal formulation, a "thing of the past."[2] To my knowledge, no one has ever really considered Hegel's choice of words in this phrase. The implicit conflation of thingness and objecthood with historicity seems all the more pertinent in the context of today's discussions about the digitization, virtualization—indeed, dematerialization—of life. If "things" as such are the quintessential Hegelian "thing of the past"—i.e., passé—art still quintessentially involves the making of things, despite countless attempts at dematerialization, and, of course, under the considerable pressure of the art economy. Indeed, the studio, as the production site for things (aka commodities), is far too crucial to the smooth operation of the all-powerful art market to be declared obsolete so casually as it has been in recent proclamations of the so-called post-studio condition. It does indeed seem much more logical to posit an "everywhere-studio" condition: rather than being assigned to history, the studio has been radically expanded. As a production site for things,

it must be everywhere, at all times—much like our 24/7 network culture itself.

Walking through documenta 14—or many recent biennials around the globe for that matter— "one could be forgiven . . . for believing the Internet does not exist," for in a world that coincides entirely with this ever-widening web, such a thing as "art" may no longer have meaning, sense, or use. And this, in the end, is not a world I and the other curators of documenta 14 were interested in promoting—it is already everywhere anyway, and in no need of further endorsement or adoption. Instead, walking around Athens and Kassel in the spring of 2017, one was treated to the old-fashioned world of work—and, indeed, of art as the kind of "work" that has in many ways been only peripherally changed by the marvels of digital technology so present everywhere (else).

* * *

In order to frame these observations within a larger context, let us look back to Catherine David's tenth edition of documenta in 1997. (For better or worse, documenta's own exhibition history has become something of an established prism through which to write recent art history as such.) This was perhaps the first truly global documenta, and the first to be organized after the popularization of the Internet and the attendant emergence of a critical digital culture, as well as the first to prominently feature representatives of the emergent electronic arts scene. It was, tellingly, also the last to do so. Subsequent editions of the exhibition have by and large disregarded developments such as net art, the singularly infelicitously named "new media" phenomenon and other artes electronicae[3]—another hint of a possibly foundational divergence, incompatibility even, between art as we (continue to) know it on the one hand, and cyberculture on the other. (To what extent this disparity is a function of the age-old ambivalence of art's relationship to technology and vice versa—echoes here of C. P. Snow's famed "Two Cultures" argument—is a question for another time.) David transformed Kassel's Orangerie into a hacker retreat or lab-cum-office-like hive of

Liam Gillick, *Everything good goes*, 2008.
HD video projection,14 min., 52 sec.
Produced by Laurent Vacher, Stephen Ghukfvin, and
Catherine Camille Cushman

humming networked activity. I remember it being full of coiling cables and flickering computer screens, with no art to speak of in the conventional sense. In retrospect, we can now look back on it as the height of '90s art culture's infatuation with a new type of office ethos and dreams of a post-work (or "post-studio"?) creative-class society. In this exhibition space, along with a dozen other places like it, from Ars Electronica in Linz to Rhizome in New York, a new idea of the studio—along with new conceptions of what constituted "artwork"—was born: dispersed, mobile, and nomadic. Mobile technology was still in its infancy at the time, but it was already clear then, in 1997, that our wired future was going to be a wireless one, forever dissolving and reappearing. In short, the studio would be "everywhere." (A year after this landmark exhibition, so pivotal to the later recalibration of artistic practice as a species of research and/or knowledge production, Nicolas Bourriaud published his seminal *Relational Aesthetics* manifesto, the boosterist high-water mark of vanguard art's collusion with the dotcom/start-up aesth/ethic and the reticular paradigm of the information economy in particular.) Flashing forward to 2017, it is now clear to see that if anything made the "everywhere studio" regime possible at all, it was, of course, the invention of the laptop—and, more recently, the smartphone. One artist associated with the relational aesthetics moment who has consistently reflected

with great acuity upon the dissolution of the traditional studio space in a meshwork of cabled and cable-less machinery (and the impact of this paradigm shift on art's work ethic) is Liam Gillick. As a practitioner famous for refusing to have a studio and insisting he "work from home," Gillick has called "the question 'Why work?' . . . the original question of current art."[4] In Gillick's world, the end of the studio equals the end of work.

* * *

After work, after the studio, after hours: I am reminded of Bruce Nauman's polemical contention, made in 1968, that, "if I was an artist and in the studio, then whatever I was doing in the studio must be art." Nauman famously made this statement at a time when his own "work" had consciously atrophied, in a deliberate reduction, to the performing of minimalist, repetitive chores in the studio—faux-ritualistic *labor* rather than *work*, to paraphrase Hannah Arendt's well-known distinction between *animal laborans* and *homo faber* as contrasting modes of man's active being-in-the-world. Nauman bounces up and down in a corner of the studio, plays a note on a violin while walking around the studio, stamps in the studio, walks with contrapposto and/or "in an exaggerated manner around the perimeter of a square" in the studio, and—my personal favorite—"fail[s] to levitate in the studio."

195

Ian Wallace, *At Work*, 1983.
Photograph, 42 × 67 in.

Arendt's magnum opus *The Human Condition*, published exactly ten years before Nauman's bodily studio musings, could still quite romantically assert that "the artist is the only 'worker' left in a laboring society";[5] in 1968 some artists seemed already to intuit or suggest that they were perhaps the last laborers left in a working society—if we take "work" to denote the type of creative activity (research, service, et al.) that came to simultaneously exemplify and replace labor in the post-Fordist, postindustrial world, and for which the avant-garde art and expanded studio practices of the late 1960s and early '70s were such inspirational (if unwitting) models. (Nauman's mythical studio space, to which he would return time and again throughout a fifty-year career, here functions as a laboratory for the radical reinvention of "work" as much as "art.") The

story of this collusion is the subject, in part, of Luc Boltanski and Ève Chiapello's magisterial *The New Spirit of Capitalism* (2005), which predictably pivots its analysis on the symbolic watershed of 1968 and its immediate, pre–oil-crisis aftermath.[6] Among a limited number of concepts that Boltanski and Chiapello identify as key to better understanding the appropriation of late '60s vanguard art principles by the neoliberal counterrevolution of the mid-'70s is the chimera of flexibility: the dematerializing and melting of all that is solid into air—and the concomitant demand, so central to this emergent economic regime, to be—and be able to work (though not labor)—"everywhere."[7]

* * *

In 2012, the year of Carolyn Christov-Bakargiev's epochal documenta 13, I attempted to formulate a critique of a type of critically acclaimed art of recent vintage that could be called "antiwork": art that flaunted the effortlessness of its coming into being above all else. This resulted, in my view, in an art of "unbearable lightness": art "after work" in the double sense of, firstly, an artistic practice ideally suited to our post-labor condition as well as, secondly, a type of art made in an offhand, after-hours fashion—sometimes merely by spending a couple of hours surfing on eBay, for instance (and never in the studio, of course).[8] In the resultant critical climate, effort (like labor at large) was to be frowned upon, and the greater the sheer physicality of that effort—the more some part of the artistic process conjured the ghost of the laborer's exertion—the haughtier the frowning. Indeed, the dominant aesthetic today is one of understatement, deskilling, and classist disdain for ostentation that converges exemplarily with the wholesale appropriation of, for instance, Minimalism by global corporate culture and the lifestyle industry. This may perhaps help to explain the sharp downward turn in the critical, discursive fortunes of the work of the erstwhile master of effort writ metaphysically large, Matthew Barney. Reflecting on the fate of the studio in contemporary art lore, we can now look back on Barney's early works, particularly the "Drawing Restraint" performance series (1987–89) as a prophetic meditation on the transformative strain undergone by art and work—and the studio, as the social plane on which the relation between the two has historically been negotiated—over the past fifty years. Writing about "Drawing Restraint" in 2002, Nancy Spector noted: "In his obstacle course of a studio—which resembled some hybrid version of Gold's Gym and a S/M fetish club—Barney climbed ramps, swung from rings, strained against tethers, jumped on a mini trampoline, and pushed blocking sleds in an effort to record the lines of a sketch, a self-portrait, a diagram."[9] With the world of work progressively receding from everyday view in the transitory period between Reaganomics and Clinton's neoliberalism-lite, Barney's studio was transformed to better accommodate the only "work" left to do, for the artist as much as for anyone else—that of the *workout*.[10] (Out with work, in with the workout! Oceans of ink have been spilled chronicling the demise of SoHo's manufacturing traditions and the artist studios taking their place in 1970s downtown Manhattan, with the artists in question all too often called out as the shock troops of gentrification—but what about the myriad gyms that followed in the artists' wake?) The studio as fitness studio or gym, a laboratory for the properly postmodern work of self-fashioning—the only effort allowed free rein in a world of diminishing prospects for labor as a political cause or way of life was that of sculpting the self, building bodies in the sanitized seclusion of the atelier. In Barney's work, art once again showed the wearisome way forward—for sculpting the self and building bodies, we all know now, is everywhere.

* * *

More than "Drawing Restraint" and the related performance-based installations and video works, it is of course the "Cremaster" cycle (1994–2002) itself that will secure Barney's status as a seminal figure in future art histories of our millennial moment, for it is in this elaborate cinematic multiverse that one of two truly defining features of '90s art reaches its apex: the gradual darkening of the white cubes of art—i.e., the proliferation of black boxes throughout the institutional spaces of art—to better accommodate the advent of film as the era's guiding frame of reference. (The other defining feature or paradigm of '90s art can be discerned, in my view, in the relational aesthetics phenomenon. Both paradigms are, of course, "related.") One of the key aesthetic effects of this crepuscular process was immersion becoming established as an essential element of much contemporary art experience. Art was no longer just something to look at (or to be looked at), but something undergone, stepped into; something which we agreed to be surrounded by and, more importantly still, subject to. An especially illuminating experience in this regard, ironically enough, was that of entering Steve McQueen's film installation *Carib's Leap/Western Deep* (2002) at documenta 11.

The film's screening in the most uncompromising of darknesses clearly made the point that the aesthetic experience provided by McQueen wasn't just a matter of watching, facing a film—it was a matter of being completely immersed in image, sound, and staging, blindness and all. I have written more systematically elsewhere about the ideology of immersion as a cornerstone of contemporary art experience, comparing it to weather, fog, the clouds shrouding the mountains in Caspar David Friedrich's ca. 1818 *Der Wanderer über dem Nebelmeer* and the like, but that was at a time, in 2010, when the most comprehensive and all-encompassing form of immersion was not yet a daily lived reality, before the advent of 24/7 wireless connectivity and the concomitant sense of immediate everywhereness that, as I have argued above, somehow feels antithetical to the idea of art as we have known it for so long.[11]

In conclusion, let us turn to the work of an artist occupying a central position in "The Everywhere Studio," namely Jay DeFeo—specifically the well-known story of her work *The Rose*, the monumental painting-cum-sculpture started in 1958 and "finished" in 1966 at the Pasadena Art Museum, after the artist's forced eviction from her studio, which had become completely taken over by the work. In retrospect, this 11-by-8-foot work, weighing over 1,500 pounds, may feel like the last painting ever made before the deluge of art's dissolution in a warren of concepts (it was certainly the heaviest), and the demise of the traditional studio model in its wake, as chronicled in Lucy Lippard's landmark 1973 book *Six Years: The Dematerialization of the Art Object from 1966 to 1972*. Seen from this perspective, *The Rose* might represent the studio's last stand before it became the "everywhere studio" of our compulsively connective, post-work times.[12] The story of DeFeo's work and the immobilizing effect it had on her life and work afterward (as *The Rose* disappeared from view, hidden behind a wall in the San Francisco Art Institute for two decades, DeFeo's output in turn was brought to a halt for three years) reads like an allegorical warning against the dangers of immersion and placelessness. Indeed, it may be advisable for art—work, the studio, and all that art entails—should it continue to exist, to be *elsewhere*. For if the Hegelian specter of the death or end of art is predicated on art's everywhereness, which is to say on its present dissolution in everyday life, one way of ensuring art's return from the dead may be found down exactly this route: in a return to the studio as art's irreducible elsewhere.

Jay DeFeo, *The Rose*, 1958–66.
Oil with wood and mica on canvas,
$128 \frac{7}{8} \times 92 \frac{1}{4} \times 11$ in.

NOTES

1. Georg Wilhelm Friedrich Hegel, *Introductory Lectures on Aesthetics*, trans. Bernard Bosanquet (London: Penguin Books, 1993), 13.

2. Hegel's spectral theory of the death or end of art has been a source of philosophical reflection throughout much of my writing life. I first properly turned to it in the context of discussing the work of Canadian photo-Conceptualist Ian Wallace, specifically Wallace's *At Work* piece from 1983 (in which the artist is shown seated in the studio, absorbed in reading rather than "working"), which is included in the present exhibition. Here is a typical sentence lifted from the essay in question, published in 2008: "Surely Hegel himself would have qualified *At Work* as an apt emblem of 'art made after the end of art,' that is, as an outstanding feat of arch-irony." My close reading of Wallace's *At Work* dealt primarily with the post-studio condition—or perhaps the everywhere-studio condition?—as exemplified by the artist's staging of art's creative process as an intellectual event first and foremost, no longer visibly artistic and/or productive in nature. See Dieter Roelstraete, "The Pleasures of the Text," in *Ian Wallace: A Literature of Images*, ed. Vanessa Joan Müller, et al. (Berlin: Sternberg Press, 2008).

3. This is an allusion to the Ars Electronica festival held every year since 1979 in the Austrian city of Linz, the heyday of its mid-to-late '90s cultural relevance to contemporary art's critical mainstream now something of a remote memory: has not all *ars* become *electronica* since then, in some way or other?

4. Liam Gillick, "The Good of Work," *e-flux journal*, no. 16 (May 2010).

5. Hannah Arendt, *The Human Condition* (Chicago: University of Chicago Press, 1958), 127.

6. In this precise historical context, it is worth reading Nauman's work from the late 1960s alongside the opening salvo of Daniel Buren's essay "The Function of the Studio" first published in 1971: "Of all the frames, envelopes, and limits—usually not perceived and certainly never questioned—which enclose and constitute the work of art (picture frame, niche, pedestal, palace, church, gallery, museum, art history, economics, power, etc.), there is one rarely even mentioned today that remains of primary importance: the artist's studio. Less dispensable to the artist than either the gallery or the museum, it precedes both." Daniel Buren, "The Function of the Studio," *October* 10 (Autumn 1979): 51. To call the studio "less dispensable to the artist than either the gallery or the museum" evidently points to the crisis the hallowed site of artistic production—an echo chamber symbolically amplifying the crisis of all traditional modes of production in the deindustrializing societies of early 1970s Europe and North America—had been undergoing since the dawn of the Conceptual art movement.

7. See Luc Boltanski and Ève Chiapello, *The New Spirit of Capitalism*, trans. Gregory Elliott (London: Verso, 2005), 194.

8. "The concept of work has been at the forefront of much critical debate in art in recent years, and art 'work' in particular, the activity engaged in by art 'workers' (now more commonly referred to as 'cultural producers'—a less politically charged equivalent), has become a rallying point for the broad discussion of 'labor' in the post-Fordist global economy. Not only are art 'practice' and various art 'activities' held up as paradigms of a new typology of production and productivity in contemporary creative capitalism, but the figure of the artist himself has now become the linchpin of a new culture of entrepreneurship and management that is predicated, in part, upon the precept that work is everywhere and nowhere at the same time; that we are always working and never at work; that life, work, and—in the artist's case—art can no longer be distinguished from each other in any meaningful sense. (That's one utopian promise fulfilled.)" Dieter Roelstraete, "The Business: On the Unbearable Lightness of Art," *e-flux journal*, no. 42 (February 2013), www.e-flux.com/journal/42/60252/the-business-on-the-unbearable-lightness-of-art/.

9. Nancy Spector, "Only the Perverse Fantasy Can Still Save Us", in *Matthew Barney: The Cremaster Cycle* (New York: Solomon R. Guggenheim Foundation, 2002), 5.

10. The background of these developments is further filled out by sporting culture (the story of Barney's youthful football career cut short is well known) and the billion-dollar business of the ever-expanding sports economy: the more sedentary and spatially immobilized our hyper-mobile working lives have become, the more we seem compelled to consume the televised spectacle of bodily motion and physical movement as the only truly valued laborious form of work today.

11. "To be in the midst of things, or to be engulfed by them: for some twenty years now (that is to say, since art became truly 'contemporary'), 'immersion' has been the object of a singularly powerful directive in art production. White cubes have become black boxes, environments interactive,

institutions self-critical, and aesthetics relational: art, in all these instances, has become that which surrounds us, a world unto itself as much as, if not more than, something in this world alongside ourselves. (We rarely stand opposite things anymore, and when we do, the thing is mostly considered retrograde, if not a remnant of reaction, or else our position is thought of as such: the promotion of clearcut subject-object relations in art is best left to historical museums.) This emergent rhetoric of emancipation through immersion is of course deeply linked to the rise of the *network* as the defining paradigm of a new economy rooted in information, immaterial labor, and the speedy transport of ideas. 'Connectivity' and 'mobility' are the reticular paradigm's greatest assets, or at the very least constitute its grandest claims—but anyone who logs on to the Internet, the paradigm's most successful and thorough incarnation, intuitively grasps the true meaning of the medium's steady transformation from a utopia of mobility to a dystopia of absolute immobility (though this last qualification seems to suggest that all immobility is innately evil, which it evidently isn't): in 'entering' the network, he or she has just stepped into the same thickening fog that art does so well to sell back to us as the height of contemporary (syn)esthetic experience." Dieter Roelstraete, "(Jena Revisited) Ten Tentative Tenets," *e-flux journal*, no. 16 (May 2010), http://www.e-flux.com /journal/16/61284/jena-revisited -ten-tentative-tenets/.

12. A tweet from Chelsea Manning dated July 9, 2017, shown to me by an artist friend during the writing of this essay, avows, minus the emojis: "all jobs are going away replaced by automation the jobs are not coming back, we need to figure this out! we need each other."

Jason Rhoades
The Grand Machine / THEAREOLA, 2002
cat. no. 94

Jason Rhoades
Mixing Desk and Chair / Yellow Ribbon in Her Hair, 2002 (detail)
cat. no. 93

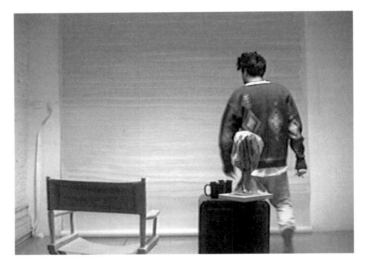

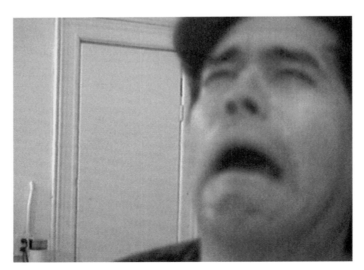

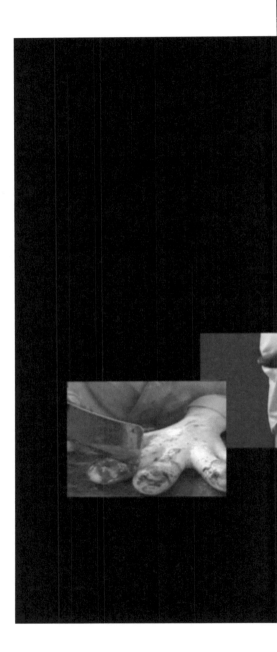

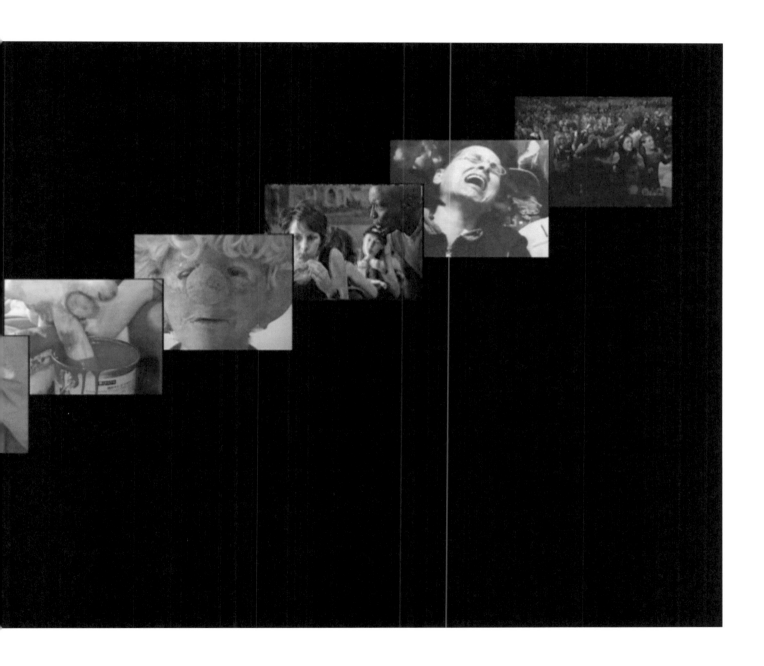

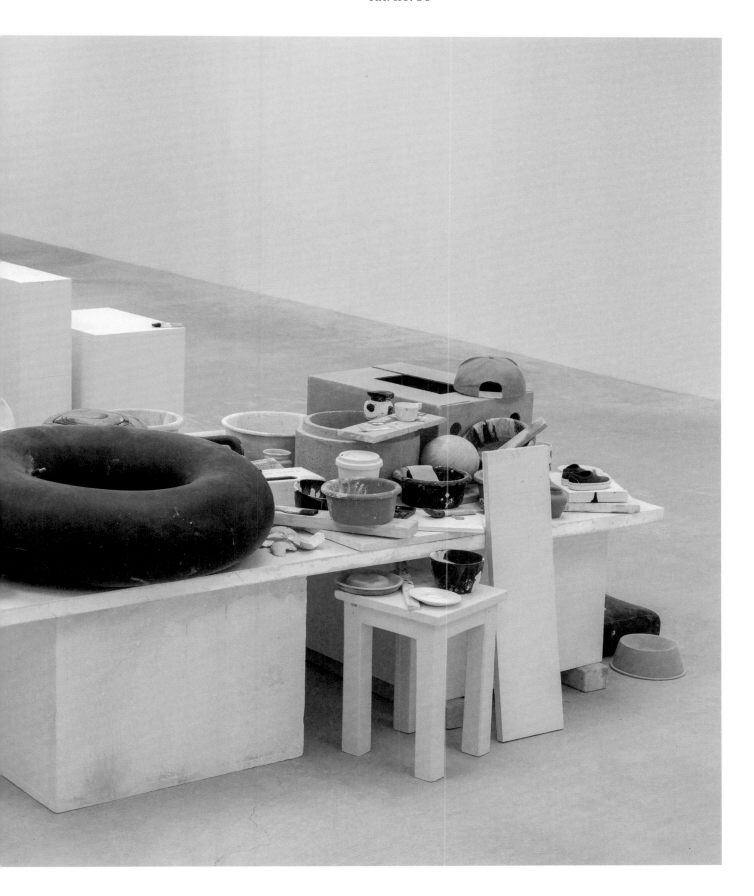

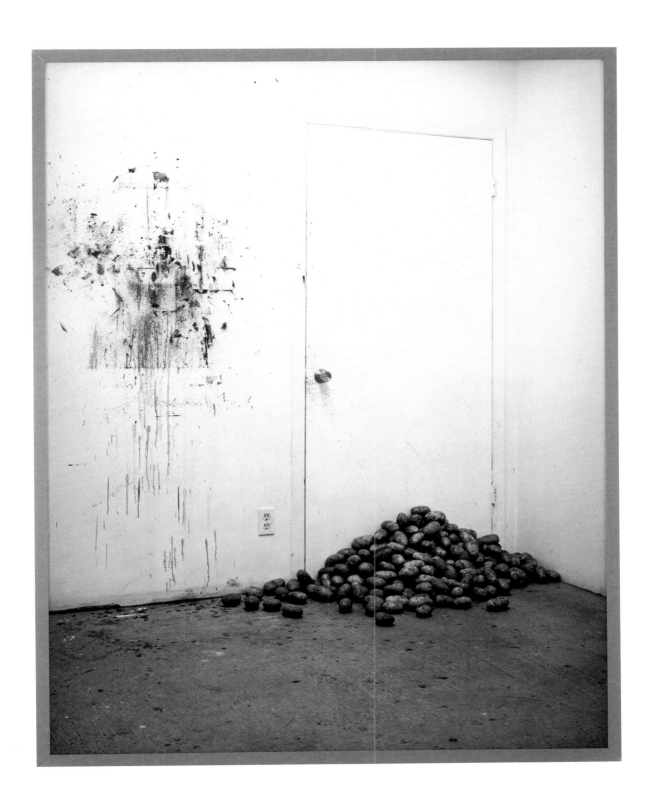

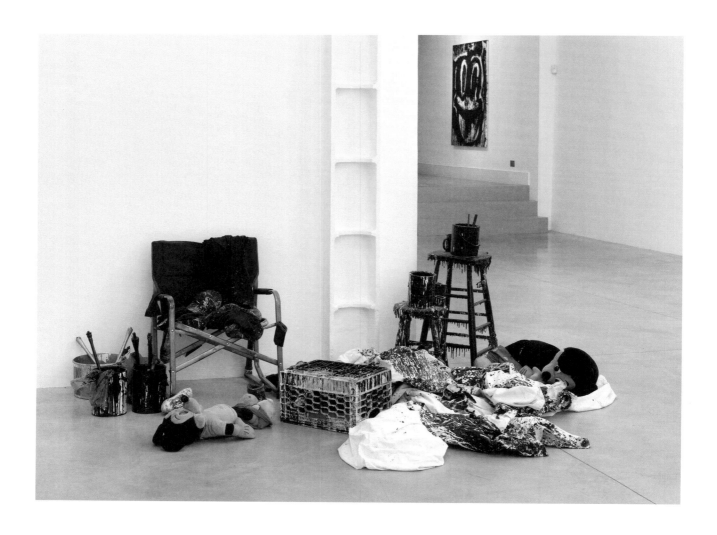

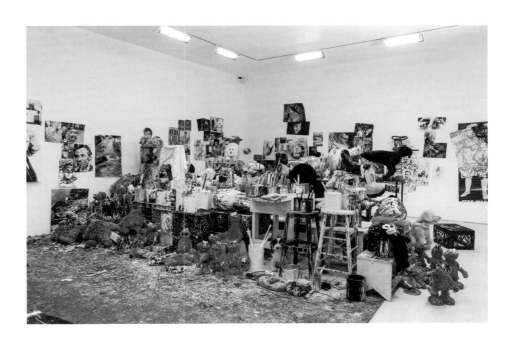

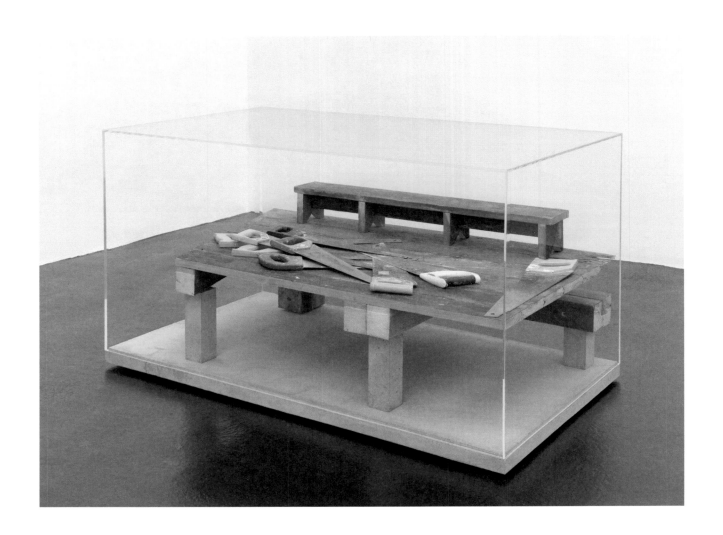

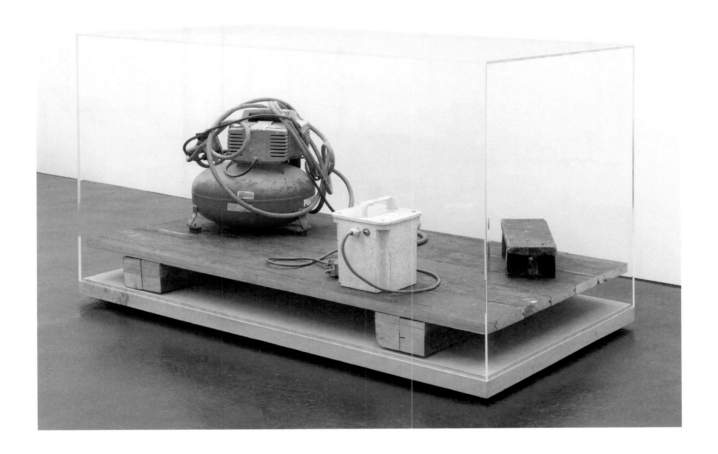

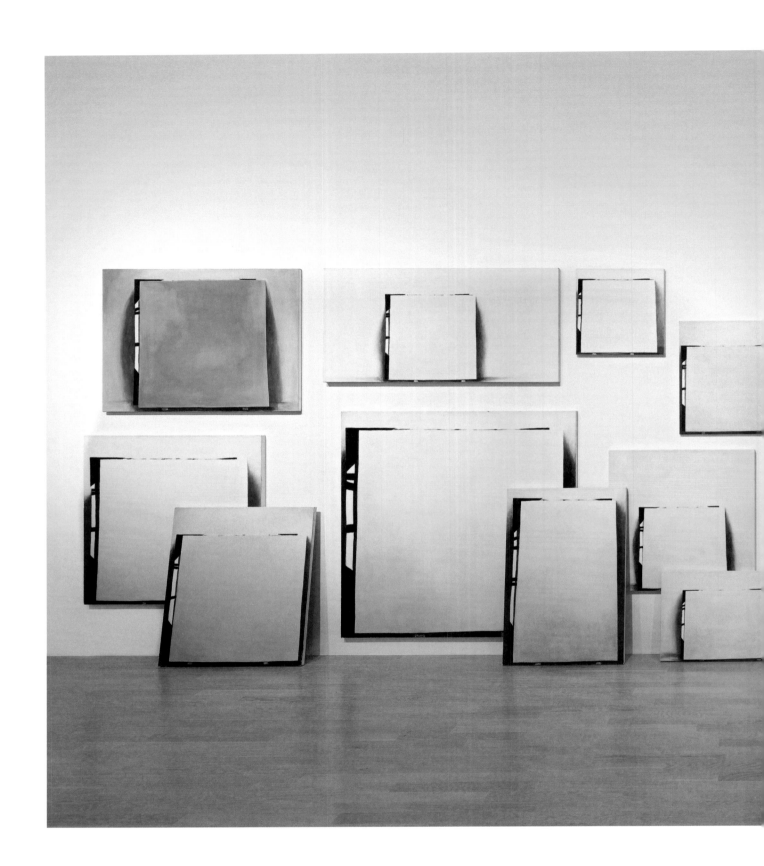

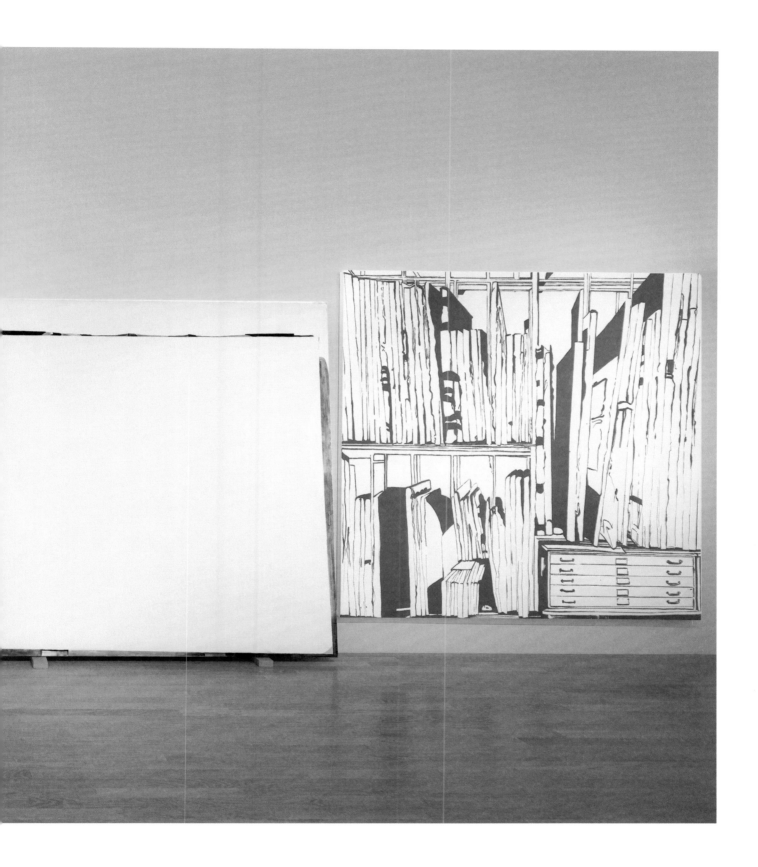

Jacob Proctor

A SPACE WITHOUT A FUNCTION

To start with, then, there isn't very much: nothingness, the impalpable, the virtually immaterial; extension, the external, what is external to us, what we move about in the midst of, our ambient milieu, the space around us.
—Georges Perec[1]

For Margaret Honda's 2015 solo exhibition in the enormous postindustrial shell of Triangle France in Marseille, the Los Angeles–based artist presented a massive new installation simply titled *Sculpture*. This labyrinthine construction comprised a schematic life-size rendering of every studio the artist has worked in over the course of her life, arrayed according to neither their geographical proximity to one another nor the order in which she occupied them. Since the installation takes the form of a succession of fifteen empty rooms, one might initially be tempted to situate *Sculpture* within a genealogy of empty exhibitions, beginning with Yves Klein's "Le Vide" in 1958, and continuing through the lineage of Art & Language, Robert Barry, Stanley Brouwn, Laurie Parsons, Roman Ondak, Maria Eichhorn, and others.[2] Or it might bring to mind a well-known passage from Georges Perec's 1974 book *Species of Spaces*, in which the author recounts his (unsuccessful) efforts to conceive of a space without use: "I have several times tried to think of an apartment in which there would be a useless room, absolutely and intentionally useless. . . . A space without a function. Not 'without any precise function' but precisely without any function."[3] But both of these associations would be mistaken, or at least radically incomplete.

Given that the work's spaces reproduce Honda's past studios, one might also connect it to the practice of painstakingly reconstructing, piece by piece, a particular artist's studio inside the walls of the museum, like the facsimile of Francis Bacon's studio at the Hugh Lane Gallery in Dublin or the replica of Constantin Brancusi's atelier installed on the plaza of the Centre Pompidou in Paris. But Honda's installation is as far from the verisimilitude of such reconstructions as it is from the voids. Indeed, the way she combines the architectonic with the archival suggests a closer analogue might be Michael Asher's 2008 exhibition at the Santa Monica Museum of Art, in which he reconstructed the skeleton of every temporary partition wall the museum had ever made. Where Asher produced a sort of institutional biography or a nonlinear account of the museum's exhibition history, however, Honda's work can be understood, at least in part, as an oblique retrospective of her own practice, represented not through the works she has made, but through the spaces in which she made them.

At the same time, *Sculpture* is, in Honda's words, "a ring-like configuration that encloses much of the exhibition space, forming a vast, dark, interior negative space that can be used as a screening room."[4] In Marseille, this makeshift black box was the venue for the premiere of Honda's film *Wildflowers* (2015). It, too, has an autobiographical origin: every spring, scores of Angelenos drive out to witness the brilliantly colored expanses of blooming native wildflowers in the deserts of Southern California. Honda recalls one such childhood trip as "the ideal Kodachrome moment," noting, further, that "it seemed as though the point of such a trip was to shoot all of this glorious color on Kodachrome."[5] Forty-five years later, armed with two fifty-foot magazines of expired 16 mm Kodachrome stock, Honda returned to the scene to film a series of individual flower specimens, with each shot lasting ten seconds. Because Kodachrome color processing ended in 2010, however, the film could only be developed as a black-and-white negative, rather than a color positive. Honda's idea was that both the flowers and the film would be drained of their most celebrated attribute—color—but it turned out that the expired film had already degraded to such an extent that it registered no discernible image at all. At that point, Honda has noted, the focus of the film "shifts to the act of projection as opposed to simply projecting, and the monochrome rectangle of light functions as a space for you to imagine."[6] In the finished film, during the ten seconds when each flower would have appeared, a male voice (that of artist and filmmaker Morgan Fisher) describes its color and other basic characteristics. Honda recently described all three of the works in her Marseille exhibition—*Sculpture*, *Wildflowers*, and the intensely descriptive but imageless publication *Writings*, which contains short texts on other works of hers—as "generative spaces."[7] Absent the images and objects we expect to encounter in such situations, it is left to the viewer to fill in the gaps, to fill the voids with their own experience and their own imagination.

Again, one is reminded of Perec's observations on the mundane, everyday spaces we inhabit and move through, usually without even noticing. Perec asserts that rooms—especially domestic ones—tend to be malleable spaces. While they have a particular function (or functions), rarely does function

actually inhere in their form. "All rooms are alike, more or less, and it is no good [architects] trying to impress us with stuff about modules and other nonsense: they're never more than a sort of cube, or let's say rectangular parallelepiped. They always have at least one door and also, quite often, a window," he writes.[8] By eliminating all architectural details from the original spaces and reproducing them only as volumes, Honda underscored the essential similarity and interchangeability of these rooms as containers for the activity of being an artist. Their identification as studios is functional rather than architectural, determined solely by the use to which they were put by the artist for the period that she occupied them. Indeed, the majority of the volumes that comprise Honda's *Sculpture* are not typical artist's lofts, but repurposed domestic spaces, from spare bedrooms and dining rooms to garages and basements, whose domestic forms are schematically transported into the exhibition space.

In this regard, it seems important to note that there is, besides the artist's studio, another kind of studio that haunts Honda's home city of Los Angeles—the movie studio. In this context, *Sculpture*'s raw, unfinished verso evokes the form of the set, not only the stand-alone interiors that were historically plopped down inside vast, hangar-like spaces in no architectural relation to one another, but also the full-scale architectural shells that populated studio backlots in Hollywood's golden age. Generally built with only a facade and the bare minimum of additional structural supports, such constructions were essentially all surface and no depth. Like the interior cavity of *Sculpture*, their "interiors"—inasmuch as they can be described as such—were raw, unfinished spaces, often repurposed as storage when not in use for filming. In its nonchronological, nongeographical configuration, then, *Sculpture* also recalls the way that historically and geographically disparate architectural styles abutted one another on studio backlots to create fantastical, impossible cityscapes. Of course, the studio backlot is by now more myth than reality, long ago superseded by location shooting as the industry norm. But, not unlike the stereotype of the artist's studio as a ramshackle industrial loft, it somehow persists, like an afterimage in the cultural imagination.

Against this background, a particular valence is created by Honda's engagement with analog cinematic and photographic technologies that are either disappearing or are already extinct. Whereas *Wildflowers* took up the paradigmatic activity (sightseeing) and technology (16 mm film) of the amateur, Honda's other films have been predicated on a rigorous engagement with the professional, technical side of the industry. Her first film, *Spectrum Reverse Spectrum* (2014), was made by exposing a single 2,500-foot reel of 70 mm film stock to precisely calibrated colored light in a continuous film printer. Over the course of the twenty-one-minute work, a uniform field of color gradually progresses through the spectrum of visible light—from violet to blue, cyan, green, yellow, orange, red, and black—and back to violet, the duration of each color in direct proportion to the amount of space it takes up in the visible spectrum. Identical head leaders at each end of the reel mean that the work does not need to be rewound between screenings. And because it is made without the use of a camera, *Spectrum Reverse Spectrum* contains neither frame lines nor an image

per se. Unlike a traditional film, it does not rely on the illusion of apparent motion. Rather, how the work appears to the eye on screen corresponds more or less analogously to its material existence on film: as one continuous gradation of color. And despite its palindromic structure, identical colors appear differently in the two halves of the film because of the eye's response to one color affects how subsequent colors are perceived.

The exacting technical process of color calibration involved in making this work led Honda, one year later, to create *Color Correction*, a 35 mm film made from timing tapes—the narrow rolls of perforated paper traditionally used in the process of correcting color imbalances in an original camera negative to ensure visual continuity across a film. It occurred to Honda that timing tape itself functioned much like a traditional negative—and that this meant one could make a standalone film from existing timing tape. In fact, *Color Correction* is conceived of as an edition, each version produced with a different set of timing tapes from a recent feature film, provided by a Hollywood film lab. Without image or sound, the quality and pace of the frequent color changes are determined entirely by the movie in question, whose identity, however, remains unknown to Honda and, of course, to the viewer. The resulting work is an unusual and visually complex hybrid of the industrial origins of the readymade, the material specificity and phenomenological investigations of structural film, and the aleatory quality of Surrealism.

Looking back a little further, we can see that *Sculpture* was not the first instance in which Honda explored the intersection of personal and cultural history, architecture, and artistic practice by playing with scale and replication. As early as 1997, she produced a series of works titled "White Objects," ten miniature versions, in the synthetic marble-alternative known as Corian, of parking lots she frequented at the time. And *Building* (2004) is a long graphite drawing on drafting film, made up of tracings from snapshots of the interior and exterior of Honda's childhood home in a working-class neighborhood of San Diego. To make the work, Honda selected family photographs in which she herself appeared, then traced only the architectural elements, erasing any human figures from the image. The result is a series of ghostly, incomplete renderings of the building, their fragmentary accumulation like a material residue of childhood memories.

In 2004 *Building* was included in Honda's solo exhibition "Transfer Pictures" at the Drawing Center in New York, and the accompanying publication served as the venue for another seminal work in this architectural trajectory. *Transfer* and *Transfer'* (2004) is a full-scale reproduction, in paper, of Honda's mother's sewing room, which had been installed in the dining room of their home, a room that would also serve as Honda's first studio. Honda divided the room's interior surfaces—walls, floor, and ceiling—as well as her mother's cutting table and sewing machine, into a grid of five hundred 11-by-17-inch cells. Each copy of the Drawing Center's in-house publication *Drawing Papers* 45, which accompanied the show, contained a single, numbered 1:1–scale section of the work, along with a diagram of the room identifying the position of each individual print in the larger whole. If all the pieces were combined in the

Installation view: "Michael Asher," Santa
Monica Museum of Art, 2008

correct order, they would form a life-size paper replica of the room. But this is, of course, not the artist's intention; instead, the publication's normal distribution process became a mechanism for scattering the work's constituent parts, which ended up miles, if not continents, apart.

Although it was not envisioned as such, *Transfer* and *Transfer'* became the first work in the ongoing series "4366 Ohio Street," a full-scale reconstruction of the entire house that Honda began in 2004. Always published as an insert or section of an exhibition catalogue or periodical, subsequent works have reproduced the house's patio (2006), hallway (2008), garage (2008), living room (2012), and bathroom (2013). In each case, both the size and quantity of the individual sections is determined by the physical format and print run of the host publication. Given what happens to its constituent parts, "4366 Ohio Street" is something of a paradoxical undertaking. As Honda herself notes, "the closer I get to finishing the house, the more fragmented it becomes, both structurally and geographically."[9] Any hope of bringing the works together diminishes exponentially as the series approaches completion.

Taken as a whole, one might see Honda's practice as an evolving answer to Daniel Buren's argument, more than four decades earlier, that the studio is a kind of purgatory from which objects have to be released in order to make their way to public (museum/gallery) or private (collection) display. If the studio has historically been understood, per this narrative, to be a private

and, above all, stationary place where portable objects (i.e., artworks) are produced, Buren's problem—what he calls "the unspeakable compromise of the portable work"[10]—was the mistaken idea of the work of art as an autonomous entity whose meaning and identity are immune to changes in context. Artists, he argues, work in the studio to produce works that are destined to be installed elsewhere. But the farther artworks get from their place of origin—the studio, which Buren describes as "the first frame, the first limit" of a work of art, "upon which all subsequent frames/limits will depend"[11]— the more compromised they become. Buren's solution, for better or worse, was to produce all works in situ, thereby eliminating (in theory, at least) this disparity between the site of production and the site of display. Honda, by contrast, situates her work in the interstices of this disparity itself, occupying its contradictions rather than attempting to resolve them.

Today, when the term "post-studio" has long since come to designate a wide range of accepted artistic activity untethered from any location beyond a laptop computer, and when the critiques of Buren and others of his generation have been thoroughly absorbed by both the art-historical and the pedagogical establishment, the idea of the studio nonetheless retains a privileged—even mythical—status in narratives of artistic creation. For many, the visit to the artist's studio persists as a crucial step in the relationship between the artist and the curators, critics, dealers, and collectors who make up the primary (both in the sense of the first and the most important) audience for new works. It may no longer be defined by fixed geographic or architectural coordinates, but "the studio" is still both an enduring concept and the place where artists go about the business of being artists.

At the same time, however, viewers have quickly become accustomed to viewing content across a multitude of platforms, and fluid migration back and forth across the analog-digital divide is commonplace. For example, a film might be shot on 16 mm, transferred to digital video for editing, and either output back to 16 mm, or simply projected digitally. Virtually any surface, it seems—from the smartphones in our pockets to the sides of entire buildings—can be transformed into a screen, while streaming video services provide instant access to moving image works in any location with sufficient bandwidth.

It is precisely these virtual conditions—platform migration, iterability, compression, versioning—that Honda ends up highlighting with *Sculpture*'s "reinstallation" at the Institute of Contemporary Art, Miami. In Marseille, *Sculpture*'s mediums were identified laconically as "wood, drywall, exhibition space," a list that is at once both technically incomplete (it tells us nothing of the fasteners holding this construction together, the paint coating the walls, or the sandbags anchoring it in place at various points) and evocatively expansive. Including the exhibition space itself among the work's constituent parts exceeds the ubiquitous banality of "dimensions variable," pointing to the central importance of the site while sidestepping the inflexibility of true site-specificity. Moreover, it emphasizes that *Sculpture*'s meaning, like its materials, will always be contingent on the immediate spatial and temporal circumstances of its display. And indeed, for the present exhibition at ICA Miami, Honda has

radically reconfigured the work in direct response to its new context. In the new iteration, titled *Model for "Sculpture"* (2017), each studio is reproduced at half-scale rather than life-size; and instead of a succession of individual rooms arranged around a central void, the footprints of the studios are superimposed or layered atop one another, compressed into a single volume of space. No longer able to enter into it directly, we instead must circumnavigate the work, peering in from the outside. As opposed to a sequence of empty spaces, we face a thicket of overlapping and intersecting walls, something that is more object than environment. Like "4366 Ohio Street," *Model for "Sculpture"* is something of a paradox: the more studios are added to the space, the more fragmented it becomes. Every space is present, but in a format that resists readability, each canceling the other out in a form of architectonic interference. In this spectral accumulation of studios, Honda has succeeded where Perec failed: the studio has become a space without a function. Or perhaps its functionlessness is only temporary. Like a compressed digital archive, all its personal and architectural histories remain intact but illegible, waiting to be expanded again in the future.

NOTES

1. Georges Perec, *Species of Spaces and Other Pieces*, ed. and trans. John Sturrock (London: Penguin Books, 1997), 5.

2. On this lineage, see *Voids: A Retrospective*, ed. Mathieu Copeland, et al. (Zurich: JRP|Ringier, 2009).

3. Perec, *Species of Spaces*, 33.

4. Margaret Honda, *Writings* (Marseille: Triangle France and Künstlerhaus Bremen, 2015), 9.

5. Ibid., 13.

6. Ibid., 11.

7. Margaret Honda, email correspondence with the author, April 21, 2017.

8. Perec, *Species of Spaces*, 28.

9. Honda, *Writings*, 57.

10. Daniel Buren, "The Function of the Studio," trans. Thomas Repensek, *October* 10 (Fall 1979): 54.

11. Ibid., 53.

Wade Guyton
Untitled, 2015
cat. no. 46

Wade Guyton
Untitled, 2015
cat. no. 47

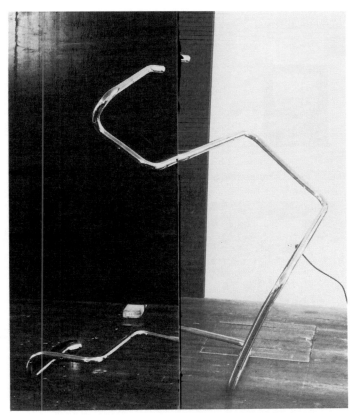

Wade Guyton
Untitled, 2015
cat. no. 48

Wade Guyton
Untitled, 2016
cat. no. 49

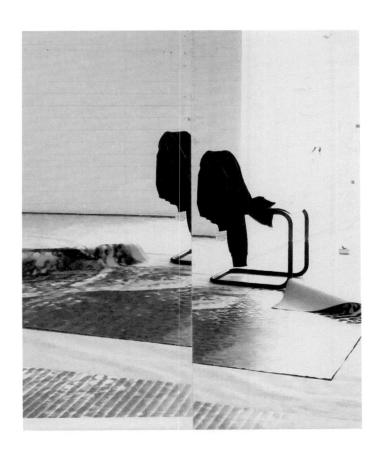

STUDIO SYSTEMS

"Every age has its own carriage, its expression, its gestures," Charles Baudelaire asserted more than a century ago, underlining how any particular time's aesthetic and artistic conventions—and, moreover, its very conception of the artist—necessarily correlate with the social and material environment in which they appear.[1] The famous adage might be seen as a precursor to less lyrical observations among artists during the 1970s and '80s that artistic gestures are necessarily linked to the institutions making them legible. Yet, when made today, any such assertions (or truisms, if you wish) only render more palpable a low-grade anxiety that has permeated contemporary art for nearly twenty years, revolving around a suspicion that artistic endeavors are losing their distinctive, contrapuntal quality with respect to cultural production in society more broadly. In fact, some would argue, the implied sides of Baudelaire's original correlation—of art and its cultural context—merge into one another all too frequently. Put another way, the material conditions of society have collapsed this distinction and thus largely rendered the poet's model and proposition obsolete. As Manuel Borja-Villel, director of the Museo Nacional Centro de Arte Reina Sofía in Madrid, observed roughly a decade ago, reflecting upon the waning authority of arts institutions in the face of the ever-increasing prominence of the so-called creative industries: "Museums have lost their privileged position in defining what we understand to be culture . . . [due partly to] a diffuse magma of cultural producers, who typically subordinate creative singularity to the selling or expropriation of creative capacity."[2]

In other words, art—as a locus of critical reflection and personal expression, as well as of the shaping of subjectivity itself—may well remain in dialogue with broader socioeconomic structures, but those structures increasingly share its material terms and aspirations (at least cosmetically). The nagging question that remains for the art world is whether its arbiter of value has also shifted from singularity to *capacity*—requiring a reconsideration of art's most fundamental

terminologies in turn, from aesthetic object back to artist, as well as to the studio that first provides a context for both. Indeed, these historical shifts definitively change the status of the "studio," which can no longer be considered the kind of site depicted by, say, Pablo Picasso or Roy Lichtenstein, featuring the artist and model or object as figures in active relation. But nor can it any longer be understood in the expanded sense it developed under the umbrella of Conceptualism, whereby John Baldessari could outsource the actual labor of painting to a sign-maker (literally and semiotically speaking)—to say nothing of its prior ritualization and display as detritus, stage, or decor by the likes of Bruce Nauman, Dieter Roth, and Daniel Spoerri. Instead, the studio—contemplated in such historical perspective—might today uniquely offer a window on to a much more abstract scene, effectively reversing that site's traditional poles of private and public, production and reception, if not suggesting their very conflation in the realm of contemporary art.

Parsing Borja-Villel's invocation of the term *capacity* turns out to be especially illuminating when it comes to assessing these developments. On the one hand, the word pertains to basic questions of size. From this perspective, the art world's anxiety regarding its contemporary standing revolves at least partly around its ostensible success at the start of the new millennium: an exponential expansion of both infrastructure (larger museums, more galleries, as well as more degree programs for artists and curators) and audience numbers, which has, however, contributed to a lost sense of cohesion and, moreover, purpose within art's discursive field. Indeed, if numerous critics and scholars were decrying the rise of pluralism during the early 1980s—arguing that the proliferation of different and unrelated artistic strategies was implementing the logic of the neoliberal marketplace, belying any historical thread to which artists might otherwise feel obliged to respond—such atomization only became entrenched and amplified with the arrival of customization throughout commercial culture.[3] (A special mission among millennial corporations

was to engage consumers' personal histories so actively with regard to creative capacity that, in the famous words of one popular business tome, "the customer is the product."[4]) More generally, numerous theorists have pointed out how a radical proliferation of media outlets in recent decades has contributed to the disintegration of the public sphere throughout broader society; people have so few shared sources of information that it is all but impossible to establish a basis for meaningful dialogue and exchange.[5] Yet the same may be said of contemporary art as forms and audiences experienced such radical growth during this century's first decade, with so many modes of artistic production put forward to be received by so many different constituencies that are considered in relation all too infrequently. (While its most prominent organizations and institutions ostensibly remain intact, many of these core institutions might be said to remain oriented—through habit, infrastructure, and architecture—around artistic, viewing, and critical practices rooted in an earlier historical moment.[6]) Even criticality in art can seem merely stylistic in this context, commonly understood as a sign of difference and directed toward a highly specific audience.

Surveying artistic practices against such an ambiguous backdrop, it is tempting to recall an observation made by art historian Thomas Crow during the late 1980s regarding a generation of artists who, he argued, had recognized that modernist abstraction—in all its aspirations toward individual autonomy—was no longer viable as a mode of resistance to the forces of mass commerce. Hence such artists, from Sherrie Levine to Peter Halley, embraced modes of appropriation (for instance), accepting that even the fundamental constitution of the creative subject herself or himself could not be seen apart from larger socioeconomic structures. As Crow observed, "Art survives now by virtue of being weak, a condition signaled in the ritual sacrifice of the artist's authorial presence," which, he continued, allowed artistic production to emulate the circulatory character of advertising, likewise "made available to endless rearrangement and repackaging."[7] And herein lies

a second meaning of *capacity* within the field of contemporary art, perhaps more important than the first: aptitude, whereby value is accrued not by virtue of what has been produced, but rather of what might yet be produced.

By putting forward this alternative sense, I mean to underscore a fundamental reorientation of many artistic practices during the past forty years. While Crow's assertion seems particularly resonant today—given the pervasiveness in contemporary art of "rearrangement and repackaging," which is readily apparent as, say, prominent artists frequently present interrelated bodies of work in exhibitions across the globe—it is intriguing that such projects are now steeped less in a discourse of appropriation than one of distribution. In other words, whereas an earlier generation of artists adopted the technique of displacing images and objects from their original cultural contexts in order to make plain otherwise implicit biases and constructions of meaning (making a "singular" interjection, as it were), artists more recently have taken an anticipatory stance with respect to such displacement—underlining how images and objects are continually subject to shifts in context, and thus have the capacity to lose and gain new meanings over time. As Seth Price would write in his text *Dispersion* (first published 2002 and repeatedly revised since), seeming to formalize the gist of Crow's observation as an endeavor associated less with production than with project management: "New strategies must be able to keep up with commercial distribution, decentralization, and dispersion. . . . The task has become one of packaging, producing, reframing, and distributing."[8] And to such an end, artists since the turn of the millennium have overtly embraced the model of the network, effectively creating systems for the sustained circulation of their own work. In fact, they have made such systems the very subject of their art. The phenomenon was described succinctly by scholar David Joselit as he was considering the 2016 Berlin Biennale, saying that the exhibition curators "DIS, along with other artist 'corporations' such as e-flux, Reena Spaulings, and K-Hole . . . structur[e] art practice as an infrastructure to

provide a network of platforms supporting a wide variety of activities including exhibitions, publishing, fashion, performance, and even traditional object making."[9]

By itself, the use of multiple platforms by artists is somewhat unremarkable—or at the very least not so new. For a structural precursor, one notes how the premise of an "aesthetic of administration" in art, whereby Conceptual projects took on the data-laden guise of corporate or legalistic infrastructure, "den[ying] the validity of the traditional studio aesthetic," has long been established.[10] As an artist a bit closer in spirit to our postindustrial era—and perhaps a more provocative case—consider Matthew Barney. While he is not typically aligned with networked artistic practices, he has regularly deployed branding design throughout his systems of imagery.

Matthew Barney, *Cremaster Suite*,
1994–2000 (detail).
Five chromogenic prints in self-lubricating
plastic frames, 45 ¼ × 35 ¼ in. each

Richard Maxwell and New York City
Players, *Untitled*, Whitney Museum of American
Art, New York, 2012

His iconic productions during the early 1990s were already moving from platform to platform, with sculptures featured in video works only to appear within gallery installations, pointing to how objects could function beyond the representational medium as they do within. (Underlining this logic of reframing, his artistic studio would occasionally be turned into a film studio. Yet early works from the "Drawing Restraint" series (1987–89) functioned in a similar way, as Barney would record photographic documentation of himself making work, "performing" for the camera, thus redistributing artistic activities native to the studio among outside viewers.[11]) In truth, such structuring was not necessarily a novelty even then, as it immediately brings to mind how Robert Smithson's films and sculptures were set within the relations of site and non-site. Nevertheless, Barney's "Cremaster" cycle (1994–2002) may be understood as a network unto itself, privileging modes of entrance and exit, whether featuring orifices, tubes, or windows that the camera approaches or passes through. Images provide a system of portals, and the artist's editing technique enables the camera to move easily from macrocosmic to microcosmic scales. Such works follow the diagrammatic logic of online pages, hyperlinks, and frames, with images accruing the metaphors of space folded within space, and with the divide between video image and physical object—or between cinema and

art gallery or institution—consisting of only one more editing cut, or "link," in the chain.[12]

The overtly adopted guise of a "corporation" subsequently becomes crucial as a primary characteristic distinguishing recent networked art from structurally similar work that came before. The guise of the artist as an incorporated figure marks a departure from the liberating "death of the author" remarked upon by Crow. Now Roland Barthes's artist or writer, understood as a manager of signs, is herself or himself newly taken up as an arbiter of value. Indeed, the artist in this instance seems a "connectionist" figure of the kind described by sociologists Luc Boltanski and Ève Chiapello: an individual who excels within an increasingly networked culture, where networking, as opposed to the creation of a physical object, as in the old studio model, is recognized as a source of value in and of itself.[13] Remarkably, the authors describe this person using much the same vocabulary as Crow does the artwork, explaining that she or he displays an incredible facility for making transitions, manipulating, circulating, and recombining symbols while moving from project to project. (It is occasionally difficult, when considering their description of the rise of Toyotaism during the early 1990s—which saw the assembly line set aside for flexible teams that could be deployed as needed—not to think of commissioning scenarios for artists whose studios incorporated high-end fabrication work during the 2000s.) The logic of commerce, in other words, migrates from the produced object to the creative individual—who has, in a sense, herself or himself been produced. And if such a figure has by numerous accounts risen to ever-greater prominence in art—among artists, curators, and critics alike—it has eroded art's public sphere from within, as critical dialogue is set aside due to fear of creating antagonistic relationships that break connections rather than multiply them. To cite scholar and critic Isabelle Graw's analysis of the art world's pluralist character: "The artistic field no longer defines itself in terms of camps and rivalries" because "today's rival could be tomorrow's crucial cooperative partner. For this reason, hardly anyone fights out in the open."[14]

Here one discovers yet another key valence for art's relationship with capacity, however, as the arbiter of art's value shifts from critical *intervention* (or deconstruction) to critical *mass*—from the strength of an artwork's illuminating force to the strength of its community, or social network, and its catalytic effect there. Numerous arts writers have pointed to a turn away from models of critique in recent years, calling attention in particular to its inefficacy. Some have suggested, for instance, that critique is fundamentally reformist in character, bound as it is to the a priori dictates of any object it engages (whereas other models, such as celebration, might give rise to entirely new models of discourse for a changed cultural time). In a more philosophical vein, Renaissance scholar Patricia Falguières has written that the roots of artistic discourse in questions of representation should be reconsidered, so that artists might turn instead to mimesis as a "mode of inscription or interlocking of the different kinds of movements that order the world, one within the other," in order to engender a real "capacity to perturb the economy of persons and things."[15] (As she explains, introducing an Aristotelian twist to a contemporary setting, this would mean art's core shifts from unpacking questions of representation to taking

effect in the world, with mimesis "[signaling] that inscription of human doing within the reparation and attempt to complete movements, which nature does not necessarily take to fruition."[16]) Yet most significant for our grasp of the artist's position might be a dynamic remarked upon by Martin Kippenberger around the time of Crow's statement, saying that he never had any clue about the quality of his works until they were released into the world. "I am not about to educate the world with a new brushstroke," he once explained to an interviewer asking about his criteria for painting. "In my case, good paintings are only good if they have this or that effect. And I will know that only when I get them to the outside. . . . I can only judge the reactions."[17] The comment is clearly relevant for our understanding of contemporary art's relation to networks, and social networks in particular. As Joselit would write in another instance, paintings might function "as the nodal point of performance, installation, and a figurative style of gestural reenactment on canvas," becoming objects embedded at once in discursive and social relations.[18] But Kippenberger's words are most remarkable for also creating a kind of inversion of public and private, showing how they interlock. In fact, the artist's observation, put forward against the backdrop of a waning public sphere and a weakening of critique—and the ensuing rise of capacity as an arbiter of value—suggests an exchanging of places between display space and studio as well. Only when the work is set in a physical relationship to the viewer is it complete. In a sense, this means the object being produced is the audience itself (which only then makes the conventional aesthetic object legible in turn). In other words, the social context itself is the artist's studio.

* * *

To offer just one salient precursor, consider a contribution made by Bernadette Corporation's John Kelsey to the aptly titled volume *Corporate Mentality* (2003), in which the artist and writer would describe the genesis of one of his collective's inspirations and collaborators, Purple Institute:

Trajal Harrell, *The Practice*, The Museum of Modern Art, New York, 2014

Founded in 1992, Purple Institute is an arrangement of multiple practices under one roof in Paris: magazine and book publishing, corporate consulting, art direction, a record label, a store, curatorial initiatives, a loose scene of friends working in art and fashion. Informed by a post-Deleuzian conception of cultural production in late capitalist society, Olivier Zahm and Elein Fleiss oversee a network of interrelated projects, some firmly engaged in corporate culture, others in the museum or in bed.[19]

Accompanying the brief text are a few images of Purple's offices—or studio, if you will—which are largely nondescript, seeming a cross between open-plan administrative areas, raw studio, and parking garage—spaces defined by utility, flexibility, and openness, effectively providing an architectural corollary for Kelsey's words.[20] But the most intriguing ambiguity here arises in the description of the people inhabiting and activating such spaces as a "loose scene of friends working in art and fashion," which suggests a low-grade professionalization (and aestheticization) of what would otherwise be informal relationships. Such a potential reframing of relations would be striking for taking place just a few years after Crow articulates his notion of a "weak" art—marking a swift move from representation to real and social space—and even more so for its resonance with contemporaneous writing by Boltanski and Chiapello regarding the fate of personal expression. Looking back at the revolutionary moment of May 1968, the authors note that one of the protestors' primary demands was for greater creative fulfillment in the workplace (the sociologists call it an "artistic critique"), the acceptance of which by corporations gave rise to a novel paradox.[21] Until then, authenticity had revolved around the notion of personal expression standing apart from the forces of commodification, and yet now it was assuming a prominent role within commercial spheres. (As it happened, corporations embracing an ethos of personal expression over subsequent decades enjoyed an unanticipated rise

in productivity.) With this new role for creativity, however, a kind of spiral was created around the idea of authenticity. The only way for individuals to retain a sense of authentic self-expression was by deploying a kind of inauthenticity—which would signal to a few knowing others their cognizance of self-expression's reification within the realm of commerce. In other words, the poles of authenticity and inauthenticity were reversed in significance, with the latter wielded to obtain some semblance of the former. And yet, returning to the template of Purple Institute, questions remain. Does the opening of the studio workplace as a way of flaunting the new conditions of commerce represent a kind of closure as well? To put it differently, is the expansion of a network of interrelated projects simultaneously a kind of contraction? Looking beyond Purple Institute to a broader legacy among artists, the notion of a corporation in art might involve an "in"corporation, too, addressing at best a public that remains private, among a group of insiders, no matter its size.

The spiral, after all, is still present as inauthenticity eventually becomes consumable as well. Indeed, another text in *Corporate Mentality* would suggest that Bernadette Corporation incorporated this shift into their work of the 1990s, saying of the collective's moves into fashion and commercial branding: "It made no sense to speak of critique from Outside, not when critique was the hottest commodity going."[22] But, to return to the subject of anxiety in art, the stakes for such an enterprise have only become greater as personal expression has been recast within institutional settings, where works steeped in social interaction—and, as significant, artistic production itself—have by now assumed a preeminent place. While corporate enterprises among artists remain pervasive, one may see them—particularly if considered as kinds of studios—as part of a larger continuum, alongside, say, open rehearsals by theater director Richard Maxwell at the Whitney Museum of American Art in 2012 and choreographer Trajal Harrell at the Museum of Modern Art in 2016. (Both installations literally put a studio situation on view as an object of consideration for gallery-goers, who witnessed an unfinished work in the making as they

Maria Hassabi, *PLASTIC*, The Museum of
Modern Art, New York, 2015–16

perambulated the spaces—with many therefore looking at time-based work as if it were image- and object-based.) And whereas the social dimension of incorporated artistic enterprises is effectively treated as a material reframed, one may find correlatives in performance works that underline the discipline's transition from a medium steeped in immediacy and singular presence to another of mediated distance, consisting partly of image and partly of object. To offer readily accessible examples, there is Marina Abramović's 2010 "The Artist is Present" at the Museum of Modern Art in New York. This exhibition's framing emphasized the artist's "presence," hearkening to the singularity of historical performance work, but nevertheless involved creating a film studio (rather than an artist's studio) in the museum's atrium—a space that is at once a gallery and passageway—lending both work and social interaction a representational quality.[23] More recently, Maria Hassabi's *PLASTIC* (2016) reflexively deployed dancers in the same atrium, where their slow—at times barely perceptible—movements made bodies at once into sculptures and representations, alternately inhabiting artistic and social spheres.

In a sense, and perhaps intuitively, audiences for such pieces encounter the gallery as the workspace we have traditionally known it to be: a figure, even while encountered within a performance, is being rendered for the eyes. But in another sense, and one that has further-reaching consequences, such works suggest the potential for another kind of space altogether. Neither an object nor an audience is produced here, but instead the studio. It is no longer the site where an individual labors behind closed doors—whether alone or with a cadre of assistants—to create work later presented publicly, but instead an emphatically social space, where the audience produces not only the meaning of the work, but in many ways constitutes the the work itself. And yet the question then becomes one of how audiences—whether they hail from the art world or the general public—might yet become reflexive collaborators within that space. Just as criticality has become a kind of style, so perhaps has participation—asking for a different language to account for a relationship between maker and beholder, production and reception, that takes account of our age's carriage, expressions, and gestures. What singularity in art will have the capacity to do that?

NOTES

1. Charles Baudelaire, "The Painter of Modern Life," in *Baudelaire: Selected Writings on Art and Artists*, trans. P. E. Charvet (Cambridge: Cambridge University Press, 1981), 404. The original French quotation is "chaque époque a son port, son regard et son sourire."

2. Manuel Borja-Villel, "The Museum Revisited," *Artforum* (May 2010): 282.

3. For the best consideration of this pluralist landscape, see Hal Foster, "Against Pluralism," in *Recodings: Art, Spectacle, Cultural Politics* (Seattle: Bay Press, 1985), 12–32. For further discussion regarding customization in the contemporary art context and its impact on discourse, see Tim Griffin, "Custom Made," *Artforum* (November 2007): 63.

4. B. Joseph Pine II and James H. Gilmore, "The Customer is the Product," in *The Experience Economy* (Boston: Harvard University Press, 2011), 163–71.

5. Philosopher Bruno Latour perhaps made this case most prominently in the early 2000s in online essays since removed from circulation. For related texts, see Bruno Latour, "Why Has Critique

Run Out of Steam? From Matters of Fact to Matters of Concern," *Critical Inquiry* (Winter 2004): 225–48; and, later, "The Year in Climate Controversy," *Artforum* (December 2010): 228–29.

6. My assertion is related to an earlier footnote regarding the art world's homogenization through the rise of pluralist economies in art as bearing the imprint of neoliberalism now giving way to an ethos of niche marketing. But an outstanding question is whether the latter development demands a shift in language as well. Given the potential stylization of critique—as a sign whose value might reinscribe rather than challenge cultural and institutional convention—and the decline of social structures within which critical discourse was modeled, what alternative techniques must be developed in terms of both art making and engagement? See Andrea Fraser, "From the Critique of Institutions to an Institution of Critique," *Artforum* (September 2005): 278–83, in which the artist begins by taking note of the institutionalization of Institutional Critique itself. In light of such developments, and as suggested by an observation from Patricia Falguières later in this text, we are witnessing a rise in materialist approaches across disciplines.

7. Thomas Crow, "The Return of Hank Heron," in *Endgame: Reference and Simulation in Recent Painting and Sculpture*, exh. cat (Boston: Institute of Contemporary Art, 1986), 16.

8. Seth Price, *Dispersion*, 2002. See http://www.distributedhistory.com/Dispersion2016.pdf.

9. David Joselit, "Four Theses on Branding," *Texte zur Kunst* (September 2016): 170.

10. See Benjamin H. D. Buchloh, "Conceptual Art, 1962–1969: From the Aesthetic of Administration to the Critique of Institutions," *October* (Winter 1990): 105–43. Notably, Joselit's text "Painting Beside Itself" (*October*, Fall 2009, 125–34) opens with a quotation from Martin Kippenberger suggesting that every canvas is enmeshed in a larger network. It is especially important to note how his studio assistants would themselves constitute a network extending from within his studio to the social sphere of an art-world public, so that objects emerging from the studio were, in a sense, specific figures of that relationship.

11. For the purposes of this exhibition, it is relevant to note how Bruce Nauman would similarly reproduce his studio environment for audiences around the same time in *Sound for Mapping the Studio Model (The Video)* (2001). Here, audiences would watch the video in a darkened gallery populated by rolling office chairs, so the reproduced studio environment seemed doubled in real space.

12. This passage is rooted in two texts I wrote some time ago on Matthew Barney and the concept of a "multiple platform artist." See "Every Age Has Its Artist," *artext* (May–July 2000): 44–45; and "Matthew Barney: The Cremaster Cycle," *Artforum* (May 2003): 162, 193. In many ways, Barney's engagement with performance, sculpture, and photographic reproduction is remarkably prescient for discussions of performance in arts institutions today.

13. Luc Boltanski and Éve Chiapello, "The Formation of the Projective City," in *The New Spirit of Capitalism* (London: Verso, 2005), 103–63.

14. See Isabelle Graw, *High Price: Art Between the Market and Celebrity Culture* (Berlin: Sternberg Press, 2010), 106–07.

15. Patricia Falguières, "Fatal Attraction," in *The New Existentialism*, ed. Tim Griffin (Dijon: Les presses du reel, 2017), 21.

16. Ibid., 22.

17. Ariana Müller, *Picture a Moon, Shining in the Sky: Conversation with Martin Kippenberger*, trans. Micah Magee (Berlin: Starship, 2007), 19. Recall here as well how the "public" might extend out from within his studio among his assistants.

18. David Joselit, "Painting Beside Itself," 130.

19. John Kelsey, "Purple Institute," in *Corporate Mentality*, ed. Alexandra Mir and John Kelsey (Berlin: Lukas & Sternberg, 2003), 156.

20. Notably, Kelsey would later depict another studio scenario from an apparently opposite direction, describing the studio of Wade Guyton as a "quasi-office"— representative of a generation of artists for whom the desktop computer monitor and printer are ordinary tools both of their craft and administrative activities. See John Kelsey, "100%," in *Rich Texts: Selected Writing for Art* (Berlin: Sternberg Press, 2010), 15–23; and "Decapitalism," in ibid., 65–74.

21. See Boltanski and Chiapello, "The Test of the Artistic Critique," in *The New Spirit of Capitalism*, 419–82.

22. Simpson, "Bernadette Corporation," 153.

23. For a great overview of this presentation within the larger landscape of performance in the museum setting, see Hal Foster, "In Praise of Actuality," in *Bad New Days* (New York: Verso, 2015), 127–40, 178–84.

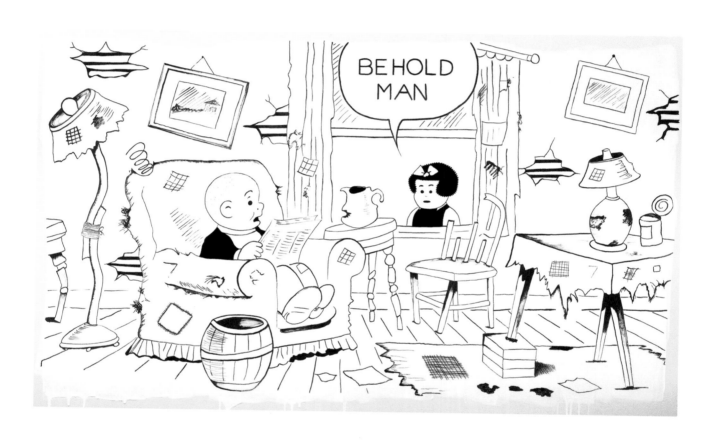

Frances Stark
Behold Man (Nancy and Sluggo recto
verso pendant pair), 2017
cat. no. 108

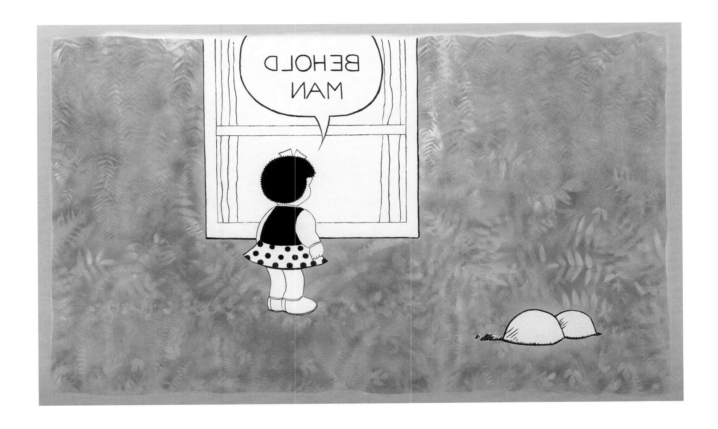

Caroline Busta

STUDIO DOMAINS

The fundamental question that has haunted art for the past century or longer—arguably even more than, "Is painting dead?"—is, "Does art still need the studio?" It can be traced back to at least the empty ateliers of the plein air painters who abandoned their built workspaces to capture the changing light across the open fields and rapidly industrializing cityscapes of the mid-nineteenth century. Yet if the vital stats of painting point to the health of the art market, the status of the studio seems a barometer of art's current standing within culture at large. With each new permutation of art's formal limits, the function of the studio is questioned anew, often compelling artists to define their practice in negative relation to whatever the "studio" at the time is understood to be.

A particularly acute example from the postwar period came in 1970 with the founding of the California Institute of the Arts (CalArts), and specifically with a class by John Baldessari on "Post Studio Art." Taking the school's library as its default location, his students would determine a point on a map using a chance procedure and then migrate off-campus to engage with the place in real life,[1] in a way not dissimilar to Robert Smithson's correlation of "site" and "non-site." Writing about this "expanded field" in 1979, Rosalind Krauss spoke of the anxiety of "sitelessness" in the post-studio age—a kind of "homelessness," as she called it, "an absolute loss of place." Krauss argued, however, that even if the field of art had expanded to include decidedly new ground, this vector of change was in fact a constant in art since modernism, perpetually recalibrated so as to correlate with the "universe of terms that are felt to be in opposition within a cultural situation" at a given historical moment. In other words, the field of art (and the studios of its practitioners) necessarily reflects the psychological, physical, and ideological limits of culture.[2]

Cut to mid-2000s America: drone warfare over Jalalabad, Afghanistan, operated from a command center in Langley, Virginia. Screenspace/battlefield: non-site/site. Here is, in a nutshell, our present-day universe of terms. Contra any notions of

"post," the studio, some forty years later, is not only as present as ever, but also literally everywhere, as site and non-site are psychologically and operationally intermeshed and omnipresent. This everywhere studio exists on the screens in our hands and the sites they access—sites that use us at least as much as we use them, and which increasingly demonstrate their own seemingly autonomous will to "create." At the same time, online platforms drive user engagement by encouraging everyone to be a "maker." "The world is your whiteboard and everybody can draw," these apps say. Let the rotorelief of site and non-site, person and persona, spin. The still-prevalent romantic conception of the artist as an exceptional individual standing in objective distance from the normative order of the world comes with the expectation that such a figure is never not making "art" and an understanding that her actions are never not feeding back into the constitution of her identity, which, as Pierre Bourdieu and others have argued, undergirds the market and attentional value of what she makes.[3] But if platform capitalism deems everyone an artist, what then remains, in the age of the "everywhere studio," to set this person or type apart from Kickstarter "creatives" or the message-board anons turned avant-gardist disrupters destabilizing actual political hierarchies with a meme?[4] Perhaps the underlying question here is what we wish to preserve by making such a distinction.

In the context of this show, it's worth noting that several of the younger artists included first became visible to me via social media, that 24/7 club where the bouncer is an algorithm and the door list is determined by a data set I inadvertently relay. Also of note: the markedly increased frequency with which "flexible coworking spaces" are appearing in my feed while drafting this text. Has big data been listening as I discuss over Messenger and Google Docs what an "everywhere studio" might now be? Yes, and it has also been tracking my locations as I write. This is no longer paranoia; it's simply the way the network now functions. Still, I'm amused as WeWork pitches itself to me as the "platform for creators." For around roughly $450 per month, per desk, Wi-Fi and caffeine inclusive, I can buy access to a "beautiful workspace, inspiring community,

and business services"—amenities that it is already supplying, it tells me, to "thousands of members worldwide." Similar platforms compete for my attention, each with its own angle: Factory Berlin, for example, the by-application "curated community" tailored to Berlin-based start-ups; or EasyBusy, a kid-friendly coworking space for freelance parents. Then there is Breather, which, rather than operating a centralized collective space, manages a portfolio of individual private rooms dispersed throughout different buildings in various cities—spaces that can be booked by the hour for meetings or to carry out an afternoon of desk work or self work or whatever other not-sex, not-partying work needs one might have. "If you wouldn't do it in your office, you shouldn't do it in a Breather," the site cautions, with fine print detailing all that it declares verboten: a list that includes animals, skateboarding, lighting candles, jumping rope, smoking, drug use, alcohol abuse, gambling or prostitution, pornography, and other sexual and/or disruptive activities.[5] Perusing these websites, I have the feeling that this is airline-industry logic applied to working space: depersonalize and molecularize every need into monetizable units, then target market them à la carte to potential user-consumers in each micro-echelon of the professional sector. At the same time, however, these parcelized segments of overhead-turned-fungible commodities do actually reflect the system of organization most compatible with our cultural situation circa 2017, which is to say a time when a single-occupancy apartment in central NYC starts upwards of $2000/month and two-thirds of millennials globally are either fully freelance or have an otherwise flexible arrangement with their employers.[6] Less reflective of Krauss's "absolute loss of place" than of the perpetual need for continual intermittent access to "any-(Wi-Fi-connected)-space-whatever," the studio today—like the office it resembles (or perhaps also is)—is epitomized by #privacyondemand and a pay-per-hour hot desk serving one "creator" after the next.

In light of the WeWork model, there's a satisfying irony to the Institute of Contemporary Art, Miami's choice of "The Everywhere Studio" as the first exhibition in its new Aranguren & Gallegos

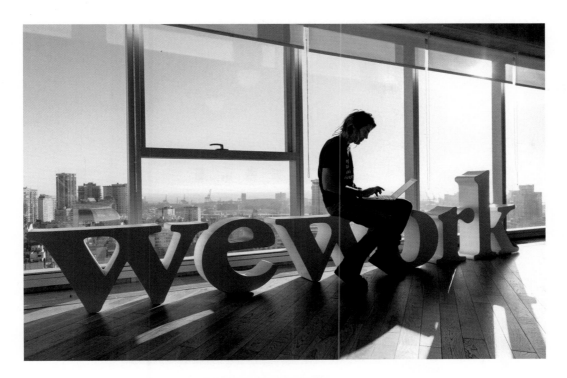

WeWork, Buenos Aires

Arquitectos–designed building, which arrives this year as an impressive addition to Miami's Design District. The gesture recalls the New Museum's choice of "Unmonumental" as the inaugural show of its 2007 landmark SANAA-designed tower on New York City's Bowery. Both themes pointedly prompt the question, "What role does a brick-and-mortar exhibition space serve in an age of pervasive decentralization and precarity?" In the ICA's case, there is also the question of what it means to erect a landmark building at a time when the city that houses it finds itself an active participant in the narrative of climate change. While the institution stands in full compliance with Miami-Dade County building code for environmental resilience, any notions of "permanence" or even futurity itself become tenuous when viewed through a frame of the Anthropocene—let alone the (hopefully soon-to-end) Trumpocene.

In effect, a new sense of "home" is emerging in our time, one in which migrancy is increasingly the norm and many different geographies and temporalities coexist. We are all already living together in each other's screens and offices, sharing each other's homes and home countries according to new contracts, whether through the terms of political asylum or Airbnb. Necessarily, our sense of privacy is changing, too. This shift is clearly reflected in the architecture of the past two decades as new advances in integrated AutoCAD/CAM design (e.g., greatly improved parametric scaling) have multiplied the potential uses of glass and steel. This trend was particularly visible in urban centers such as Williamsburg, Brooklyn, where eighteenth- and nineteenth-century factories and working-class housing gave way, seemingly overnight, to floor-to-ceiling glass condos. I remember, circa 2005, walking down Wythe Avenue and seeing a person going about life in his apartment two floors up. You could just stand there and watch the guy, shirtless in his boxers playing a videogame. With the rise of Facebook around this time, I'd think of that image often: *the bachelor stripped bare in his studio (apartment), even*—this ur-contemporary body framed by our new kind of large glass.

The Museum of Modern Art, New York

Facebook campus, Menlo Park

Residents of London's NEO Bankside luxury flats (newly exposed to the viewing balcony of the Tate Modern's recent extension) may disagree,[7] but generally we're seemingly quite OK with this new transparency, even monumentalizing it in our most important new design. The ICA's move from Miami's historic brick-and-mortar Moore building to a new glass-and-steel construction is a case in point, where the striking facade makes some of the art and its viewers visible from outside. The ICA is not alone in this, of course: from the Museum of Modern Art's Taniguchi-designed 2004 expansion in New York (allowing visitors and staff to see each other across the courtyard) to Mark Zuckerberg's glass conference room (free-standing amid one of the open floorplans of Facebook's Frank Gehry–designed Menlo Park campus), transparency is associated not just with openness, but also with power. It's arguably a show of dominance to flex the nothing-can-hurt-me confidence that comes from having nothing to hide. Yet physical transparency may be a sleight of hand, distracting (human viewers, at least) from the opacity of information hidden away in digital space. Maybe

power, in our time of everywhere surveillance, means knowing how to hide in plain sight—a manipulation not of where and when one is seen, but of how what is seen is understood.

A cultural precedent for the kinds of agency offered by this paradoxical situation can be found in Bertolt Brecht's so-called dialectical theater, wherein actors present both staged characters and "actual" selves, reaching across the proscenium to engage the audience (perhaps not unlike @realDonaldTrump addressing his base via Twitter) so as to render it active within, rather than in front of, the drama. Such de-hierarchizing of the stage would be explored in manifold ways across postwar artistic production, from Kaprow's Happenings to Andy Warhol's silver studio, from Peter Handke's *Offending the Audience* (1969) to John Cage's pivotal four minutes and thrity-three seconds of aleatoric silence-sound. In each case, the viewer-subjects were content providers (avant la lettre), no matter how mundane the material they supplied. But while this activity without directed meaning—or rather, this becoming-meaningful of everyday life—was more or less

John Singer Sargent studio, London

innocuously recuperated by the participatory frameworks of Happenings, Fluxus, and so on, viewer-users would unwittingly come to play a darker role in the past decade, where their (our) content serves as the raw material of big data, propelling platforms such as Amazon, Facebook, and Google to positions of titanic power. In the age of the everywhere studio, we work night and day for the network as the monetizable celebrities of our own lives.

Nearly five decades post-Baldessari's first CalArts class, the studio is now not only everywhere, it is also all the time. In his 2013 book, *24/7: Late Capitalism and the Ends of Sleep*, Jonathan Crary updates Luc Boltanski and Ève Chiapello's 1999 notion of the "new spirit of capitalism,"[8] extrapolating the consequences of a hyper-connectionist society in which failure to ping the network equals death. Crary points to how we feel obligated today, in light of the nonstop operations of global finance, to match the activity cycles of the machines we monitor. We rent our desks, subscribe to our Adobe suite studios, pay per hour for privacy—and, pressured by the concomitant growing economic/class precarity,

we have developed a cultural understanding of sleep as "unprofitable downtime." Never mind that extreme sleep deprivation is a form of systemic torture commonly used in military black sites to effect, per Crary, "the violent dispossession of self."[9]

One wonders here how such self-abuse squares with the demands of "self-responsibilization," called for by Margaret Thatcher and Ronald Reagan in the '80s (and in Germany, two decades later, with the implementation of Hartz IV unemployment-benefit reforms) as a key tenet of neoliberal order. It is important to keep in mind here that while the forces of financialization may be seemingly totalizing, and all the more so now with big data at capital's helm, the system itself is fundamentally schizoid. Within the "complex assemblage of legal and accounting systems, technical capacities, and embedded logics of power"—as Saskia Sassen has summarized the system's current manifestation—logical gaps abound.[10] It is in these fractures and at this "systemic edge" (per Sassen) that we can find Krauss's "psychological, physical, and ideological limits of culture" today.

258

Amid these fractures, at this edge, is also where some of today's most interesting articulations of the studio are to be found. Take the work of Yuri Pattison, for example, which reflects the industrial materials of the present, its modes of labor, and its aesthetics of display. As though an update of Donald Judd's serially aligned, machine-cut aluminum boxes (which as theorized by James Meyer, Branden W. Joseph, and others, channeled the postwar dissolution of the traditional spaces of manufacturing), Pattison gives us the modularly arrangeable room dividers, ergonomic seating, and transparent desks of today's spaces of production. Further, he presents his work in continuous form, elements from one show figuring more or less centrally in the next, their value perpetually updating and carrying new meaning every time. This was literally true, for instance, with a Bitcoin mining rig that Pattison set up to be powered by the gallery's electrical supply in his 2016 show "user, space" at Chisenhale Gallery in London. Significantly energy-intensive, the rig initially generated actual (crypto-currency) value when first installed. But as the supply of available Bitcoins diminishes and, reciprocally, the cryptographic problems that miners need to solve get harder and harder, the rig would soon cost more to run than it could possibly make in return. Matthew Angelo Harrison likewise utilizes both the material and procedural technology of contemporary commercial production in his art. And he similarly refrains from making clear where a given work begins and ends, either authorially or materially. His structures often involve open-source software and reference materials that are in the public domain, while the 3-D printing machine that figures sculpturally in his current installation *BKGD: BROUWN* (2017) appears as a live actor of sorts—programmed by Harrison to create a series of art objects—performing the labor that human workers are no longer hired to carry out. This is to say that the work Harrison makes is visible to viewers in all its stages, laid bare in a way that's analogous not just to the public ledger that underwrites (smart-contract) crypto-currency trades on the blockchain, but indeed also to the indelible traces of our own personal/professional development now. Yes, we live in public; the Internet never forgets.

These unbounded schema of Harrison's and Pattison's work find unified form in some of the recent sculptures of Neïl Beloufa. Wire-frame installations such as *L'atelier* (2017) in "The Everywhere Studio" present a physical skeleton of the contemporary work environments—office chairs, desks, tech hardware—that the other two artists also offer up each in their own way. But in Beloufa's hands, the contemporary "aesthetics of administration" are reduced (like pixel vectors in screen-space) to a common "line," an infrastructure from which he builds out with additional elements (video screens, scraps of colored diaphanous material) appearing in the work something like new flora growing up from carbon-rich, scorched earth.

Avery Singer's work is similarly resonant in the way it compresses complex space. Decidedly a "studio artist," Singer makes large paintings in acrylic on canvas and requires a physical workspace to do so. While these works are characterized by an unnatural-seeming, even inhumanly precise composition, her method of production itself also bears relevance to the theme of this show: before putting brush to surface, Singer pre-renders the dimensional spaces she paints using the 3-D modeling software SketchUp. Operationally, this procedure aligns her with contemporary architectural design, but also updates the post-studio correlation of non-site and site by substituting Smithson's physical location outside the gallery with the digitally rendered "site" in screenspace that she then translates to her physical working surface. Jana Euler's canvases also distill the "network" in the space of the painterly frame, except her "everywhere" is more human-focused, rendering bodies in a state of becoming something seemingly other than human, something other that is part of a larger living mass. In Euler's sphere, the system appears not antiseptic, but fleshy and biological: the social network as living organism and schizophrenic brain.

If, on the one hand, these artists' practices reflect the expansion of Krauss's expanded field, on the other, they point to a need for a new vocabulary that reflects both the persistence and the changing nature of the difference between artists and viewers/users/workers/content providers.

As the borders between body and image, system and subject, production and consumption likewise mutate or dissolve, do we find ourselves now at a point of *resisting* the directive so celebrated in press releases everywhere, the call for art to "blur the line between"? To talk about art in a way that feels liberatory now, we may need a language that is less invested in dismantling old binaries and more in establishing new models for discussing art's presentation, reception, circulation, and critique—models capable of reflecting the new economies of money and attention within art's newly technologized ecosystem of feedback systems and data flows, whether that means the studio as atelier, hot desk, or digital node.

NOTES

1. See Calvin Tomkins, "No More Boring Art: John Baldessari's Crusade," *New Yorker* (October 18, 2010).

2. Rosalind Krauss, "Sculpture in the Expanded Field," *October* 8 (Spring 1979): 30–44.

3. See, for example, Pierre Bourdieu, *The Rules of Art: Genesis and Structure of the Literary Field* (Palo Alto: Stanford University Press, 1992); Wendy Brown, *Undoing the Demos: Neoliberalism's Stealth Revolution* (Cambridge, MA: MIT Press, 2015); Caroline Busta, "The Opening," in *Merlin Carpenter: The Opening* (Berlin: Sternberg Press, 2011); and Isabelle Graw, *High Price: Art Between the Market and Celebrity Culture Today* (Berlin: Sternberg Press, 2009).

4. See Matt Goerzen, "Notes Toward the Memes of Production," *Texte zur Kunst*, no. 106 (June 2017): 86–106.

5. "Anything else I can't do in a Breather space?", https://support. breather.com/hc/en-us/articles /211545937-Anything-else-I-can-t -do-in-a-Breather-space-.

6. "Compared to our 2016 survey . . . we see a significant expansion in the numbers able to work from locations other than their employer's primary site. The current figure of 64 percent is fully 21 points higher than last year's survey, reflecting how rapidly technology is facilitating mobile working, and how employers are becoming increasingly comfortable with such arrangements." "Freelance Flexibility with Full-Time Stability: Deloitte Millennial Survey 2017," Deloitte, https://www2.deloitte .com/us/en/pages/about-deloitte /articles/millennial-survey-freelance -flexibility.html.

7. NEO Bankside flat owners are suing the Tate on grounds that the extension renders their £1.5 million homes a no longer "safe or satisfactory home environment for young children," given that gallery visitors can now peer into their private spaces, take pictures of what they see, and even post photos to social media. See Hannah Ellis-Petersen, "Tate Modern Viewing Platform Challenged by Luxury Flat Dwellers," *Guardian*, April 19, 2017, https://www.theguardian .com/artanddesign/2017/apr/19 /tate-modern-viewing-platform -prompts-writ-from-luxury-flat -dwellers.

8. Luc Boltanski and Ève Chiapello, *The New Spirit of Capitalism*, trans. Gregory Elliott (London: Verso, 2005).

9. Jonathan Crary, *24/7: Late Capitalism and the Ends of Sleep* (New York: Verso, 2013); see also Alain Ehrenberg, *The Weariness of the Self: Diagnosis the History of Depression in the Contemporary Age* (Montreal: McGill-Queens Press, 2009), which explores the mental and psychological damage caused by having to incessantly prove your worth to the market.

10. "The systemic edge is the point where a condition takes on a format so extreme that it cannot be easily captured by the standard measures of governments and experts, and thereby becomes invisible, ungraspable. In this regard, that edge also becomes invisible to standard ways of seeing and making meaning." Saskia Sassen, "The Possibility of Life at the Systemic Edge," *Texte zur Kunst*, no. 97 (March 2015): 44–53.

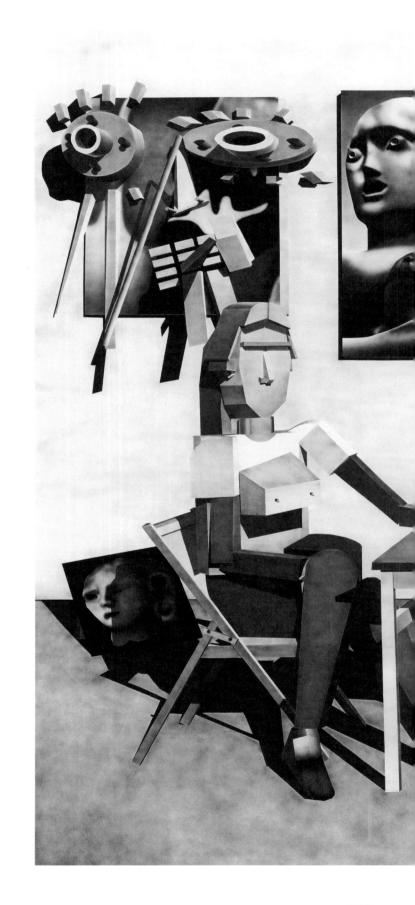

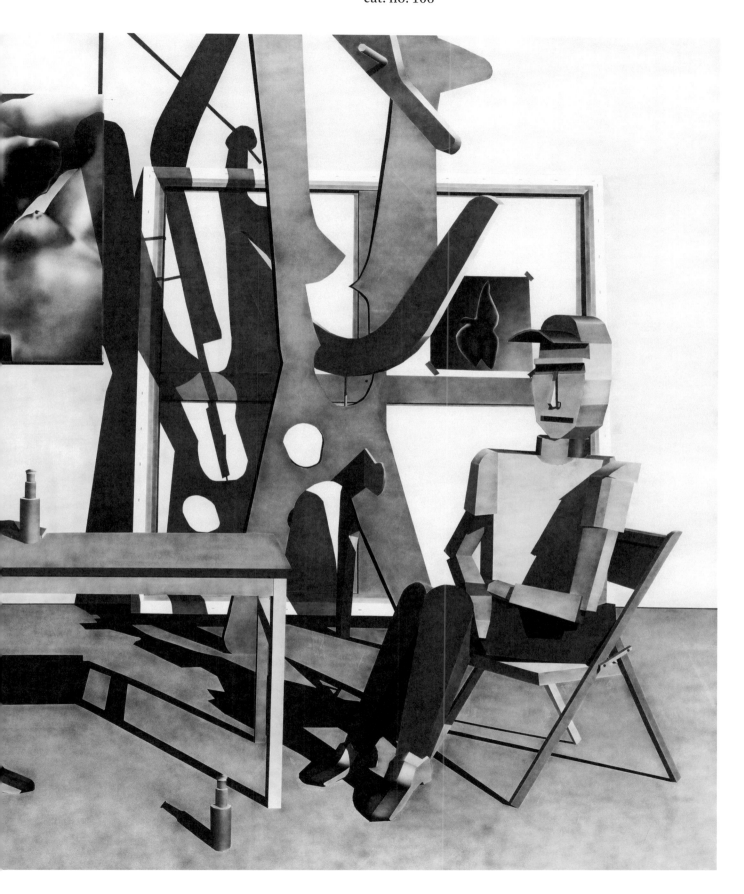

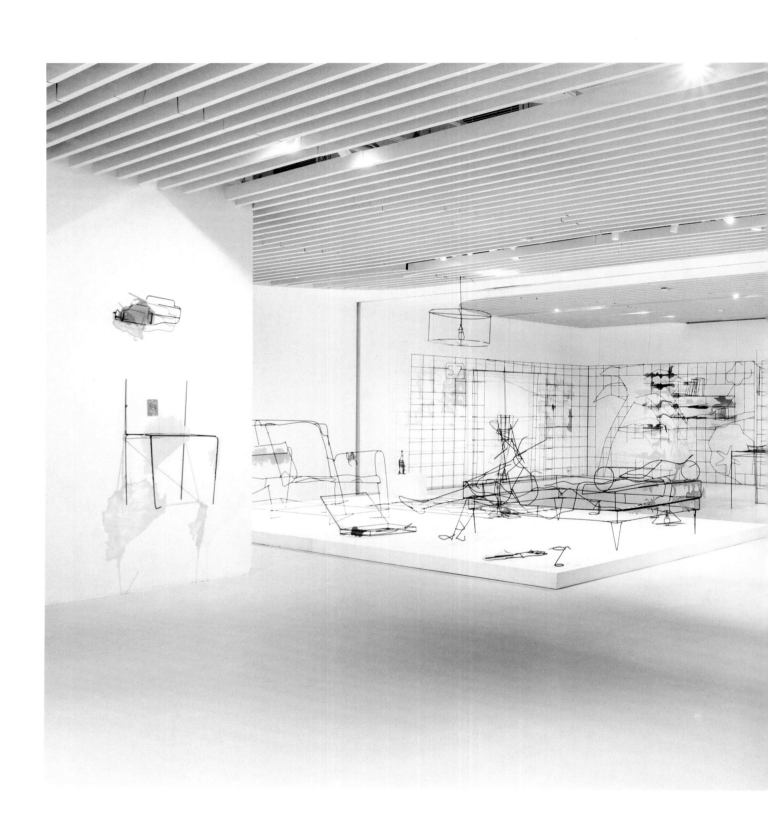

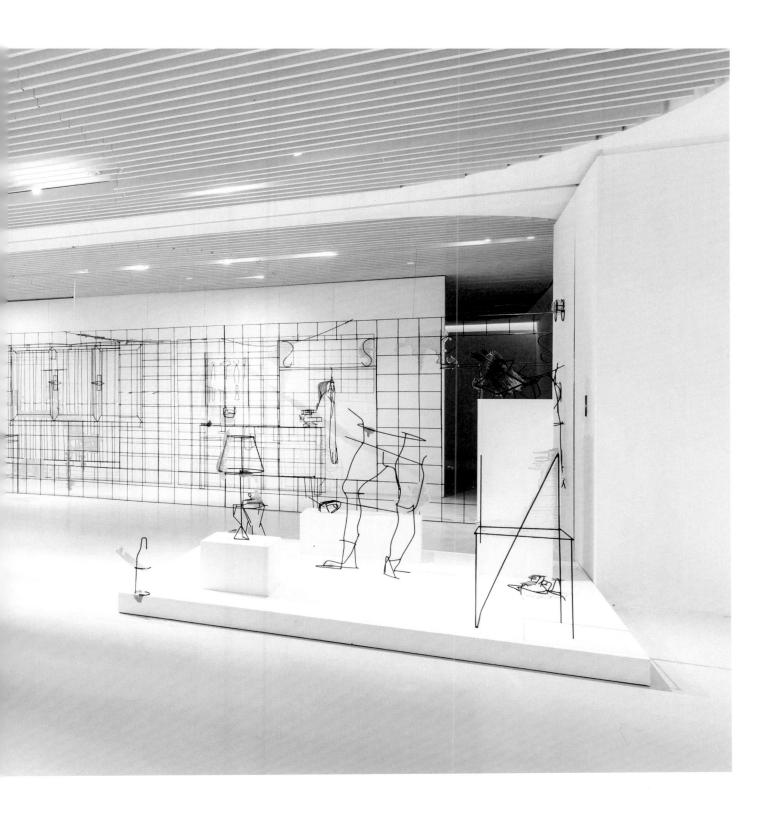

Neïl Beloufa
Untitled, 2016
cat. no. 13

Neïl Beloufa
Untitled, 2016
cat. no. 15

Neïl Beloufa
Untitled, 2016
cat. no. 12

Neïl Beloufa
Untitled, 2016
cat. no. 14

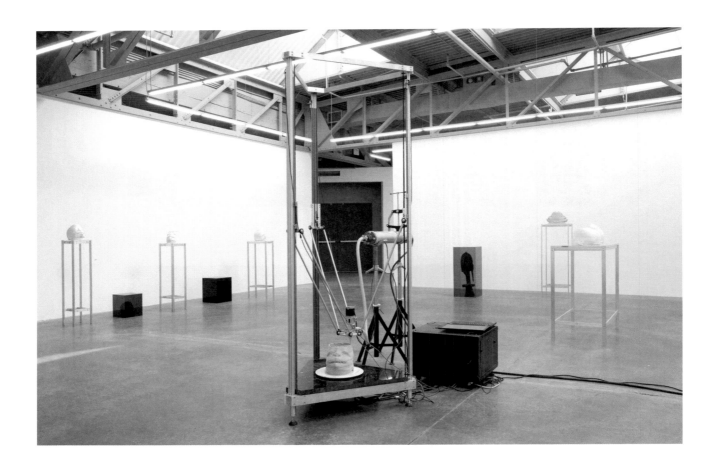

Matthew Angelo Harrison
Mk-003-Splinter, 2017
cat. no. 53

Matthew Angelo Harrison
Dark Povera Part 1, 2017
cat. no. 52

Matthew Angelo Harrison
Mk-003-Splinter, 2017

Matthew Angelo Harrison
Dark Povera Part 1, 2017

LIST OF WORKS

Works not in the exhibition are denoted with the symbol *.

Art & Language

1. *Index: The Studio at 3 Wesley Place Painted by Mouth (I)*, 1982
Ink and crayon on paper
129 ⅞ × 307 ⅞ in.
Herbert Foundation, Ghent
Courtesy the artists and Lisson Gallery, London and New York

2. *Index: The Studio at 3 Wesley Place Illuminated by an Explosion Nearby (VII)*, 1983
Oil on canvas
105 ⁵⁄₁₆ × 156 ⁵⁄₁₆ in.
Museum moderner Kunst Stiftung Ludwig (mumok), Vienna

3. *Study for Index: The Studio at 3 Wesley Place in the Dark (IV) and Illuminated by an Explosion Nearby (VI)*, 1982
Acrylic paint on paper
12 ¹⁄₁₆ × 25 ⅛ in.
Tate Gallery, London

John Baldessari

4. *Commissioned Painting: A Painting by Anita Storck*, 1969
Acrylic and oil on canvas
59 ¼ × 45 ½ in.
Courtesy the artist and Marian Goodman Gallery, New York

5. * *Commissioned Painting: A Painting by Edgar Transue*, 1969
Oil and acrylic on canvas
59 ¼ × 45 in.
Courtesy the artist

6. * *Commissioned Painting: A Painting by Elmire Bourke*, 1969
Acrylic and oil on canvas
59 ¼ × 45 ½ in.
Courtesy the artist and Sprüth Magers

7. * *Commissioned Painting: A Painting by Pat Perdue*, 1969
Acrylic and oil on canvas
59 ¼ × 45 ½ in.
Courtesy the artist and Sprüth Magers

Matthew Barney

8. *Drawing Restraint 2*, 1988
Documentary photograph, digital image
Jointly owned by Laurenz Foundation, Schaulager, Basel; and the Museum of Modern Art, New York, Richard S. Zeisler Bequest and The Blanchette Hooker Rockefeller Fund (both by exchange)

9. * *Drawing Restraint 5*, 1989
Documentary still
Jointly owned by Laurenz Foundation, Schaulager, Basel; and the Museum of Modern Art, New York, Richard S. Zeisler Bequest and The Blanchette Hooker Rockefeller Fund (both by exchange)

Joseph Beuys

10. *Tisch mit Aggregat* (Table with Accumulator), 1958–85
Bronze, wire cables
38 ¾ × 22 ¹³⁄₁₆ × 66 ¹⁵⁄₁₆ in.
Courtesy Galerie Thaddaeus Ropac, London, Paris, and Salzburg

Neïl Beloufa

11. * *Life as Data*, 2016
Installation view: "Neil Beloufa: Soft(a)ware," chi K11 Art Space, Shanghai, 2016

12. * *Untitled*, 2016
Steel, resin, and pigment
38 ½ × 68 ½ × 22 in.
Courtesy the artist and Ghebaly Gallery, Los Angeles

13. * *Untitled*, 2016
Steel, resin, and pigment
24 × 39 ½ × 11 ½ in.
Courtesy the artist and Ghebaly Gallery, Los Angeles

14. * *Untitled*, 2016
Steel, resin, and pigment
41 × 23 × 20 in.
Courtesy the artist and Ghebaly Gallery, Los Angeles

15. * *Untitled*, 2016
Steel, resin, and pigment
57 × 26 × 66 in.
Courtesy the artist and Ghebaly Gallery, Los Angeles

Heidi Bucher

16. *Borg*, 1975–77
Textile, latex, mother-of-pearl
pigments, and bamboo
90 ⁹⁄₁₆ × 129 ¹⁵⁄₁₆ × 7 ⁷⁄₁₈ in.
Courtesy The Estate of
Heidi Bucher

Stuart Brisley

17. *ZL656395C*, 1972
Seventeen-day continuous
performance, Gallery House,
London, twelve documentary
photographs by Alaric Aldred,
Brian Marsh, and unknown
photographer
4 ¼ × 3 ¼ in. to 11 ³⁄₁₆ ×
7 ⅝ in. each
Courtesy the artist, Galeria
Jaqueline Martins, São Paulo;
Hales Gallery, London; and
Mitchell Algus Gallery, New York

Alan Charlton

18. *Channel Painting*, 1973–91
Acrylic on canvas
65 ³⁄₁₆ × 104 ½ in.
Courtesy Galerie Tschudi, Zuoz,
Switzerland, and Konrad Fischer
Galerie, Düsseldorf

Marc Camille Chaimowicz

19. *Folding Screen (Five-part)*, 1979
Acrylic paint and hand-tinted
photographs on wood
88 ³⁄₁₆ × 69 ¹¹⁄₁₆ × 1 in.
Courtesy the artist and Cabinet,
London

Christo

20. *Dolly*, 1964
Wooden box, tarpaulin,
polyethylene, rope, girth, and
metal wheels
72 × 40 × 32 in.
Courtesy the artist

Hanne Darboven

21. *Halbjahreskalender* (*Six-Month
Calendars*), 1971–2008
Offset printing on cardboard,
pencil, ballpoint pen, and felt
pen on paper
74 parts, 8 ¹¹⁄₁₆ × 12 ³⁄₁₆ in. each
Courtesy Hanne Darboven
Stiftung, Hamburg | Hanne
Darboven Foundation, Hamburg

Jay DeFeo

22. *Lotus Eater No.1*, 1974
Acrylic, mixed media, graphite,
and collage on Masonite
72 ½ × 48 ½ in.
Courtesy the Jay DeFeo
Foundation and Mitchell-Innes &
Nash, New York

23. *Untitled*, 1971
Gelatin silver print
4 ⅛ × 4 ¹⁄₁₆ in.
Courtesy the Jay DeFeo
Foundation and Mitchell-Innes &
Nash, New York

24. *Untitled*, 1976
Gelatin silver print
8 ⅜ × 7 in.
Courtesy the Jay DeFeo
Foundation and Mitchell-Innes &
Nash, New York

25. *Untitled*, 1973
Gelatin silver print
7 ¹¹⁄₁₆ × 7 ¾ in.
Courtesy of the Jay DeFeo
Foundation and Mitchell-Innes &
Nash, New York

26. *Untitled*, 1975
Gelatin silver print
4 ⁵⁄₁₆ × 4 ¼ in.
Courtesy the Jay DeFeo
Foundation and Mitchell-Innes &
Nash, New York

27. *Untitled*, 1973
Gelatin silver print
7 ⁹⁄₁₆ × 7 ⁹⁄₁₆ in.
Courtesy of the Jay DeFeo
Foundation and Mitchell-Innes &
Nash, New York

28. *Untitled*, 1971
Gelatin silver print
5 ¼ × 6 in.
Courtesy the Jay DeFeo
Foundation and Mitchell-Innes &
Nash, New York

29. *Untitled*, 1973
Gelatin silver print
4 ¹³⁄₁₆ × 4 ¾ in.
Courtesy the Jay DeFeo
Foundation and Mitchell-Innes &
Nash, New York

30. *Untitled*, 1973
Gelatin silver print
4 ¹³⁄₁₆ × 4 ¾ in.
Courtesy of the Jay DeFeo
Foundation and Mitchell-Innes &
Nash, New York

Cheryl Donegan

31. *Rehearsal*, 1994
Digital video, transferred from
analogue, with sound,
14 min., 25 sec.
Courtesy Electronic Arts Intermix
(EAI), New York

Nicole Eisenman

32. *Morning Studio*, 2016
Oil on canvas
66 × 83 in.
Hort Family Collection

33. * *Night Studio*, 2009
Oil on canvas
65 × 82 in.
Courtesy the artist, Anton Kern
Gallery, New York, and Susanne
Vielmetter Los Angeles Projects

Jana Euler

34. *Four Rooms Transparent Ceiling*,
2017
Acrylic on canvas
82 ⅔ x × 82 ⅔ in.
Courtesy the artist and Galerie
Neu, Berlin

Rochelle Feinstein

35. *Before and After*, 1999
Oil on canvas and linen
Two large: 74 × 74 in.; 15 small:
between 18 × 18 in. and 24 × 24 in.
Städtische Galerie im
Lenbachhaus, Munich

Peter Fischli and David Weiss

36. *Untitled*, 1994–2013
Hand-carved and painted
polyurethane
159 parts, 63 ⅛ × 130 ½ ×
101 ½ in. overall
Courtesy Matthew Marks Gallery,
New York

Gilbert & George

37. * *Bad Thoughts No. 1*, 1975
Mixed media
98 ¹³⁄₁₆ × 83 ¹⁄₁₆ in. overall
Courtesy White Cube

38. *Bad Thoughts No. 2*, 1975
Mixed media
97 × 81 in. overall
Stephen and Petra Levin

39. * *Bad Thoughts No. 8*, 1975
Mixed media
48 ¹³⁄₁₆ × 40 ¹⁵⁄₁₆ in. overall
Courtesy White Cube

Rodney Graham

40. *Potatoes Blocking My Studio
Door*, 2006
Painted aluminum lightbox
with transmounted
chromogenic transparency
82 × 64 × 7 in.
Courtesy the artist and
303 Gallery, New York

Philip Guston

41. *The Door*, 1976
Oil on canvas
81 × 96 in.
Collection of Martin Z. Margulies

42. *Pittore*, 1973
Oil on canvas
72 ¾ × 80 ½ in.
Private collection

43. * *Painter's Table*, 1973
Oil on canvas
77 ¼ × 90 in.
National Gallery of Art,
Washington, DC, Gift (Partial and
Promised) of Ambassador and
Mrs. Donald Blinken in memory
of Maurice H. Blinken and in
Honor of the 50th Anniversary of
the National Gallery of Art

44. * *Studio Bench*, 1978
Oil on canvas
68 × 80 in.
Private collection

45. * *The Studio*, 1969
Oil on canvas
48 × 42 in.
Private collection

Wade Guyton

46. *Untitled*, 2015
Epson UltraChrome HDR inkjet
print on linen
84 × 69 in.
Courtesy the artist and Petzel
Gallery, New York

47. * *Untitled*, 2015
Epson UltraChrome HDR inkjet
print on linen
84 × 69 in.
Courtesy the artist and Petzel
Gallery, New York

48. * *Untitled*, 2015
Epson UltraChrome HDR inkjet
print on linen
84 × 69 in.
Courtesy the artist and Petzel
Gallery, New York

49. * *Untitled*, 2016
Epson UltraChrome HDR inkjet
print on linen
84 × 69 in.
Courtesy the artist and Petzel
Gallery, New York

50. * *Untitled*, 2017
Epson UltraChrome HDR inkjet
print on linen
84 × 69 in.
Courtesy the artist and Petzel
Gallery, New York

David Hammons

51. *Traveling*, 2002
Harlem earth on paper, with
black cloth suitcase
116 ⅛ × 49 × 17 ¾ in.;
suitcase: 25.55 × 18.27 × 4 ¼ in.
Private collection

Matthew Angelo Harrison

52. * Installation view:
"Dark Povera Part 1," Atlanta
Contemporary, 2017
Courtesy the artist and Jessica
Silverman Gallery, San Francisco

53. * *Mk-003-Splinter*, 2017
Ceramic, acrylic, and aluminum
10 ¼ × 6 ¼ × 9 ¼ in.
Courtesy the artist and Jessica
Silverman Gallery, San Francisco

Margaret Honda

54. * Digital rendering of *Model for
"Sculpture,"* 2017
Courtesy the artist and Grice
Bench, Los Angeles
Courtesy KWY, Copenhagen
and Lisbon

Jörg Immendorff

55. *Selbstbildnis im Atelier* (*Self-
Portrait in the Studio*), 1974
Acrylic on canvas
78 ¾ × 59 in.
Musée d'Art Moderne de
la Ville de Paris

56. * *Wo stehst du mit deiner Kunst,
Kollege?*, 1973
Acrylic on canvas
51 ¼ × 82 ¾ in.
Musée d'Art Moderne de
la Ville de Paris

Edward and
Nancy Kienholz

57. *White Easel with Wooden
Hand*, 1978
Mixed media
105 × 182 × 28 in.
Courtesy the artist and L.A.
Louver, Venice, CA

Martin Kippenberger

58. *Worktimer* (*Peter* sculpture*)*, 1987
Steel, lacquer, hard rubber, and
briefcases
95 ¹¹⁄₁₆ × 101 ³⁄₁₆ × 55 ⅛ in.
Private collection.
Courtesy the Estate of Martin
Kippenberger, Galerie Gisela
Capitain, Cologne

Yves Klein

59. *Untitled Anthropometry,
(ANT 81)*, ca. 1960
Dry pigment and synthetic resin
on paper, mounted on canvas
80 ³⁄₁₀ × 62 ⅖ in.
Collection of Irma and Norman
Braman

60. *Untitled Anthropometry
(ANT 89)*, ca. 1961
Dry pigment and synthetic resin
on paper, mounted on canvas
87 × 59 ½ in.
Private collection

61. * *Anthropometry:
Princess Helena*, 1960
Oil on paper on wood
78 × 50 ½ in.
The Museum of Modern Art, New
York, Gift of Mr. and Mrs. Arthur

62. *Untitled Anthropometry
(ANT 31)*, 1960
Dry pigment and synthetic resin
on paper mounted on canvas
42 ⁹⁄₁₀ × 29 ⁷⁄₁₀ in.
Paul and Trudy Cejas

Tetsumi Kudo

63. *Portrait d'artiste dans la crise*
(*Portrait of an Artist in Crisis*),
1980–81
Metal, wire, wood, plastic, cotton,
adhesive, paint brush, string, toy
bird, toy plastic rat, French coins,
pills, glass eyes, plastic flowers,
thermometer, and Styrofoam
13 ⅜ × 6 ³⁄₁₆ × 4 in.
Collection of Agnes and
Edward Lee

64. *Portrait de l'artiste* (*Portrait of
the Artist*), 1976
Painted cage, artificial soil,
cotton, plastic, polyester, resin,
and string
15 ½ × 14 ½ × 9 ¼ in.
Private collection. Courtesy
Andrea Rosen Gallery, New York

65. *Meditation between Memory
and Future*, 1978
Painted cage, artificial soil,
flowers, cotton, plastic, polyester,
resin, thread, sand, yarn, wood,
fly-fishing feather lure, and
thread
16 ½ × 19 ¼ × 9 ½ in.
Private collection. Courtesy
Andrea Rosen Gallery

Sean Landers

66. *Anyone's Orgasm*, 1992
Color video, with sound,
1 hr., 2 min., 36 sec.
Courtesy the artist and Petzel
Gallery, New York

67. *Fart*, 1993
Oil on Linen
84 × 112 ½ in.
Hadley Martin Fisher Collection

Roy Lichtenstein

68. *Artist's Studio with Model*, 1974
Oil and Magna on canvas
96 × 128 in.
Collection of Irma and
Norman Braman

69. * *Artist's Studio No. 1
(Look Mickey)*, 1973
Oil, magna, and sand on canvas
96 ⅛ × 128 ⅛ in.
Walker Art Center, Minneapolis,
Gift of Judy and Kenneth Dayton
and the T. B. Walker Foundation

70. * *Artist's Studio, "The Dance,"*
1974
Graphite, colored pencil, and cut-
and-pasted paper on paper
20 ½ × 26 in.
The Museum of Modern Art,
New York, Gift of the Artist

Kerry James Marshall

71. *Black Artist (Studio View)*, 2002
Inkjet print on paper
50 ½ × 63 in.
Courtesy the artist and David
Zwirner, London

Paul McCarthy

72. *Face Painting - Floor, White
Line*, 1972
Performance, video,
photographic series
Videography: Mike Cram
Courtesy the artist and Hauser &
Wirth

Bruce Nauman

73. *Bouncing in the Corner No. 1*, 1968
Digital black-and-white video,
transferred from analogue,
with sound, 60 min.
Courtesy Electronic Arts Intermix
(EAI), New York

74. *Bouncing in the Corner No. 2:
Upside down*, 1969
Digital black-and-white video,
transferred from analogue,
with sound, 60 min.
Courtesy Electronic Arts Intermix
(EAI), New York

75. *Sound for Mapping the Studio
Model (The Video)*, 2001
Color video, with sound,
61 min., 20 sec.
Courtesy Sperone Westwater,
New York

Mike Nelson

76. *Tools that see (possessions of a
thief – compressor)*, 2016
Concrete, Plexiglas, wood, metal,
air compressor, and transformer
35 ⅝ × 58 ¹¹⁄₁₆ × 33 ⅙ in
Rennie Collection, Vancouver

77. * *Tools that see (possessions of
a thief – hand saws)*, 2016
Concrete, Plexiglas, wood,
metal, and handsaws purchased
in Britain, various locations
and dates
35 ⅝ × 58 ¹¹⁄₁₆ × 33 ⅙ in.
Courtesy the artist and
neugerriemschneider, Berlin

Anna Oppermann

78. *Paradoxe Intentionen (Das Blaue
vom Himmel herunterlügen)
(Paradoxical Intentions [To Lie the
Blue Down from the Sky])*, 1988–92
Mixed media
Dimensions variable
Courtesy the Estate of Anna
Oppermann and Galerie Barbara
Thumm, Berlin

Giulio Paolini

79. *Hi-fi*, 1965
Enamel on primed canvas,
enamel on canvas mounted on
wooden silhouette, easel
Canvas: 78 ¾ × 90 ⁹⁄₁₆ in.; wooden
silhouette: 53 ¹⁵⁄₁₆ × 20 ⅞ in.;
118 ¹⁄₁₈ × 90 ⁹⁄₁₆ in. overall
Courtesy Klassik Stiftung
Weimar, Museen, former
Sammlung Paul Maenz

Yuri Pattison

80. * Installation view: "user, space,"
Chisenhale Gallery, London,
2016. Commissioned and
produced by Chisenhale Gallery
Courtesy of the artist; mother's
tankstation limited, Dublin;
H.M. Klosterfelde, Berlin; and
Labor, Mexico

Joyce Pensato

81. * Installation view: "Fuggetabout
It!," Lisson Gallery, London, 2014
Courtesy the artist and Lisson
Gallery, London

82. * Installation view: "Batman
Returns," Petzel Gallery,
New York, 2012
Courtesy the artist and Petzel
Gallery, New York

Pablo Picasso

83. *Le peintre et son modèle* (The Painter and his Model), 1963
Oil on canvas
31 ⅞ × 15 ½ in.
Nahmad Collection, Monaco

84. *Le peintre et son modèle II* (The Painter and his Model II), 1963
Oil on canvas
35 ¹⁄₁₆ × 45 ¹¹⁄₁₆ in.
Nahmad Collection, Monaco

85. * *Le peintre et son modèle* (The Painter and his Model), 1963
Oil on canvas
18 ⅛ × 21 ¾ in.
Nahmad Collection, Monaco

86. * *Le peintre et son modèle* (The Painter and his Model), 1963
Oil on canvas
28 ¾ × 36 ¼ in.
Nahmad Collection, Monaco

87. * *Le Peintre* (The Painter), 1963
Oil on canvas
38 ³⁄₁₆ × 51 ³⁄₁₆ in.
Nahmad Collection, Monaco

88. * *Le Peintre et son modèle* (The Painter and his Model), 1963
Oil on canvas
51 ³⁄₁₆ × 63 ¾ in.
Nahmad Collection, Monaco

Laure Prouvost

89. *The Artist*, 2010
Digital color video, with sound,
10 min., 10 sec.
Courtesy the artist and carlier | gebauer, Berlin

Faith Ringgold

90. *American People Series #17: The Artist and his Model*, 1966
Oil on canvas
30 × 24 in.
Courtesy ACA Galleries, New York

91. * *The French Collection #7: Picasso's Studio*, 1991
Acrylic on canvas
73 × 68 in.
Worcester Art Museum, Massachusetts

92. * *The French Collection #5: Matisse's Model*, 1991
Acrylic on canvas
73 ½ × 79 ½ in.
Baltimore Museum, Baltimore, Maryland

Jason Rhoades

93. *Mixing Desk and Chair / Yellow Ribbon in Her Hair*, 2002
Desk: Two 55-gallon containers, Perfect World aluminum pipe, Mackie mixing board, Composer Pro audio limiter, CD burner, headphones, wood pallet, wood wedges with bolts, shovel, halogen flood light, PeaRoeFoam (dried peas, salmon roe, Styrofoam beads, glue), shrink wrap, custom-made tape, yellow web strapping, and other various materials; chair: Perfect World aluminum pipe, three felt-lined wood boxes, yellow rubber boots, paper towels, plastic bucket, PeaRoeFoam cardboard box with artist's handwritten "Directions for PeaRoeFormance," collaged Behind the Green Door poster, PeaRoeFoam (dried peas, salmon roe, Styrofoam beads, glue), custom-made tape, yellow web strapping, and other various materials; Yellow Ribbon in Her Hair: wood pallet with cardboard boxes containing Marilyn Chambers Ivory Snow boxes (PeaRoeFoam kits that include dried peas, salmon roe, Styrofoam beads, glue, latex gloves), microphone, extension cord, Marilyn Chambers Ivory Snow boxes, PeaRoeFoam (dried peas, salmon roe, Styrofoam beads, glue), plastic corner

guards, shrink wrap, custom-made tape, yellow web strapping, and other various materials
Desk: 76 × 61 × 66 ½ in.; chair: 75 × 45 × 37 in.; Yellow Ribbon in Her Hair: 59 × 43 × 38 ½ in.
Courtesy The Estate of Jason Rhoades, Hauser & Wirth and David Zwirner, New York/ London

94. * *The Grand Machine / THEAREOLA*, 2002
Perfect World aluminum pipes, eleven plastic banquet tables, two round mesh bins, rolling aluminum staircase, "THEAREOLA" neon sign, VocoPro Colt karaoke machine, amplifier, three headphones, headphone amplifier, two microphones, four speakers, mini-disc player, karaoke CDs (with "Areola" CD holders), nine signs with artist's handwritten instructions, three reclining office chairs, Marilyn Chambers chair, folding chair, Marilyn Chambers Ivory Snow boxes (PeaRoeFoam kits), PeaRoeFoam, and other materials
Dimensions variable
Courtesy The Estate of Jason Rhoades, Hauser & Wirth and David Zwirner, New York/ London

Dieter Roth

95. *Tischmatte (Trophy)*, 1979
Crayon, graphite, ink, glue, acrylic, and collage on paper
27 ¾ × 31 ¼ in.
Courtesy Hauser & Wirth, Zurich

96. *Matte aus Stuttgart*, 1979
Ink, graphite, tape, glue, and acrylic on paper
21 ⅝ × 25 ⅝ in.
Courtesy Hauser & Wirth, Zurich

97. *Buchbands-Matte*, 1979–1980
Glue, acrylic paint, pencil, ink,
fabric, and adhesive plastic tape
on cut chipboard
27 ¼ × 40 ½ in.
Courtesy Hauser & Wirth, Zurich

98. *Table Hegenheimerstrasse*,
1980–2010
Acrylic paint, pencil, felt tip
pen, marker, ballpoint pen,
and collage (plastic adhesive
tape, transparent plastic foil)
on chipboard; two sawhorses,
chair, lamp, ceramic jar, glass
jars, brushes, markers, pens,
scissors, utility knife, paint cans,
spray paint can, paper towel, and
cardboard tray of oil color paint
48 × 64 ¾ in.
Courtesy Hauser & Wirth, Zurich

Lucas Samaras

99. *Still Life*, June 29, 1978
Dye-diffusion transfer print
(Polaroid) with hand-applied ink
9 ½ × 7 ½ in.
San Francisco Museum of
Modern Art; gift of Dr. William
and Nancy Tsiaras

100. *Still Life*, September 5, 1978
Color Polaroid photograph
9 ½ × 7 ½ in
Courtesy the artist and Pace
Gallery, New York

101. *Still Life (Blue Glass, white phone)*,
June 22, 1978
Polaroid Polacolor II photograph
10 × 8 in.
Courtesy the artist and Pace
Gallery, New York

102. *Still Life*, July 26, 1979
Polaroid Polacolor II photograph
and ink
9 ½ × 7 ½ in.
Courtesy the artist and Pace
Gallery, New York

103. *Still Life*, July 26, 1979
Polaroid Polacolor II photograph
and ink
9 ½ × 7 ½ in.
Courtesy of the artist and Pace
Gallery, New York

Carolee Schneemann

104. *Eye Body: 36 Transformative
Actions for Camera*, 1963
Photo series taken in Carolee
Schneemann's studio.
Twelve gelatin silver prints
9 ¾ × 10 ¾ in. to 12 ¾ ×
9 ⅞ in. each
Photos: Erró
Courtesy the artist; PPOW
Gallery, New York; and Galerie
Lelong, New York
Collection of Amy Gold and
Brett Gorvy

Miriam Schapiro

105. *Time*, 1988–91
Acrylic and fabric on canvas
82 × 90 in.
Collection of Eleanor Flomenhaft

Avery Singer

106. *The Studio Visit*, 2012
Acrylic on canvas
72 × 96 in.
Courtesy the artist and
Gavin Brown's enterprise,
New York and Rome

Daniel Spoerri

107. *Fallenbild – Tableau Piege aus
dem Restaurant Spoerri
in Düsseldorf vom 28. Oktober
1972*, 1972
Assemblage on wood with
plexicap
27 ⁹⁄₁₆ × 27 ⁹⁄₁₆ × 15 ¾ in.
Bischofberger Collection,
Männerdorf-Zurich

Frances Stark

108. *Behold Man (Nancy and Sluggo
recto verso pendant pair)*, 2017
Ink, spray paint, and gesso
on canvas
Two parts, 51 × 84 in. each
Courtesy the artist
and greengrassi, London

Sturtevant

109. *The Dark Threat of Absence*, 2002
Seven-channel video installation
Dimensions variable
Courtesy Estate Sturtevant, Paris,
and Galerie Thaddaeus Ropac,
London, Paris, and Salzburg

Rosemarie Trockel

110. *O-Ton*, 2014
Mixed Media
86 ⅝ × 29 ¹⁵⁄₁₆ × 25 ⁹⁄₁₆ in.
Courtesy Sprüth Magers

111. *Cat's-eye*, 2015
Multimedia installation
Dimensions variable
Courtesy Sprüth Magers

Andy Warhol

112. *Dance Diagram [3] ["The Lindy
Tuck-In Turn-Man"]*, 1962
Casein on linen
69 ¾ × 54 in.
The Broad Art Foundation,
Los Angeles

113. * *Dance Diagram [6] ["The
Charleston Double Side Kick –
Man and Woman"]*, 1962
Casein and graphite on linen
71 ½ × 53 ⅜ in.
Daros Collection, Switzerland

114. *Dance Diagram [2][Fox Trot: "The Double Twinkle-Man"]*, 1962
Casein and graphite on linen
71 ½ × 51 ¾ in.
The Andy Warhol Museum, Pittsburgh; Founding Collection, Contribution The Andy Warhol Foundation for the Visual Arts, Inc.

Andrea Zittel

115. *Free Running Rhythms and Patterns Version II*, 2000
Walnut veneer panels, latex and oil based paint, vinyl lettering, and photographs
27 panels, 79 × 31 ⅝ × 2 in. each
Olbricht Collection, Essen, Germany

Works in the exhibition not illustrated

Neïl Beloufa
L'atelier (The Studio), 2017
Rebar, epoxy resin, medium-density fiberboard, and cardboard
Four parts, 98 ⁷⁄₁₆ × 43 ⁵⁄₁₆ × 98 ⁷⁄₁₆ in. each
Courtesy the artist

Matthew Angelo Harrison
BKGD: BROUWN, 2017
Acrylic, books (paper), marble, ceramic clay, steel, bone, and aluminum
Dimensions variable
Courtesy the artist and Jessica Silverman Gallery, San Francisco

Margaret Honda
Model for "Sculpture," 2017
Metal, drywall, and paint
8 ft., 10 ¼ in. × 7 ft., 6 in. × 11 ft., 8 ¼ in.
Courtesy the artist and Grice Bench, Los Angeles

Yuri Pattison
intermodalism study (working title), 2017
Grid beam, Unistrut, LCD monitors, networked media players, network and power cables, metal and plastic sheet material, LED light panels, scale model miniatures, network cameras
Dimensions variable (within 2.6 × 2.4 × 2.4 m)
Courtesy the artist and mother's tankstation limited, Dublin

Joyce Pensato
Fuggetabout It!, 2017
Stuffed animals, figurines, paint cans, paint brushes, canvas, stretcher bars, part of a studio floor, printed materials, pictures, and other studio ephemera
Dimensions variable
Courtesy the artist and Petzel Gallery, New York

CONTRIBUTORS

Sampada Aranke

is an assistant professor in the art history, theory, and criticism department at the School of the Art Institute of Chicago. Her research interests include performance theories of embodiment, visual culture, and black cultural and aesthetic theory. Her work has been published in *Artforum, Art Journal, e-flux journal, Ecquid Novi: African Journalism Studies*, and *Trans-Scripts: An Interdisciplinary Journal in the Humanities and Social Sciences* at University of California, Irvine. She has contributed essays to exhibition catalogues on Sadie Barnette, Zachary Fabri, and Kambui Olujimi. She is currently working on her forthcoming book *Death's Futurity: The Visual Culture of Death in Black Radical Politics*.

Stuart Brisley

is an British artist who has studied in London, Munich, and the United States. Considered one of Britain's most influential performance artists, he has developed a complex oeuvre that encompasses drawing, painting, sculpture, film, sound, text, and photography works. At the center of his diverse practice lies an exploration of what it means to be human. His work challenges his body in physical, psychological, and emotional ways. Vulnerable and exposed, Brisley's "body in struggle" dramatizes the conflict between human anatomy and institutional forces. His work is included in many major museum collections

Sabeth Buchmann

is an art historian and critic based in Berlin and Vienna. She is professor of history of modern and postmodern art at the Academy of Fine Arts, Vienna. She is a board member of *Texte zur Kunst* and coedits, together with Helmut Draxler, Clemens Krümmel, and Susanne Leeb, *PoLyPen*, a series on art criticism and political theory published by b_books, Berlin. Her publications include *Putting Rehearsals to the Test: Practices of Rehearsal in Fine Arts, Film, Theater, Theory, and Politics*, coedited with Ilse Lafer and Constanze Ruhm (2016); *Textile Theorien der Moderne: Alois Riegl in der Kunstkritik*, coedited with Rike Frank (2015); *Hélio Oiticica, Neville D'Almeida: Block-Experiments in Cosmococa—program in progress*, coauthored with Max Jorge Hinderer Cruz (2013); *Film, Avantgarde, Biopolitik*, coedited with Helmut Draxler and Stephan Geene (2009); *Denken gegen das Denken: Produktion, Technologie, Subjektivität bei Sol LeWitt, Yvonne Rainer und Hélio Oiticica* (2007); and *Art after Conceptual Art*, coedited with Alexander Alberro (2006).

Caroline Busta

is a writer based in Berlin. From 2014 to 2017, she served as editor-in-chief of the critical cultural journal *Texte zur Kunst*, and from 2008 to 2014, as an editor of *Artforum International*.

Alex Gartenfeld

is deputy director and chief curator at the Institute of Contemporary Art, Miami. He has curated solo exhibitions of Ida Applebroog, Thomas Bayrle, Shannon Ebner, Laura Lima, John Miller, Senga Nengudi, Virginia Overton, Ryan Sullivan, and Andra Ursuta, among many others, and has organized projects for Allora & Calzadilla, Abigail DeVille, and Charles Gaines. He is working on forthcoming solo exhibitions of Terry Adkins, Larry Bell, Judy Chicago, Donald Judd, and Sterling Ruby. Gartenfeld is cocurator of the 2018 New Museum Triennial.

Tim Griffin

is executive director and chief curator of The Kitchen in New York, where he has organized exhibitions and programs by artists including Chantal Akerman, Ed Atkins, Glenn Branca, Cory Henry, Ralph Lemon, Aki Sasamoto, Danh Vo, and Xiu Xiu, among many others. He recently conceived of and coorganized the institution's yearlong program "From Minimalism into Algorithm," and is currently completing a book on algorithms and culture.

Tomohiro Masuda

is curator of the National Museum of Modern Art, Tokyo. He graduated with master's degree in art history from Waseda University, Tokyo, and specializes in modern and contemporary Western and Japanese art. Masuda has helped curate many exhibitions at the National Museum of Modern Art, including *No Museum, No Life?: Art-Museum Encyclopedia to Come* (2015), *Takamatsu Jiro: Mysteries* (2014), *Your Portrait: A Tetsumi Kudo Retrospective* (2013–14), and *Francis Bacon* (2013).

John Miller

is an artist, writer, and musician based in New York and Berlin. In 2011 he received the Wolfgang Hahn Prize from the Museum Ludwig in Cologne. Miller's books include *Mike Kelley: Educational Complex* (Afterall

Books, 2015), in addition to *The Ruin of Exchange and Other Writings On Art* (2012) and *The Price Club: Selected Writings (1977–1998)* (2000), both copublished by JRP|Ringier and Les Presses du réel as part of their Positions series. He has had solo exhibitions at Le Magasin, Grenoble; the Kunstverein, Hamburg; and the Kunsthalle Zurich. In 2016 the Institute of Contemporary Art, Miami, featured "I Stand, I Fall," his first comprehensive survey in the United States. Miller is a professor of professional practice in the art history department at Barnard College, New York.

Gean Moreno

is curator of programs at the Institute of Contemporary Art, Miami, where he founded and runs the Art + Research Center. He is currently organizing solo exhibitions on Terry Adkins, Larry Bell, and Hélio Oiticica. In 2017 he served on the advisory board of the Whitney Biennial, and is the codirector of [NAME] Publications. Moreno has contributed texts to various exhibition catalogues and publications, including *Art in America*, *e-flux journal*,

and *Kaleidoscope*, and has lectured at numerous universities.

Dieter Roelstraete

is a curator, writer, and teacher based in Chicago. From 2014 until 2017, Roelstraete was a member of the curatorial team of documenta 14.

Stephanie Seidel

is associate curator at the Institute of Contemporary Art, Miami, where she cocurated Thomas Bayrle's survey "One Day on Success Street," and is currently working on solo exhibitions of Judy Chicago and Tomm El-Saieh. She was previously a curator at the Neuer Aachener Kunstverein, Germany, as well as for the commissioning project "25/25/25" for the Arts Foundation of North Rhine-Westphalia, Düsseldorf, where she worked with Neïl Beloufa, Sam Lewitt, Ken Okiishi, Pamela Rosenkranz, and Tercerunquinto, among others. In 2013 Seidel founded the project space Between Arrival & Departure in Düsseldorf, where she organized solo presentations of Sam

Anderson, Olga Balema, and Studio for Propositional Cinema, among others.

John C. Welchman

is professor of art history in the visual arts department at the University of California, San Diego. His books on art include *Guillaume Bijl* (JRP|Ringier, 2016), *Art after Appropriation: Essays on Art in the 1990s* (Routledge, 2001), *Invisible Colours: A Visual History of Titles* (Yale University Press, 1997), and *Modernism Relocated: Towards a Cultural Studies of Visual Modernity* (Allen & Unwin, 1995). *Past Realization: Essays on Contemporary European Art, XX–XXI* (Sternberg, 2016) is the first volume of his collected writings. Welchman is coauthor of *Kwang Young Chun: Mulberry Mindscapes* (Rizzoli, 2014), *Mike Kelley* (Phaidon, 1999), and *The Dada and Surrealist Word Image* (MIT Press, 1987), and editor of *Black Sphinx: On the Comedic in Modern Art* (JRP|Ringier, 2010), *The Aesthetics of Risk* (JRP|Ringier, 2008), *Institutional Critique and After* (JRP|Ringier, 2006), and *Rethinking Borders* (University of Minnesota Press, 1996). He is chair of the Mike Kelley Foundation for the Arts.

REPRODUCTION CREDITS

303 Gallery, New York; ACA Galleries, New York; The Approach, London; Studio Neïl Beloufa; Bischofberger Collection, Männerdorf-Zurich; Collection of Irma and Norman Braman; Studio Stuart Brisley; The Broad Art Foundation, Los Angeles; The Estate of Heidi Bucher; Cabinet, London; carlier | gebauer, Berlin; Paul and Trudy Cejas; CHRISTO Studio; Hanne Darboven Foundation, Hamburg; The Jay DeFeo Foundation; Electronic Arts Intermix (EAI), New York; Hadley Martin Fisher Collection; Collection of Eleanor Flomenhaft; Galerie Neu, Berlin; Galerie Tschudi, Zuoz, Switzerland; Marian Goodman Gallery, New York; Collection of Amy Gold and Brett Gorvy; greengrassi, London; Grice Bench, Los Angeles; Hauser & Wirth, Zurich; Hort Family Collection; Klassik Stiftung Weimar, Museen former Sammlung Paul Maenz; Laurenz Foundation, Schaulager, Basel; Collection of Agnes and Edward Lee; Stephen and Petra Levin; Collection of Martin Z. Margulies; Matthew Marks Gallery, New York; mother's tankstation limited, Dublin; Musée d'Art Moderne de la Ville de Paris; The Museum of Modern Art, New York; Museum moderner Kunst Stiftung Ludwig (mumok), Vienna; Nahmad Collection, Monaco; Olbricht Collection, Essen, Germany; Estate of Anna Oppermann; Pace Gallery, New York; Petzel Gallery, New York; Rennie Collection, Vancouver; Estate of Jason Rhoades; Richard S. Zeisler Bequest and The Blanchette Hooker Rockefeller Fund; Galerie Thaddaeus Ropac, London, Paris, and Salzburg; Jessica Silverman Gallery, San Francisco; Sprüth Magers; Städtische Galerie im Lenbachhaus, Munich; Estate Sturtevant, Paris; Galerie Barbara Thumm, Berlin; David Zwirner, London; and generous private lenders.

This book is published on the occasion of the exhibition "The Everywhere Studio" Organized by the Institute of Contemporary Art, Miami

December 1, 2017–February 26, 2018

Published in 2017 by the Institute of Contemporary Art, Miami, and DelMonico Books•Prestel

Funding from the Knight Contemporary Art Fund at the Miami Foundation has made "The Everywhere Studio" and this catalogue possible.

Presenting sponsors:
Deutsche Bank, Saint Laurent

Media sponsor:
W Magazine

Major support was provided by Art Mentor Foundation Lucerne; and the Dr. Kira and Mr. Neil Flanzraich Fund for Curatorial Research at ICA Miami. Additional support was provided by The Jacques and Natasha Gelman Foundation.

Editors:
Alex Gartenfeld
Gean Moreno
Stephanie Seidel

Text editors:
Alex Scrimgeour
Lloyd Wise

Research fellow:
Deborah Lehman Di Capua

Copy editor:
Cherry Pickman/
Pickman Editorial

Design:
Chad Kloepfer

Production:
Die Keure, Bruges
Printed in Belgium

Cover: Stuart Brisley, *ZL656395C*, 1972
17 days continuous performance
Gallery House, London
Photographer: Alaric Aldred
Courtesy of Galerie Jaqueline Martins, São Paulo; Hales London; Mitchell Algus Gallery, New York
Copyright: The Artist

Institute of Contemporary Art, Miami
61 NE 41st Street
Miami, Florida, 33137
icamiami.org

DelMonico Books, an imprint of Prestel, a member of Verlagsgruppe Random House GmbH

Prestel Verlag
Neumarkter Strasse 28
81673 Munich

Prestel Publishing Ltd.
14-17 Wells Street
London W1T 3PD

Prestel Publishing
900 Broadway, Suite 603
New York, NY 10003

www.prestel.com

Library of Congress Control Number:
2017957945

A CIP catalogue record for this book is available from the British Library.

ISBN: 978-3-7913-5691-4